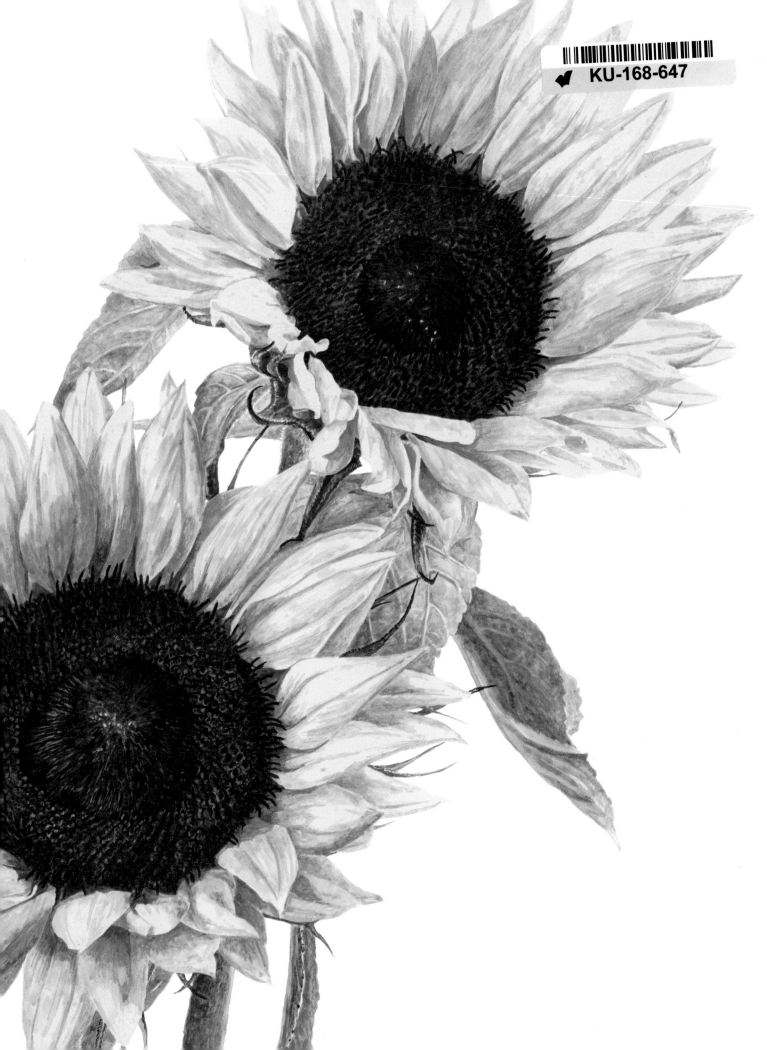

# Anna Mason's
# Watercolour
# World

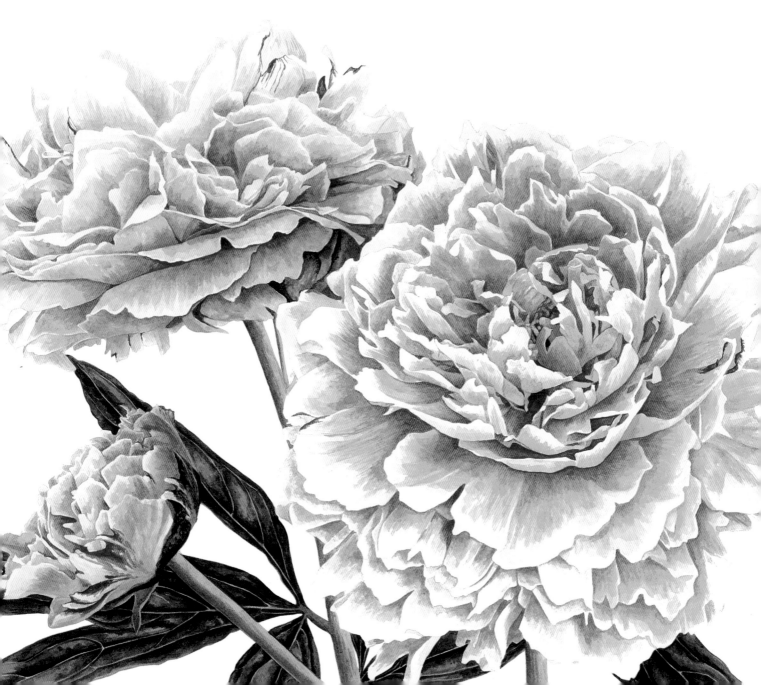

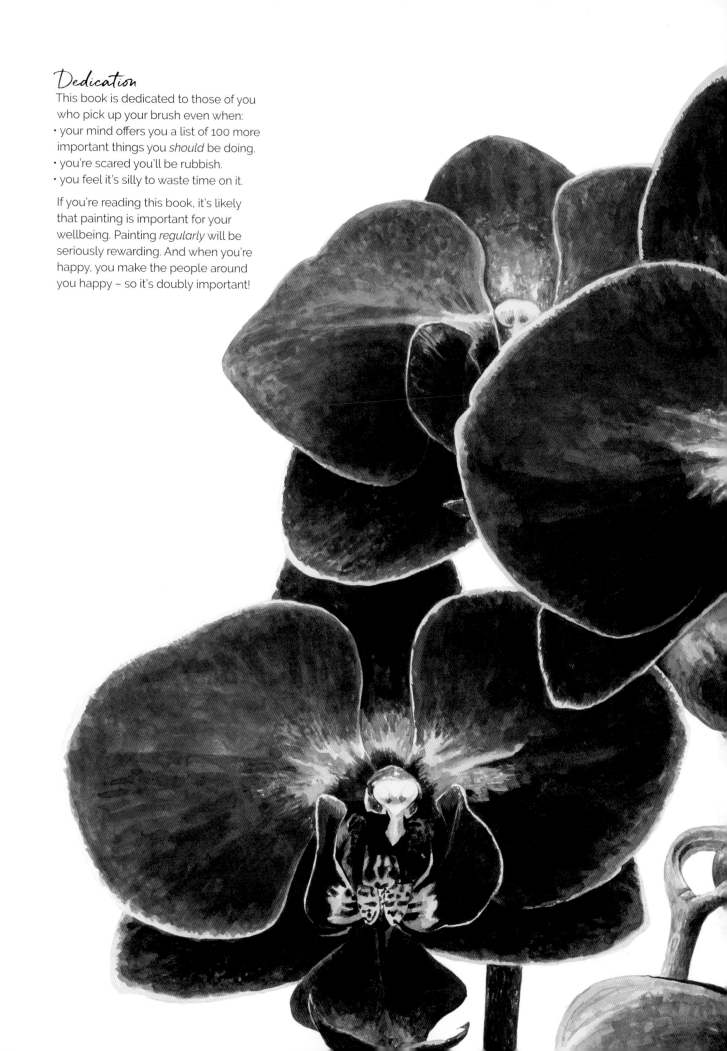

## Dedication

This book is dedicated to those of you who pick up your brush even when:
• your mind offers you a list of 100 more important things you *should* be doing.
• you're scared you'll be rubbish.
• you feel it's silly to waste time on it.

If you're reading this book, it's likely that painting is important for your wellbeing. Painting *regularly* will be seriously rewarding. And when you're happy, you make the people around you happy – so it's doubly important!

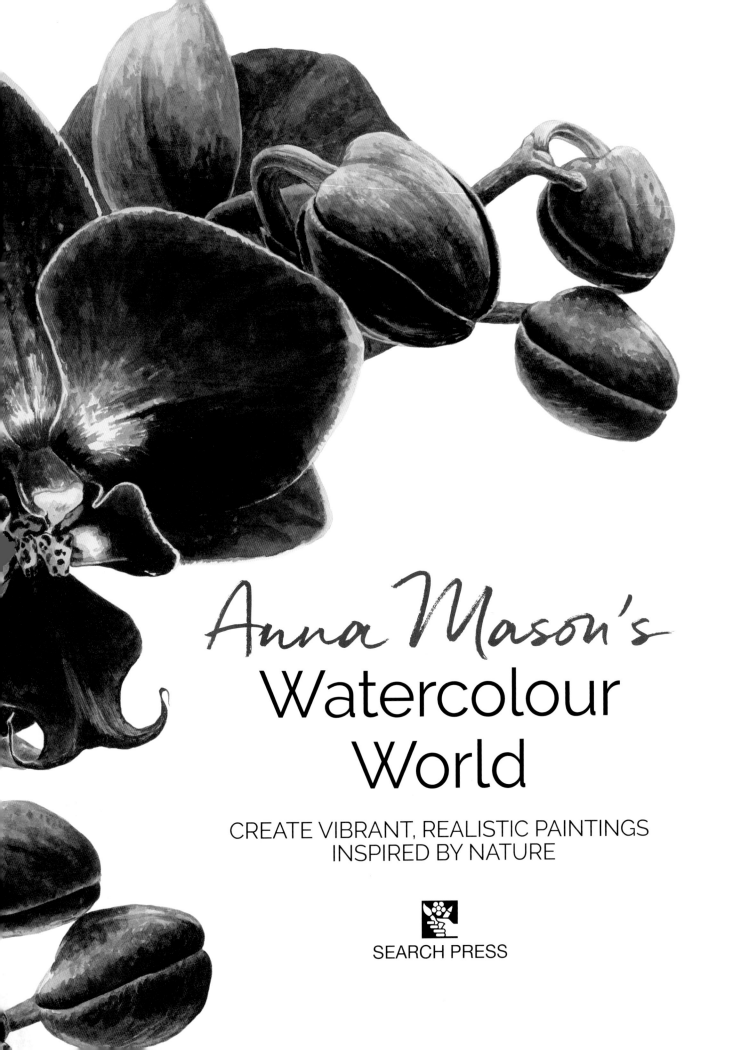

# Anna Mason's
# Watercolour World

CREATE VIBRANT, REALISTIC PAINTINGS
INSPIRED BY NATURE

SEARCH PRESS

First published in 2018

Search Press Limited
Wellwood, North Farm Road,
Tunbridge Wells, Kent TN2 3DR

Text copyright © Anna Mason 2018

Photographs by Aki Lalani: 9, 10, 16–17, 20, 30–31, 46, 70,
116, 118–119, 131
Photographs © Shutterstock: 40 (top centre), 42, 43, 52,
53, 68, 72–82, 84–88, 92–100, 102–110, 112
Apart from snapshots, all other photographs by
Roddy Paine Studios

Photographs and design copyright ©
Search Press Ltd 2018

ISBN: 978-1-78221-347-5

Suppliers
For details of suppliers, please visit Anna's website:
annamasonart.com

If you would like to watch video demonstrations of
technique, receive support and personal feedback, as
well as share your experience of learning to paint in
this style, you are invited to join Anna's online class and
community via her website: annamasonart.com

Printed in China through Asia Pacific Offset

## Acknowledgements

Huge thanks to Phil and Carrie; without
their committed work I'd never have been
able to write this book whilst still running
my online school.
To Anna Ghublikian from Craftsy who was
so skilled and helpful in getting me to think
through and verbalise my painting process.
To Aki Lalani for taking the wonderful
photos in my garden, and also to
Becky Robbins for being such a
supportive and empowering editor.

*Cover*
### Anna's Hummingbird on Foxglove
*71 x 50cm (28 x 20in)*

*Page 1*
### Peonies
*41 x 31cm (16 x 12in)*

*Pages 2–3*
### Purple Phalaenopsis
*41 x 31cm (16 x 12in)*

Publisher's note
All the step-by-step photographs in this book
feature the author, Anna Mason, demonstrating
watercolour painting. No models have been used.

# Contents

# Welcome to my world

*Spring sunshine lights up a vibrant anemone at the side of the path.*

*Rays of light dapple through branches onto ripening fruit.*

*A bird perches for a moment on the fence, its feathers iridescent in the fading evening sun.*

These precious moments, the kind that make you stop in your tracks and feel grateful to be here, are what inspire my watercolours. In this book I'm thrilled to invite you to spend some time with me – in my garden and my studio – as I share with you my inspiration as well as my tips and techniques for capturing your own inspiration with your paints.

   Sunshine and vibrant colour: their power to lift the spirits has made them an enduring theme in my paintings. And that's been reflected in the pages of this book, which I hope will transport you to a warm and sunny September afternoon, while they fire you up to get your own paints out. And once fired up, the book gives you practical exercises to coach you in my method. I believe the satisfaction you get from completing a full painting is so powerful that it's the best way of learning. This is why I provide you with four really in-depth painting projects to tackle for yourself. If you need help with any of them, be sure to check out my website, AnnaMasonArt.com, where there are short instructional videos – and you can even join my online school. Whether you've taken my video classes for a while now or are totally new to my method, I hope this book will be a ray of sunshine.

Happy painting,

*Anna*

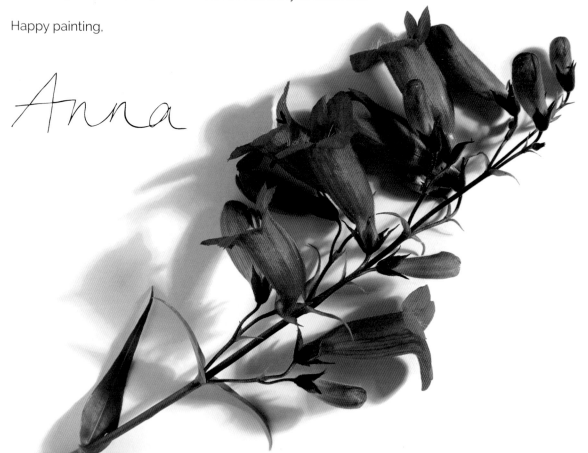

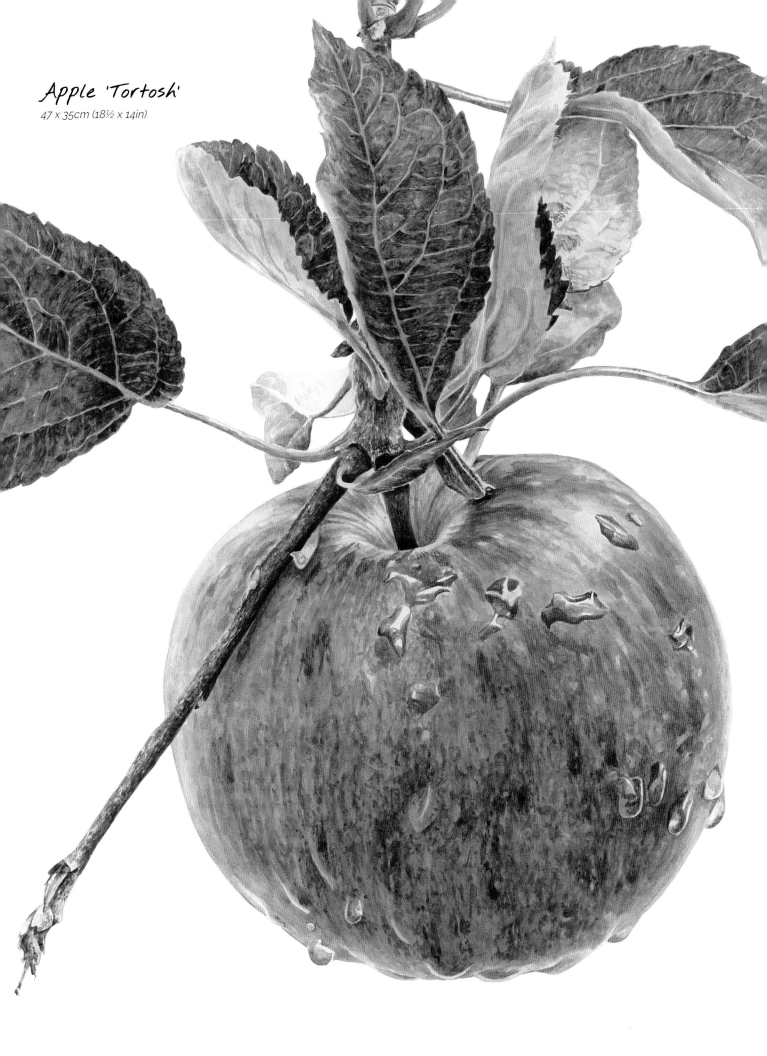

Apple 'Tortosh'
*47 x 35cm (18½ x 14in)*

# How I got here

I've been painting since I was two years old. And although I loved to paint and draw when I was a child, I never thought I'd become a professional artist. In fact, even though I took art when I was at school, I pursued academic subjects at university and ended up working in local government, spending eight years without painting at all.

It was gardening that got me back into painting. In my mid-twenties I moved into a house with a little garden and became quite obsessed with planting things and watching them grow. All of a sudden it became somehow totally fascinating and inspiring. My creativity was re-ignited and the desire to paint came back again, stronger than ever. It was when I saw some botanical artwork online that I realised there was a style of painting out there that could combine these two passions. And the *realism* of botanical art really appealed too. I remembered from painting as a child that it was always fun to me to paint a subject and get it to look just the way it does in real life. But I'd picked up messages throughout school and since that there was something uncool and even naive about painting in a realistic way, and about painting beautiful things.

However, botanical art, with its tradition dating back centuries, was a style of painting unashamedly realistic and focused on subject matter that I now found fascinating and beautiful. I *just knew* that I'd found what I wanted to do with my career and I went straight out and bought myself paints and paper. The skills I'd developed from thousands of hours of painting as a child hadn't left me, and from my first attempts I knew my paintings had something special. Using my own self-taught method, my paintings weren't quite so traditional and they were big and bold. They conveyed a life to their subjects that people responded to.

So I decided to enter a botanical art competition run by the Royal Horticultural Society (the RHS) and won their prestigious Gold Medal and Best in Show awards. Just one year later I took the brave, and scary, step of quitting my job to paint full time.

I regularly exhibited at the RHS Chelsea Flower Show and following on from that began to teach classes at venues with the RHS and across the UK and US. It was then I found my next passion – helping other people to develop their own painting skills. My students were getting such great results, their confidence soaring, that it seemed a logical next step to take the teaching to a wider audience through online video classes (the photograph here shows me in the studio). I launched my online school in 2014, which I'm honoured to say now has thousands of members from over 70 countries around the world!

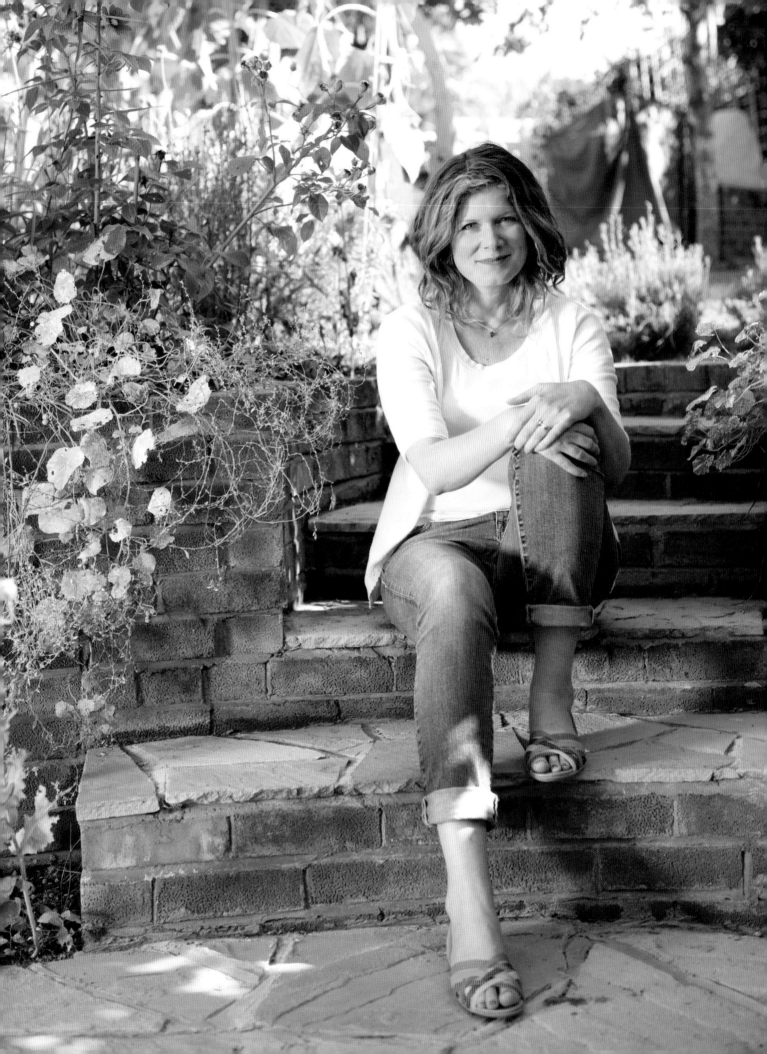

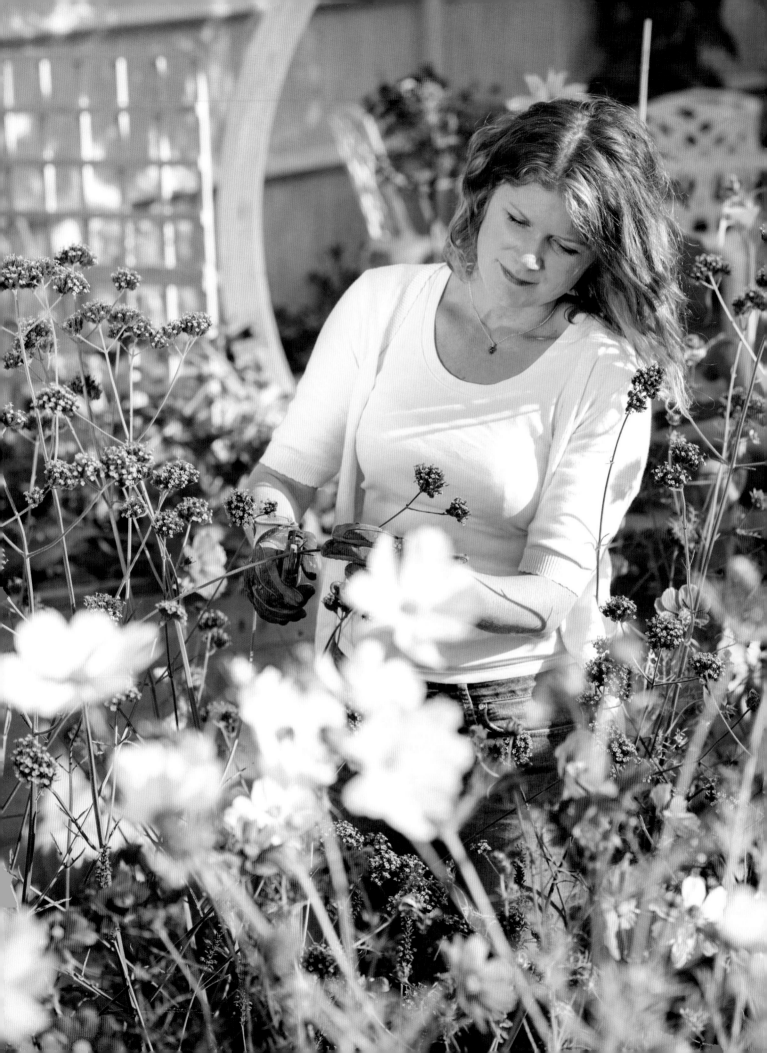

# The Inspiration

# Being in nature

When I quit my 'sensible' job to work as an artist full-time, the first thing I did was get a dog. Little did I know it but getting Dexter was probably *the* best thing I could have done for my creativity and inspiration.

Every day I was forced to go for a walk with him and, when he was a puppy, we needed to walk for at least an hour or so to really tire him out. What I discovered was that doing this day in, day out turned out to be quite meditative. I'd begin the walk with a mind brimful of all the things I needed to do in the day ahead. But by the time I'd walked for around 30 minutes or so, my mind had usually quieted down enough for me to really start to 'see' my surroundings more clearly, to feel more present in my environment. To 'come to my senses'.

It wasn't just the fact I was walking, though that was a part of it. It was the fact I was walking *in nature*. I'd moved back to the countryside because I'd grown up there, and when I'd lived in towns I'd always really missed it. During my walks I was surrounded by trees, birds, ferns and wildflowers. As my mind quietened, my visual sense heightened and I could 'see' so much more clearly. It was stunning.

In fact, it's in the later stages of a walk that I'll often spot something on the ground or in the hedgerow that's crying out to be painted. When we're busy or rushing we tend not to notice these little and often unexceptional objects like feathers, leaves and pine cones. But when you *really look* they can be rich with beautiful detail that can make for a really enjoyable painting. And they can often be taken home easily to be photographed and painted there (though be careful, I once burned my fingers bringing home a beautiful but, as it turned out, *toxic* mushroom!).

Being in nature with a quiet mind not only provides inspiration at the level of views and found objects, but it also improves your concentration* when you're back at home, which will aid your painting no end. And it can also make space for *inspired* thoughts to pop up from within you. Whether that's thoughts about what to paint next, or what creative project to begin, or purely an inspired thought about what to do in a difficult life situation you're going through, what's certain is that the quality of your thoughts will be better after a period of quietening your mind.

*For more information on this, search for 'Attention Restoration Theory'.

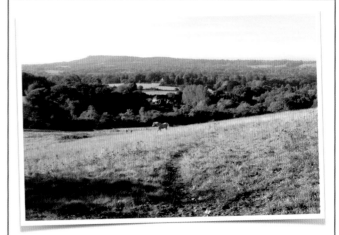

## Inspiration tip

*My favourite place for being in nature is at the top of the hill where I live. As you walk up it, the noise from the surrounding area drops away and you're left with just the noise of some birdsong. Bliss. To be aware of this you need to be listening. And if you're truly listening then you're not doing any thinking about what you're doing later in the day. So if you're listening, you're already providing some space for your senses, both auditory and visual, to heighten, and for those genuinely creative thoughts to emerge. So for a creative boost, do seek out some quiet time in nature. Even if you live in a town, parks can often be really peaceful, especially early on a light summer's morning.*

*Relaxing in sunshine and nature aged two (without a to-do list to think about!)*

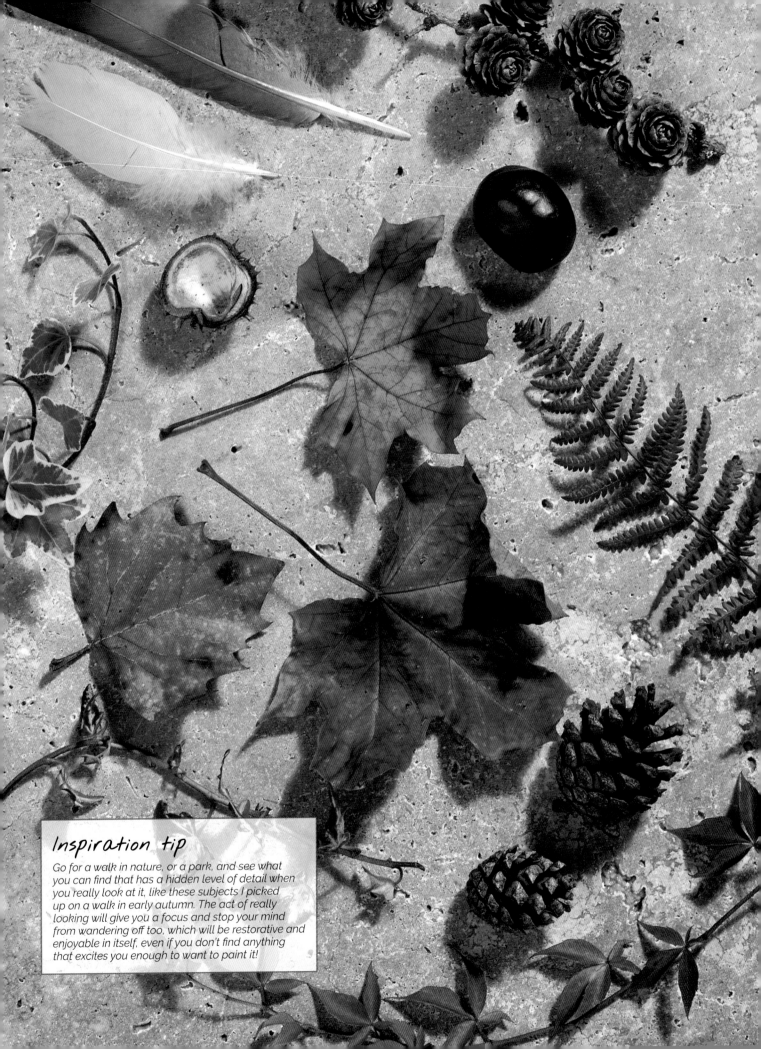

## Inspiration tip

Go for a walk in nature, or a park, and see what you can find that has a hidden level of detail when you really look at it, like these subjects I picked up on a walk in early autumn. The act of really looking will give you a focus and stop your mind from wandering off too, which will be restorative and enjoyable in itself, even if you don't find anything that excites you enough to want to paint it!

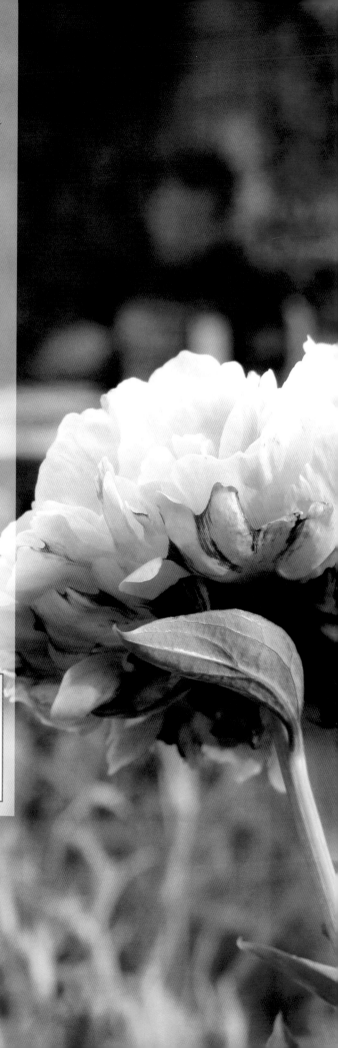

# Being in gardens

If nature can be great for getting you in a creative headspace, for lovers of plants and flowers, there's something uniquely special about being in a garden. In a garden someone has taken the time to select the plants, usually for their beauty and the way they look with one another. Where I live in England, gardening is a national obsession and we're blessed with thousands of gardens that are open to the public every spring and summer. So even without a garden of your own, you're still able to visit other people's gardens to get inspired.

Again the key has to be *being* in a garden and not being mentally off somewhere else. If you're constantly chatting to the friend you've come with you might have a nice time but you're much less likely to leave really inspired.

I'm lucky enough to have a mum who is a keen gardener and has created her beautiful garden over many years. So even before I had developed my own garden, I could go and spend time in hers. (The photograph on this page is of her garden, with her, my dad and husband Phil enjoying it.)

In the excellent book *Tending the Earth, Mending the Spirit: The Healing Gifts of Gardening* (Nodin Press, 2012) Connie Goldman and Richard Mahler get to the heart of what's going on when we're in a garden:

'When we step into our gardens, we are submerged in sights, smells, sounds and textures. This is a wake-up call for the part of our brain that processes experience directly and intuitively instead of categorising and analysing it in a detached way. When this part of the brain is stimulated, we tend to become more aware of the sensations and emotions that underlie our busy rational mind.'

By becoming more aware of our senses and our immediate experience, we can be more 'present' in the moment, and more open to inspiration.

## Inspiration tip

*When you're visiting someone else's garden or a public garden, you're not going to be able to cut flowers or fruit to take home with you to photograph or paint. So it's best to take your camera with you so you can capture any subjects that strike you as inspiring and possibly worth painting. There are tips on how to do that on page 30.*

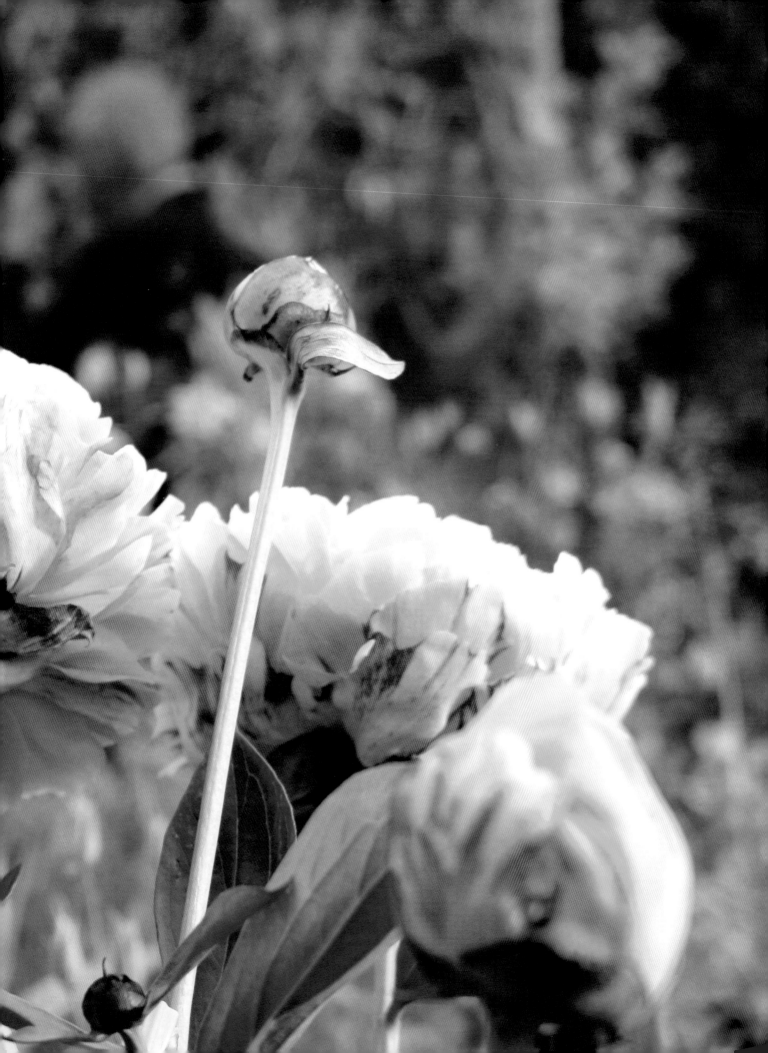

# The act of gardening

Even though my mum is a great gardener and I'd grown up with her wonderful garden, I'd previously taken it for granted. But when I first got my own garden, though it was tiny and in a rented property, I got the gardening bug. It's helped my painting and, even if you only have the space for a windowbox, it can help yours too in these ways:

## Creativity increases your creativity

Gardening itself is fundamentally creative. The act of sowing a seed and nurturing it as it develops into a plant is about the most perfect creative thing you can do (and it's so easy). The satisfaction you get when that seedling sprouts up – let alone when it flowers, is priceless. And so by gardening you're doing something positive for your painting because, with creativity, it tends to be that the more creative you are in one area of life, the more creative you become in others too.

## Bringing you back to your senses

The act of gardening itself is really absorbing – much like painting can be – and can take you back to the moment. It's usually done alone, for quite long periods, and usually in silence. It's an antidote to the distracting modern world where we are constantly 'plugged in' to our devices. And it's from this meditative activity, just like when walking in nature, that you can feel more present in your environment – and more likely to become inspired by something you see around you or inspired about what to paint next.

## Providing you with subjects to paint

If you plant your garden, or windowbox, full of the flowers you love the most, you'll maximise just how inspired and uplifted you're going to feel there. And you'll be able to create paintings based on the plants you've nurtured. Artists have a long relationship with painting gardens, and none more so than Claude Monet (1840–1926). His garden was his exclusive subject for over twenty years and he's quoted as saying:

"My garden is my most beautiful work of art."

# The experience of painting

The physical experience of painting has two sensory pleasures for me, which light me up every time I even think of them. There's the delicious physical sensation of the brush scooping up paint and then depositing it on the paper and moving it around. And then there's the visual treat of adding water to paint in the palette, of mixing colours to the desired consistency. *Colour* has to be the most inspiring part of this for me.

## Paint as a sun substitute

*"Sometimes it rained, but mostly it was just dull, a land without shadows. It was like living inside Tupperware." – Bill Bryson*

That was how the travel writer Bill Bryson described a winter in the UK in his book *The Lost Continent* (Black Swan, Penguin Random House 1999). I read that quote years ago and it's stuck with me. I often think of it when we experience several grey days in a row. I love where I live, but, like Bill, I don't love the lack of sunshine during the winter. And mainly that's because of the lack of *colour*! So when the occasional sunny day does arrive, it's precious and amazing and I feel myself come to life. For me it's the bright, vivid kaleidoscope of colours, shadows and high contrast on a sunny day that make it so uplifting. I think that's the main reason I love spring. We get more sunny days, flowers emerge and that means more colour!

But during the many, many, grey days we have here in the UK, I've found painting to be a great way to inject some uplifting colour into my daily experience, and bring with it the accompanying feeling of wellbeing and even inspiration. The brightest possible colours seem to work best for this (especially the 'warm' ones such as reds and pinks), and I'm sure it's one of the main reasons that flowers have been such a focus of my artwork.

### Inspiration tip

*Wellbeing statistics and scientific studies show that it's not sunny weather by itself that makes us feel happy. Rather, it's the change from grey skies to sun that makes us experience a 'lift' and effectively brings us to our senses. So it's likely that if you live somewhere with a year-round sunny climate, you might find that you get a lift from painting with more muted, subtle and even 'cooler' colours, like blues and greys.*

*A sunny walk in the country after a couple of grey days can be a recipe for getting your creative juices flowing!*

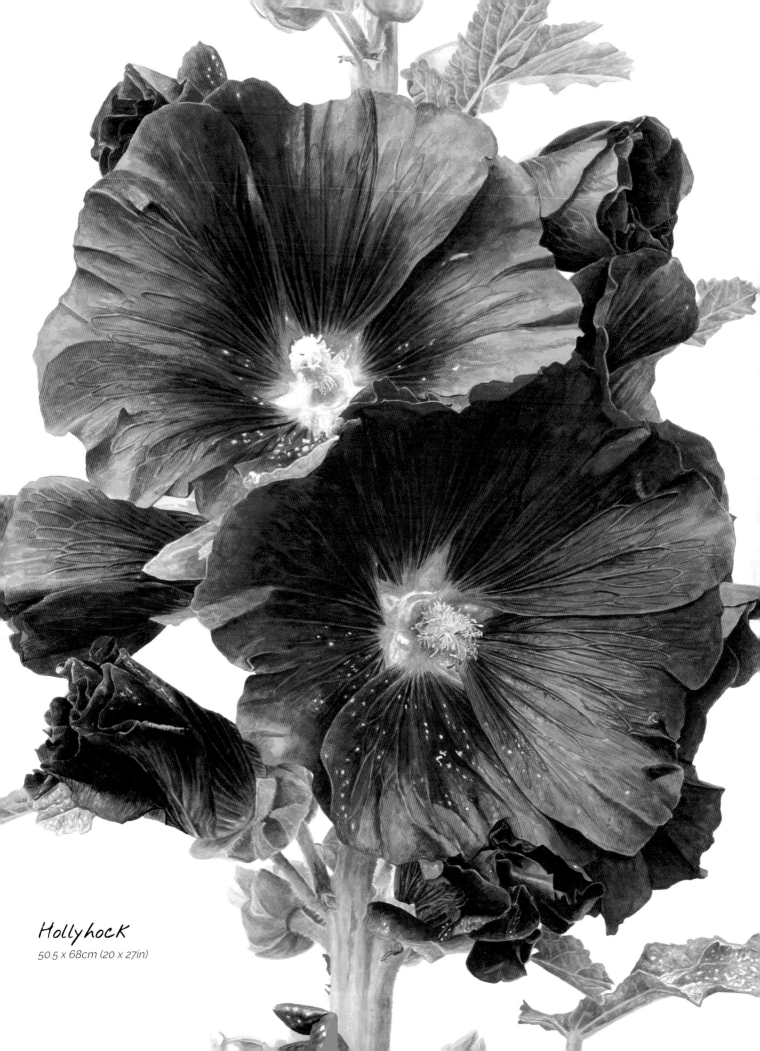

Hollyhock
*50.5 x 68cm (20 x 27in)*

# The Approach

# Detail and impact

Painting detail is crucial to achieving realism in paintings. It's something I've always enjoyed doing and, as you're reading this book, you're probably drawn to painting detail too. My approach is to paint what I see in my subject – everything I see – all details included. And to that end, I like to paint my subjects larger than life, because it makes painting all that detail easier. It also means that the painting itself has more impact. Impact is really important because I want my paintings to be able to grab attention from the other side of the room. I'd like people to be stunned into paying attention to the details that are usually right under their nose but not noticed.

Another way I give my paintings impact is that I usually don't include any kind of background at all. I did this initially because, when I started, I was wanting to fit in with the botanical art tradition. As botanical illustrations were produced as scientific studies of their subjects to aid identification, they never had a background. But as I worked larger than life and with my naturalistic style of composition, I realised that the lack of background served an important function in my paintings too; it removed all distraction from the subject and allowed the viewer to focus exclusively on the subject in all its detail and beauty. The white space of the paper also became a part of the composition. I found I enjoyed using the white 'negative spaces' around my subjects to create visually appealing pattern-like shapes.

Sometimes I do add a shadow to give an otherwise 'floating' subject a little context (see the shell on page 24); sometimes I like the distraction-free floating look (see the raspberry on page 47). Occasionally I do paint a background, as for the owl on page 37, which I felt needed context, and the orchid, below. There are no rules!

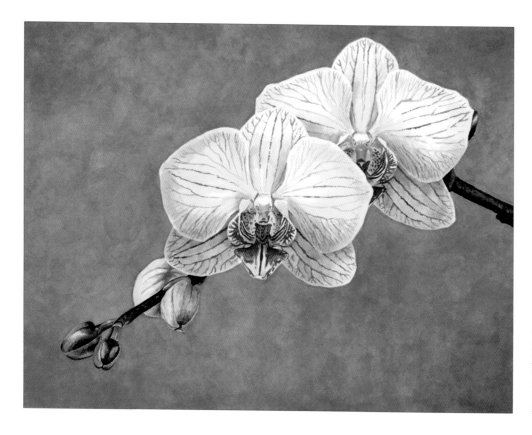

*Painting a background can be helpful when you're looking to give a very pale subject like this orchid some more impact, as it makes it stand out in comparison.*

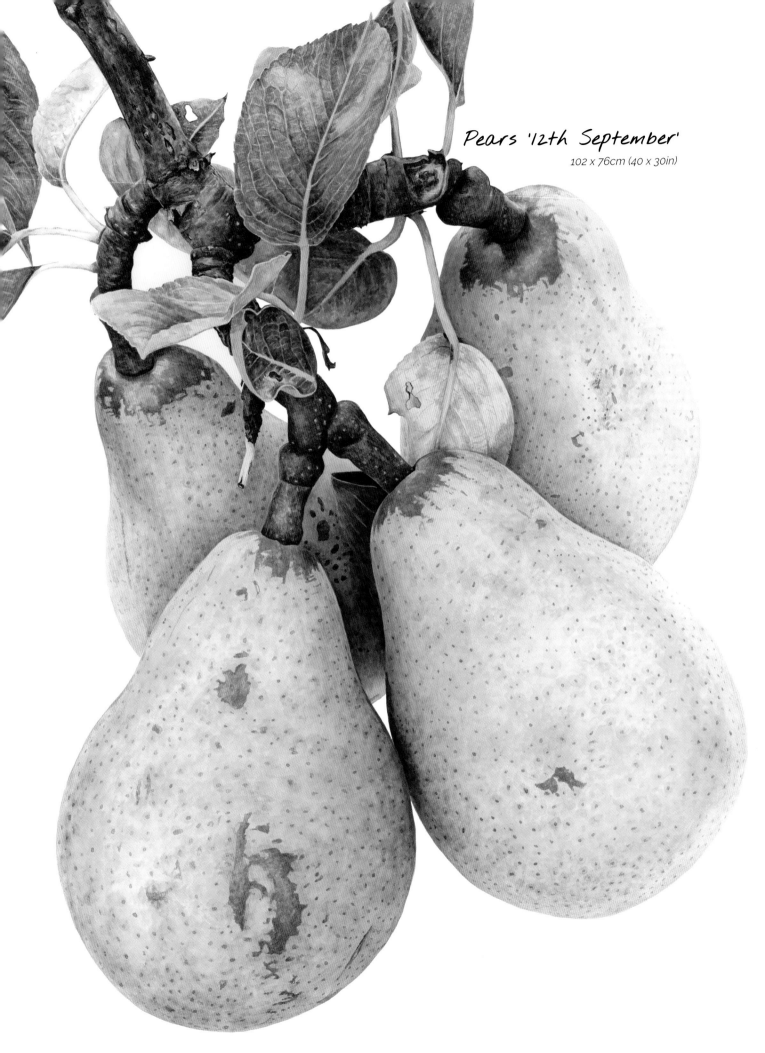

Pears '12th September'
102 x 76cm (40 x 30in)

# Small subjects painted big

I've been fascinated by details in the natural world for as long as I can remember. When I was six years old I became obsessed with micro-shells on a family holiday to Spain. Each handful of sand on the beach contained hundreds of fairly large grains of sand a couple of millimetres wide. And for every four handfuls or so, there would be a micro-shell not much larger hiding in amongst them. I spent many blissful hours hunting for these shells and collected several hundred in a jam jar! These shells possessed a level of detail and beauty that my six-year-old mind found fascinating.

Now, instead of just looking at this level of beauty in detail, I paint it. By painting it in a realistic way it truly feels like I get to soak those gorgeous details up in to my very core during the painting process. And by painting my subjects larger than life, I get to show this detail to people who wouldn't ordinarily take the time to notice it.

The wonderful macro capacities of our modern digital cameras can help us to 'see' far more detail than the naked eye can perceive, which is one of the reasons using photographs is so helpful for painting in this way.

*On a rare break from shell hunting, aged six (surfing was not my thing!)*

"To see a world in a grain of sand,
And a heaven in a wild flower,
Hold infinity in the palm of your hand,
And eternity in an hour." –
William Blake (1757–1827)

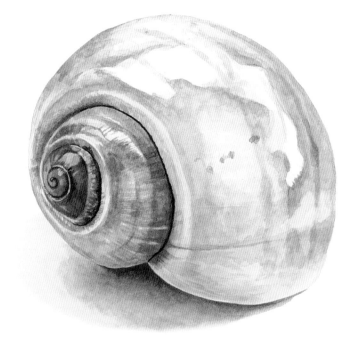

## Shiny Shell

*23 x 23cm (9 x 9in), right*
*Painting allows you to soak in all that detail: colour, pattern, texture.*

*The most prized micro-shells from my treasured jam-jar collection.*

 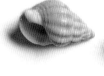 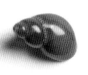 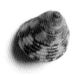 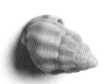 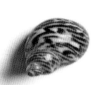 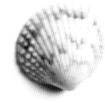

  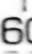

½ mm 10    20 mm 30    40    50    60

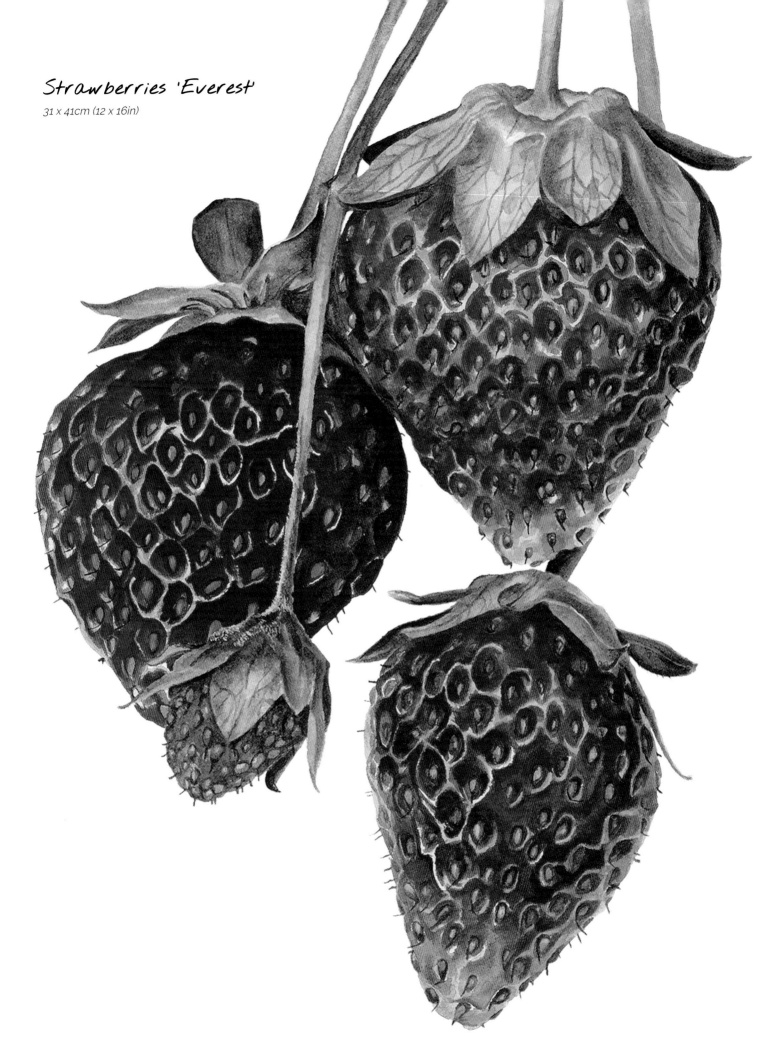

Strawberries 'Everest'
*31 x 41cm (12 x 16in)*

## Black Swans

*102 x 76cm (40 x 30in)*

*Swans are fairly large birds so I wanted to paint
them as close to life size as I felt comfortable
working, in order to capture as much detail
as possible. This painting was painted onto
illustration board. Notice how I still use my regular
(and small) size brushes when working this big!*

# Painting from photographs

In some art circles, painting from photographs has a bad reputation. It's seen as inferior to working from life or imagination. But when it comes to painting in this realistic and detailed style, I think it's perfect! As long as your photographs are of a good quality, it has a number of practical advantages:

*1.* Using a modern camera's macro function means your photograph can capture more detail than the human eye could. View that photograph on a quality computer screen and you can zoom in to see even more!

*2.* The photograph will capture a moment in time showing you exactly how light was falling on the subject – something that's crucial for creating three-dimensional shape in your paintings. If you work from life, the lighting on your subject *will* change in the many hours (if not days) it will take to paint it. Likewise, the subject may change during that time too (i.e. the fruit may rot) or, in the case of wildlife, it *will* move (if you were skilled enough to find it in the first place).

*3.* Working from a photograph means you can paint at a time and pace to suit you (including painting an uplifting pink flower in the depths of a gloomy winter).

*4.* It can be an aide to setting up your compositions, which I'll cover on pages 30–35.

Some criticisms of using photographs to paint from probably stem from the days of poor-quality consumer cameras, which led to poor-quality photographs. This is *not* the case today – with a little bit of practice, anyone can take photographs good enough to paint from.

However, the criticisms often go deeper and often imply that painting from photographs lacks creativity and interpretation. In short, 'why bother to paint, when we could just look at the photograph'. I used to have that attitude myself. It was one of the things that kept me from picking up a brush for over eight years; lacking 'inspiration' and not knowing what to paint, but *really* missing the act of painting. However, as soon as I discovered botanical painting and had a goal of realism and accuracy, the act of painting from a photograph became totally liberating.

Taking a photograph I was inspired to paint became a really creative part of the process. It's the act of finding and photographing beautiful subjects that forms my personal interpretation of them.

Once I have the photograph (or photographs) to work from I can, in a sense, simply 'copy' the photograph. I don't have to think about what I am painting at all. I don't have to make any decisions about what to include or not include. I don't need to try to conjure anything up from my imagination to paint. So long as I replicate it faithfully, it can be nothing other than accurate.

I can get in the right-brain 'zone' and the painting just flows in a way that feels both stimulating and relaxing (more on this on page 137). In short, I can enjoy the process of painting and don't waste any time not knowing what to paint. Plus, I *know* there is a significant difference between the photograph and my painting when I've finished – the process of painting always adds something valuable and I do end up making decisions, often subconsciously, about how to paint certain areas.

So working from photographs makes the process more enjoyable for me. And the process needs to be enjoyable. Otherwise really, what's the point?

## Choosing a camera

Modern digital cameras will take fantastic reference photographs, but you might just need to consult the manual! I use a compact camera like the one shown left, rather than a more complex (and more expensive) digital SLR. A compact camera has the advantage over a phone camera because, on all but the most basic models, you can usually gain some control over the different settings without them being too complicated. And they also allow you to use them one-handed, which is an advantage, as you'll see on page 30.

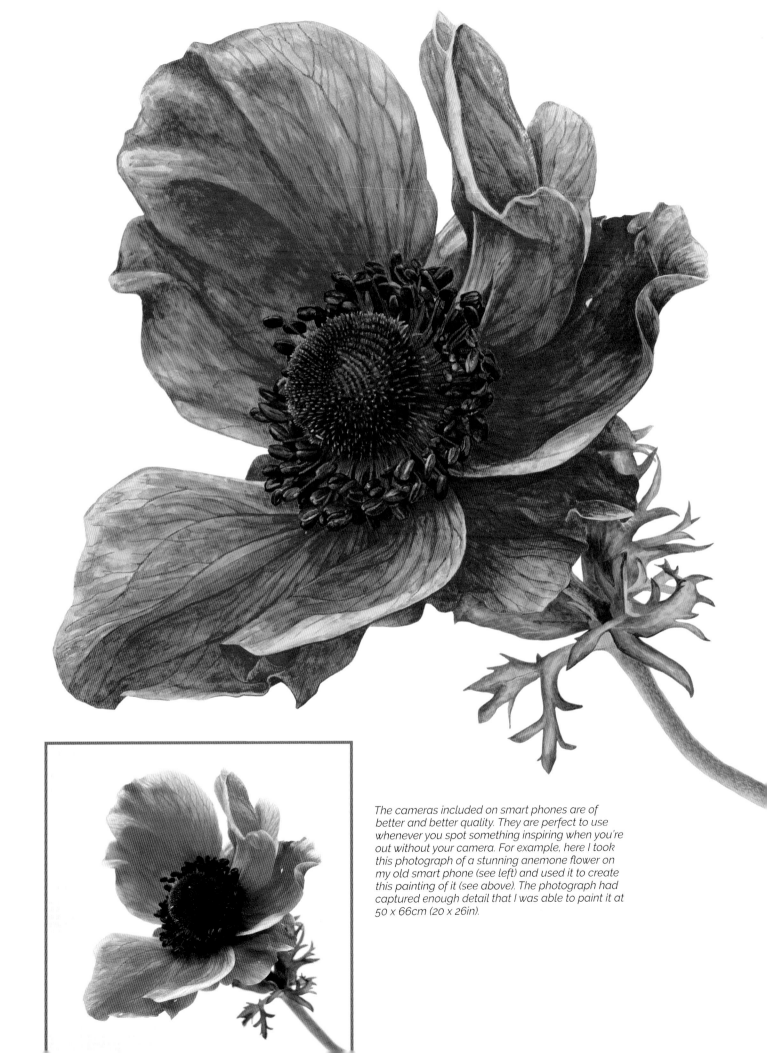

The cameras included on smart phones are of better and better quality. They are perfect to use whenever you spot something inspiring when you're out without your camera. For example, here I took this photograph of a stunning anemone flower on my old smart phone (see left) and used it to create this painting of it (see above). The photograph had captured enough detail that I was able to paint it at 50 x 66cm (20 x 26in).

# Photographing tips

Taking your own photographs to work from can be a really inspiring thing to do. Crucially, it allows you a lot of control in setting up your compositions. Instead of having to sketch out a composition to see what it looks like, you can shift your own position, or even your subject, and in the click of a button you can see what the composition looks like. Of course, flowers and all botanical subjects do us the favour of staying still, unless it's windy, which gives us a fighting chance of getting some good shots to work from! Photographing wildlife requires serious photography skills, so for wildlife photographs it's best to source your photos online. Be really aware of copyright so look for photo-sharing websites where photographers have given permission for you to paint their photographs or approach wildlife photographers direct for permission to paint.

## Isolate your subject with white card or plastic

Positioning white card or plastic behind your botanical subject as you photograph it means you can instantly see your composition clearly. Of course, you could crop your photographs after you've taken them, but I love using the full frame because that way I can test out that my compositions look right as I photograph. Plus, the aspect ratio (proportions) of the camera's default photograph settings is the same proportions as the standard blocks of paper I use to paint on, so it makes it even easier to imagine how the photograph will look as a painting.

  Holding the card behind the subject while photographing it takes a bit of practice, and it's really helpful if you can hold your camera and take the photograph using one hand, while you position the card behind your subject with the other. This means you'll need to be only an arm's length away from your subject. This is another reason why a compact digital camera works best for this as, when using a digital SLR, you'll find you need to be further away from your subject so will need someone else with you if you're to be able to position the card behind it.

## Make sure your camera is on the biggest photograph setting

The bigger your photograph in terms of pixels, the more detail you'll be able to capture. So make sure your camera is set to take photographs at the biggest size it can. This will mean you'll fit less on your memory card, so you may want a second memory card on hand in case you fill one up!

## Choose the right day

Having enough light is *so* important for the quality of your photographs. The ideal day would be really bright but with a bit of cloud so that there aren't strong shadows. If the sun is out, you'll want to try to photograph in the shade so that the contrast levels in your photographs won't be too high and your subject won't be covered in shadows. It's also best to choose a day with minimal wind so that your subjects – if they're flowers or leaves – won't move too much.

## Holding your camera still

It's not necessary to use a tripod to photograph botanical subjects. Usually they stay still enough that you can get a good result by simply making sure you keep your camera steady by tucking your arms into your body for stability. The less you move as you photograph the more crisp your photographs will be.

## Avoid under-exposure

Most of the time you'll find that if your photographs are coming up a bit under-exposed (i.e. too dark, with the white card appearing grey) you can use photo-editing software to increase the exposure levels afterwards and make the photo lighter.

  But if you've photographed on a darker day, you may find that your photographs are too under-exposed and go too grainy when you try to increase the exposure afterwards. Using the white card can often confuse the way the camera gauges the light levels because there is so much white in the shot – and the result is that the camera adjusts itself to make a photograph that's under-exposed overall. So if you have a camera where you can go beyond the 'auto' setting, you can compensate for this by using the AV setting. The AV setting allows you to adjust the aperture size, while letting the rest of the exposure settings be handled by the camera. There are free tutorials online that can help you with this and the key is not to put up with poor results, as you can make big improvements with just a little bit of effort.

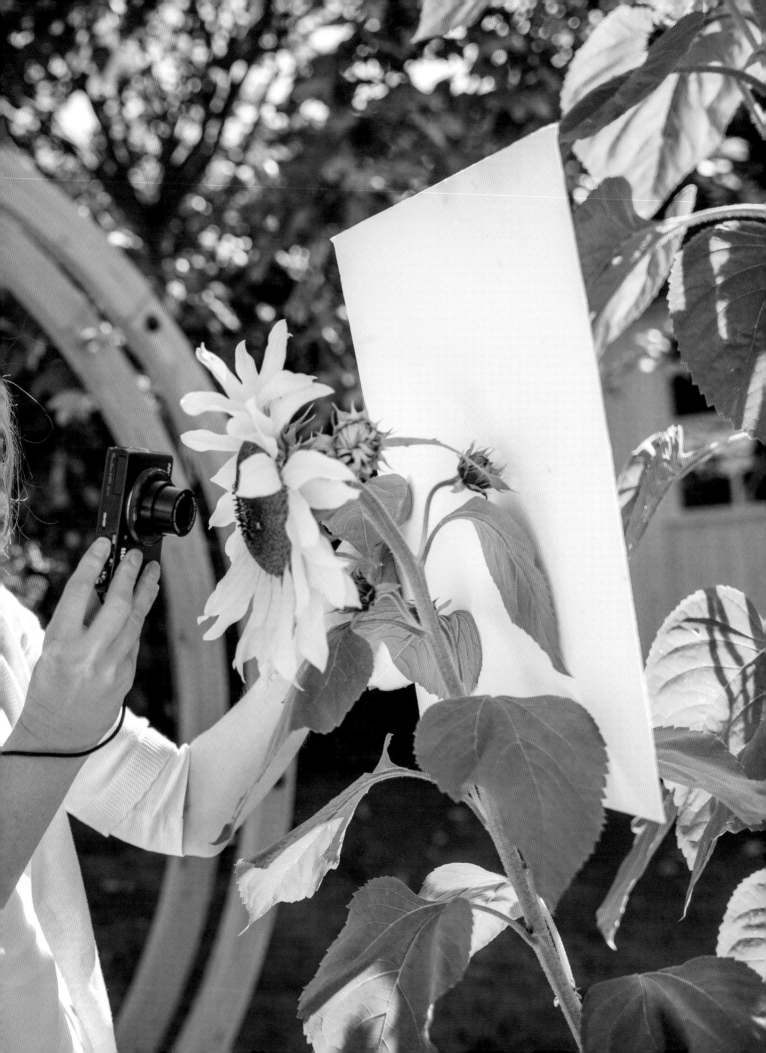

# Composing with your camera: mastering negative space

## It's OK to be odd (or even!)

It's pretty much common knowledge when setting up a composition that odd numbers of elements tend to look better than even ones. And a lot of the time that's true. Look at these two sunflowers together. Of course they're gorgeous, but their composition is not very pleasing to the eye. There's no interest. But why? You might think it's because there's just two of them, but actually that's *not* the reason. It's because there's been no consideration of the white space around them (often called 'negative space'). They're just right in the centre of the frame.

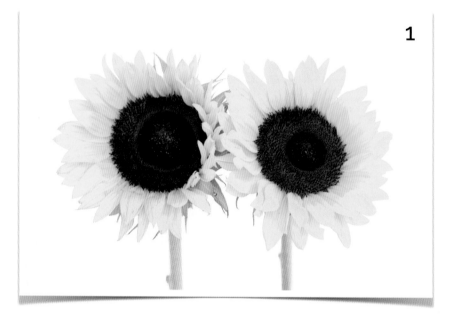

**1**

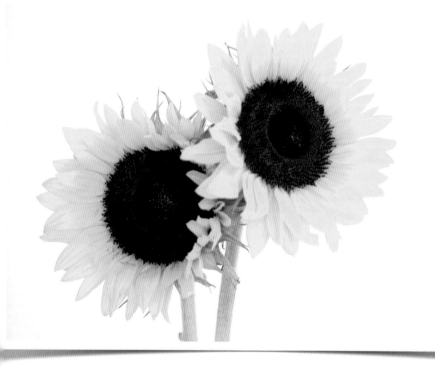

**2**

In this composition the negative space has been considered. There's more of it and it's larger on the right-hand side. Having an uneven distribution of negative space like this almost always looks better. It basically becomes another element of the composition, creating an 'odd' number of elements and making the overall composition more pleasing. These sunflowers were cut flowers, so I could actually move them around easily; if you were out in a garden you would need to change your own position to alter the angle, or keep your eyes peeled for some better arranged flowers!

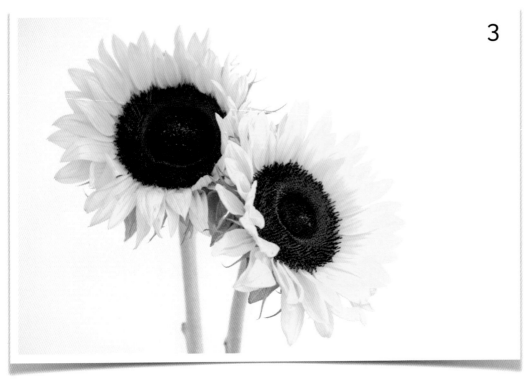

**3**

For me, this composition has the edge over composition 2. The left-hand flower is now taller than the right one and is filling the top left of the frame, creating a pleasing diagonal line of interest from the top-left corner down to the negative space in the bottom-right corner.

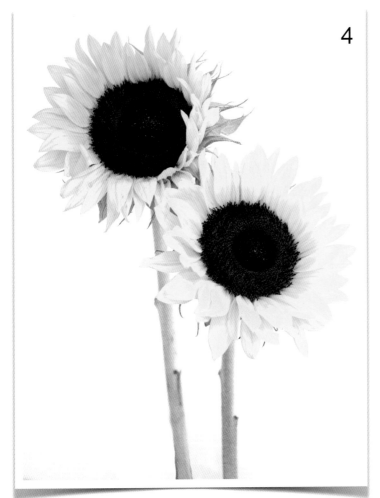

**4**

## Portrait or landscape?

Of course you can also play around with the orientation of your camera. A portrait shot is often great when you're trying to convey height – so would work well for these tall sunflowers. But the compromise is that you won't be painting the blooms as big. Just remember to consider your negative space and the choice is yours: focus on showing the plant's height or focus on its flowers. Whatever takes your fancy!

# It has to click for you

As long as you're considering the negative space in your compositions, there really are no rules about what works. In fact, I would encourage you to get out of your thinking brain and concentrate instead on your emotional reaction to each composition you photograph. How does it make you feel? You need to have a personal reaction to the composition if you're going to spend many hours painting it!

## The style I look for

There's nothing 'wrong' with the composition below. It contains three flowers, so if the 'odd numbers are more pleasing than even ones' theory was always true, it should look better to me than composition 3 on page 33. But to my eyes it doesn't. Again it comes down to a lack of negative space. The space around the flowers has been considered, but not the space between the flowers. They're really close together and this gives them the appearance of being in a bunch. While that is a perfectly valid style, I prefer a little more space between them.

5

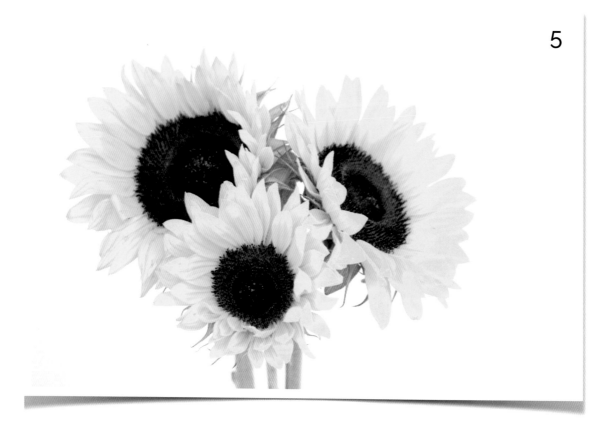

To me, this composition feels better than composition 5 because it has more negative space between the flowers, and the negative space above and below the flowers is balanced. I'd be happy to paint this, but it does look a little staged or artificial because of the even spacing of the flowers.

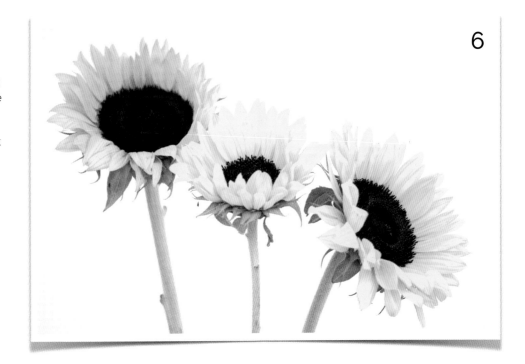

6

## Naturalistic = my favourite

This would be my favourite of all the compositions. The negative space is balanced but the flowers look totally natural – as though they could have been growing like this in the garden. This is the one that gets my fingers itching for the paintbrush!

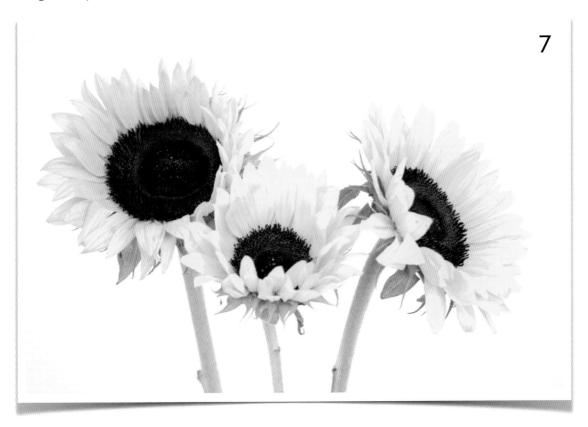

7

# Realism

I enjoy realism for two reasons. First and foremost, it's because it allows me to truly get into the flow when I work. That's because I'm looking to realistically re-create what I see in a photograph or series of photographs, so I only have to make minimal decisions about what colours and textures to paint where. All those decisions have been made for me by the camera. During the painting process my conscious, language-centred thinking mind can take a break. I can get into the flow and paint what I'm seeing rather than having to 'think' about what I'm doing.

And there's a happy by-product of this process, which is the second reason I love realism. When people do a double-take when they look at one of my paintings, and for a second or two think it's a photograph, they often experience a 'wow' moment. They're amazed that it's a painting, but that amazement actually gets them to stop for a few seconds or longer and truly appreciate the beauty from the world around us. They get a moment of joy and peace that they wouldn't have experienced when they thought what they were seeing was 'only' a photograph.

*Tawny Owl*
*36 x 49cm (14 x 19in)*

36

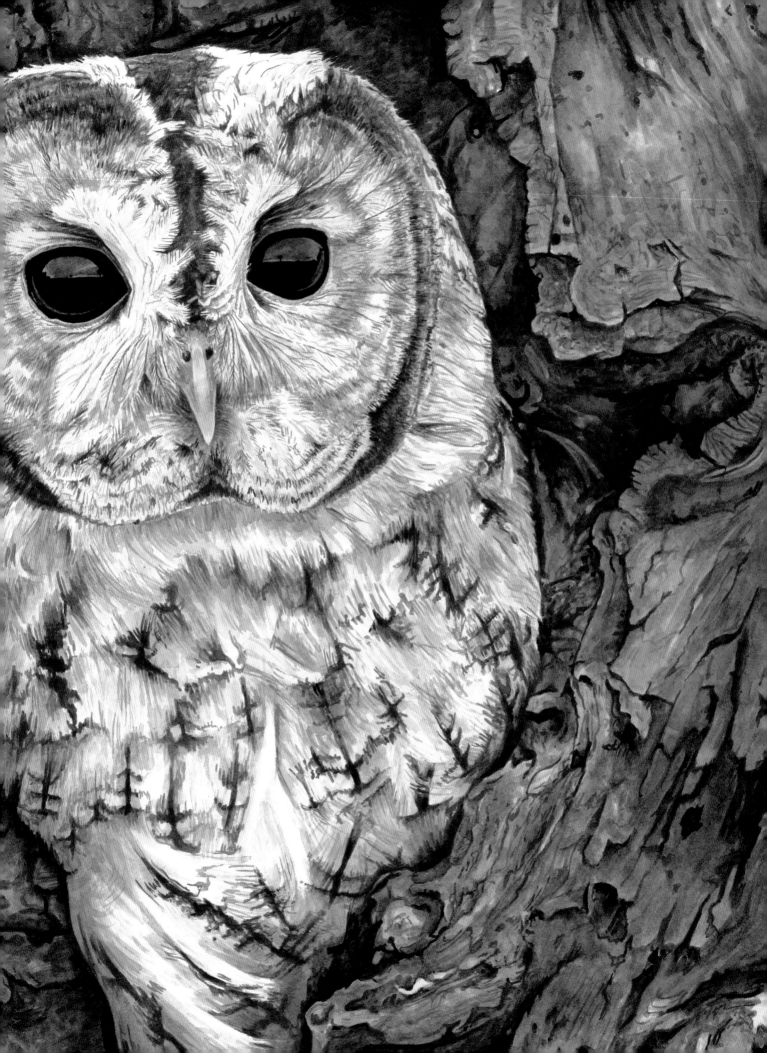

# Understanding colour

Analysing and describing colour is something that's pretty complex and it's something scientists struggled with for years. But there are two aspects of colour I think are important for learning how to paint it accurately: tone and hue.

*Sap +
wins
Lemon*

*w lemon*

*pur
ple
v. watery*

*To someone not used to seeing things in the way needed to paint realistically, a hollyhock flower like this would probably be described as 'white', or 'creamy white' at a push. But if you're looking to paint it realistically you need to be more precise than that. When you slow down and look closely, you can observe that the petals actually contain greens, yellows and pinks as well as greys – some lighter in tone and some darker where there are creases and shadows. The fun thing is that the more you practise, the more colour variation you will begin to see in the subjects you observe.*

## Tone

The tone aspect of colour is how light or dark it is; often this is referred to as the colour's 'value'. As we'll see, it's this aspect that is absolutely crucial to painting form and achieving three-dimensional effects. Because of its role in creating form, I believe tone is *the* most important factor to consider in your painting.

## Hue

The hue aspect of colour is pretty straightforward. It's what we usually think of when we use the word 'colour': so this is whether the colour is, for example, green or orange. It's possible for two colours to be very different in terms of hue, but the same in terms of tone. For example, take a look at these two rectangles:

Their hues are green and orange but if we strip the hue out, you can see that this green and orange are actually the same tone.

## Relativity

Only by capturing variations in both tone and hue as we paint colour can we get a textured, realistic result. What we need to remember when it comes to painting colour realistically is the fact that hue and tone are relative. In other words, the way we perceive colours – both their hue and their tone – depends very much on the hues and tones we see around them. We'll look at this more on page 48.

# Exercise

Using either a photograph or the real thing, take a 'single' colour flower like this clematis and spend a whole five minutes (set a timer so you're not tempted to rush!) looking very closely to find all the different hues and tones within its petals.

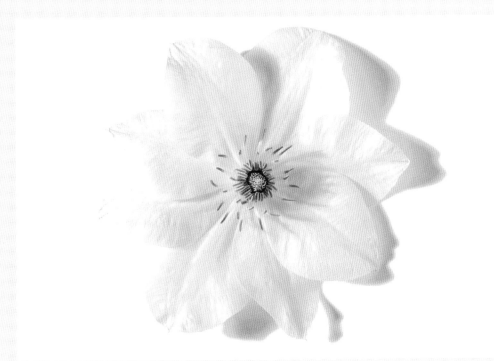

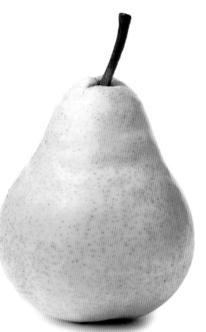

# Form and texture

We instinctively know when a painting has captured a subject realistically. It looks right to us. But to understand it more fully, and to be able to improve the realism in our own painting, it helps to understand that realistic paintings successfully achieve two things: a sense of three-dimensional form and a realistic texture. Let's look at this photograph of a pear (top left) and then three ways of depicting it.

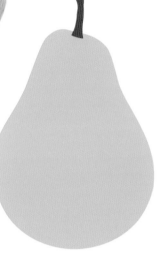

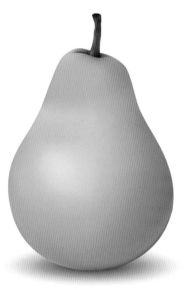

## Example 1

In this illustration, the green of the pear contains just one tone or value, with no variation in light and dark. The result is fun, but is totally flat and unrealistic looking because it lacks form. To give the pear form, we must capture the full tonal range in the pear, from the highlights through to the darkest tones. And we need to get them in the right place in relation to each other. For instance, in this pear the right-hand side needed to be darker than the left, and there needed to be an area of highlight along the centre. To get these tonal relationships correct we need to perceive our subject as a whole. When we do get it right, it gives us a sense of how light falls on the subject and makes it seem three-dimensional to us.

## Example 2

In contrast, this illustration of a pear looks three-dimensional because it has tonal range. There are areas of highlight and of darker colour in the right sort of places. But it still doesn't look very realistic – and that's because there is no texture to it.

## Understanding texture

The texture on the pear (see right) is actually something I call 'visual texture'. The pear's skin would be pretty smooth in terms of its physical texture if we were to touch it, but when we take a close look at the skin we can see that it's really mottled. It's not just one solid colour of green. We can see shapes of lighter green and shapes of darker green. And the changes aren't just in terms of tone. There are also shapes of more yellow-green, more blue-green and even spots of brown. It's these different shapes of colour and the transitions between them that will create the texture of our piece.

## Example 3

Here I've painted a pear. I've paid attention to the tonal relationships at the level of form (the right-hand side is a little darker than the left), but I've also painted the texture of the skin and stalk. This meant close study and painting of the detail. When aiming for realism, we must keep switching our attention between 'zooming out' and painting at the level of the whole subject to capture form, and then 'zooming in' to paint the detail of texture.

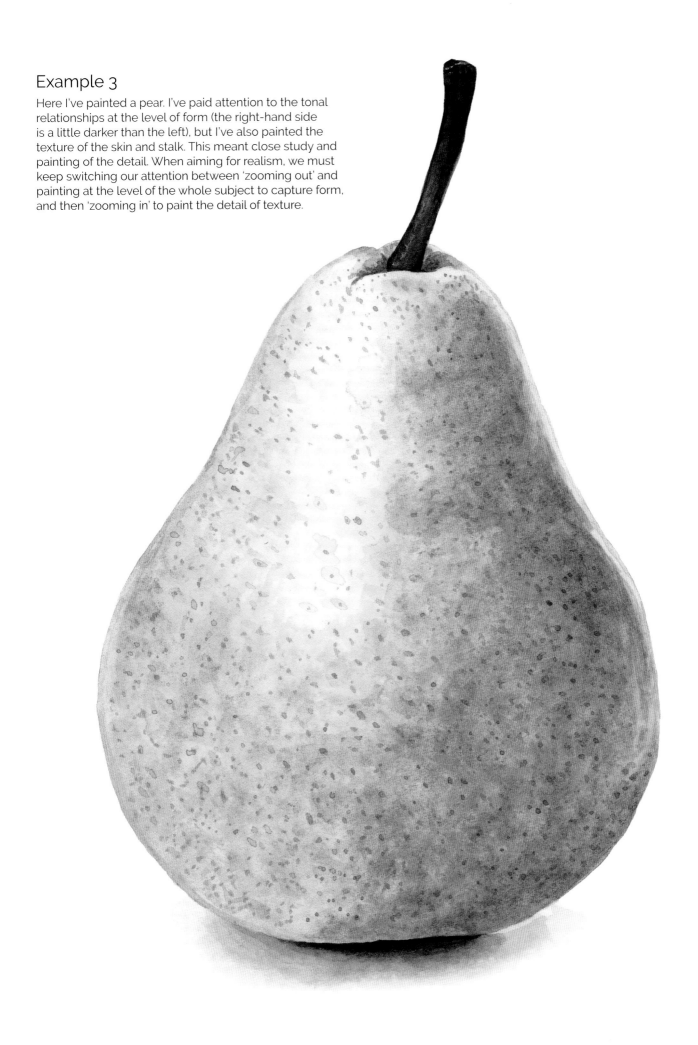

# 'Tuning in' to see visual textures

As you practise painting in this detailed style not only will you tune in to seeing more nuanced colours, but your visual sense perception will also adjust and you'll find yourself seeing more detail in your subjects too. And what is detail? We can think of it as the 'visual texture' in your subjects. To practise seeing different visual textures and understanding them in terms of shapes of colour, let's examine in close-up this coconut, which contains a lot of them.

## Smooth visual textures

There aren't actually many truly smooth textures in nature when you look close enough at them.

*For example, here this area inside the coconut appears smooth, but when we look close enough we can see shapes of slightly different tones, with more of a darker grey towards the bottom. It's easier to see this when we change the colour of the slightly darker tones to pink. When we look at the transitions between these shapes of colour, we can see that they are fairly smooth, progressing gradually from a darker colour to a lighter one. For this reason I call this kind of transition a 'graduated' one. If we were to try to draw these shapes by outlining them, we would struggle because their boundaries do not have neat lines to them.*

## Hairy visual textures

As we zoom in on this hairy part of the coconut's shell, we can again start to see it as a series of shapes of different colours – the lighter hairs and the darker areas around them. To make it even clearer we can change the darker shapes to pink.

*The transitions between the lighter and darker shapes of colour here have hard, clear, solid-line edges. If we were to draw them, we could outline these shapes with a simple pencil line to map out where they are.*

# Transitions are key

So it's different shapes of colour – be that tone or hue – that create visual texture, and the key to differentiating between types of texture is found in the transitions between the shapes of colour that make up that visual texture. Let's take a look at a couple more visual textures from the coconut and examine them for their shapes of colour and the transitions between them.

## Heavily flecked visual textures

A type of rough visual texture, this area is less hairy but instead contains many more very small and irregular shapes of different tones and hues, all up against one another.

*The transitions between the shapes are pretty defined with clear line boundaries, as you can see when we turn the darkest tones pink.*

## Striped visual textures

This is a texture we see a lot in the botanical world as it features in patterns and creases as well as veins and ridges.

*The shapes of different colour are long and thin. Often the transitions between them are clearly defined by hard lines or, as in this case, the transitions themselves are more textured. As the stripes here are of fairly similar colours and are therefore quite subtle, it's easiest to see when the darkest tones are made pink.*

## Lightly flecked visual textures

This sort of slightly rough, mottled visual texture is really common when you're looking at subjects close up. Here we see shapes of colour, some of which are clearly defined with hard-line transitions between them, but some, like the midtone shapes, are larger and with more textured transitions to them. Take a look at the version where the midtones are made pink to more easily see the different shapes of colour and their transitions.

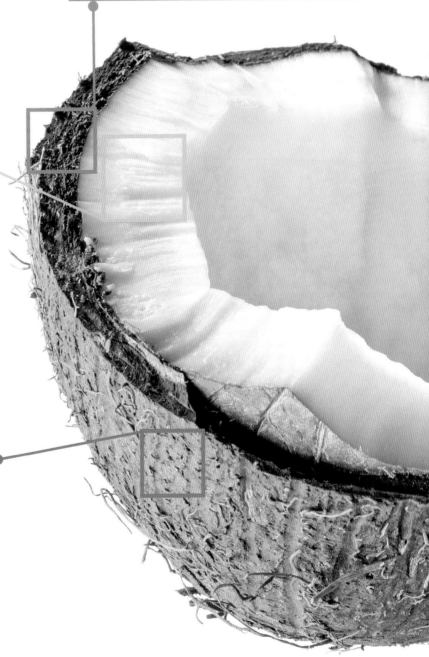

So I'm hoping you can start to see that to paint realistically, we need to be able to break our subjects down into shapes of colour. Then replicate them, and the transitions between them, with our paint.

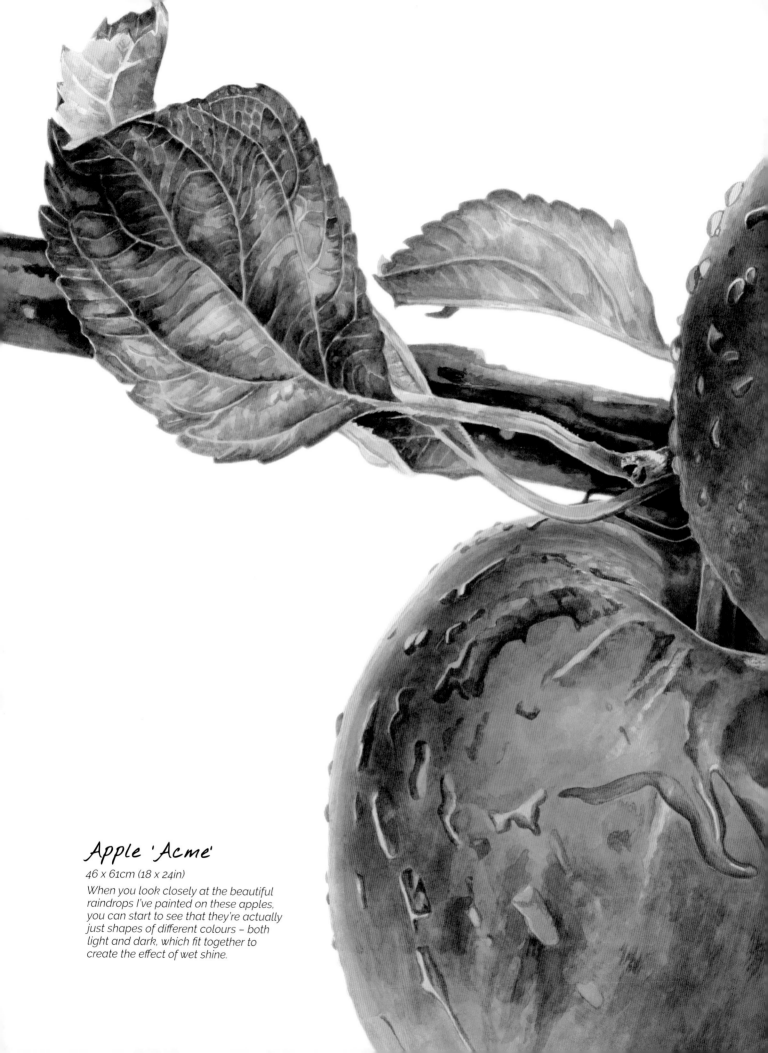

## Apple 'Acme'

*46 x 61cm (18 x 24in)*

*When you look closely at the beautiful raindrops I've painted on these apples, you can start to see that they're actually just shapes of different colours – both light and dark, which fit together to create the effect of wet shine.*

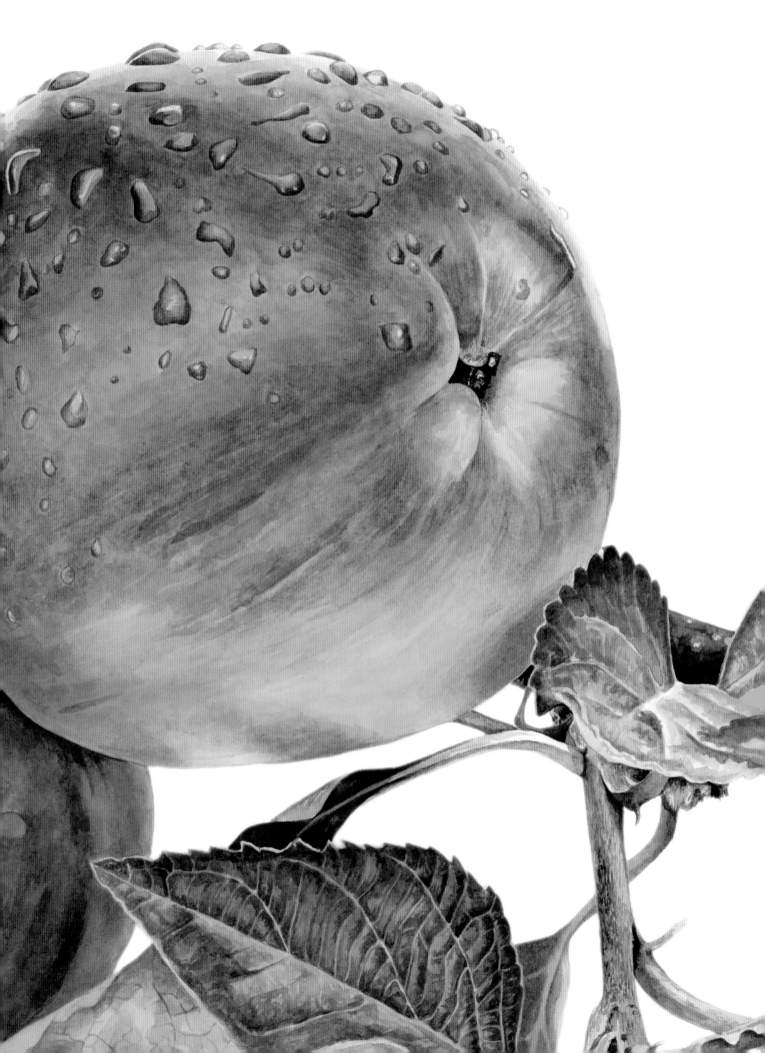

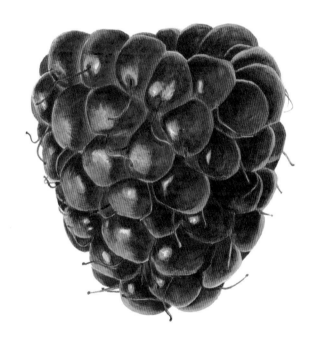

# The Painting Method

# My method: a 5-stage process

People are often surprised that my paintings are actually watercolours because they associate watercolour with more watery, pale and fluid styles. But watercolours can also be used in a much more controlled way to achieve realism and really dark colours. To understand my method let's first go back to basics and think about how watercolours work. When mixed with even a little water they're translucent, and so when they're applied to white paper we can use the white of the paper visible through the paint to create the lightest tones in our paintings. In fact, it makes creating these lightest tones easy.

But the downside to translucency is that it if you try to apply a lighter colour on top of a darker one, you'll still be able to see through to the darker colour underneath. Combine this with the fact that watercolours often can't be wiped off the paper because they stain it, and you can see why watercolours are often considered tricky to use. If you paint an area darker than you meant to, then you're in trouble. That's especially a problem when you're looking to achieve realism, because with realism it really matters that you get your subject's tonal range just right. But by layering the paint, my method works to offset these negative aspects of the watercolours' transparency, as well as allowing for the fact that we perceive tones and hues relative to the tones and hues around them.

What the relativity of tone and hue means for us when we're painting is that we won't be able to judge whether we have the greys in our petals the right tone or hue...

... until the darker leaves are painted too.

But we can't get the leaves right until the petals are as dark as they should be!

So, in short, we need to gradually build up our painting, bit by bit, assessing our tones and hues as we go.

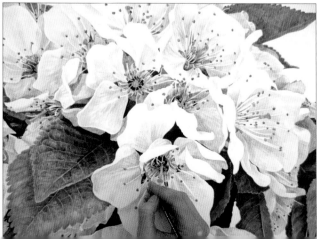

# Using my method

To allow for this gradual build-up of tones and hues, my method has us painting in the following 5-stage process:

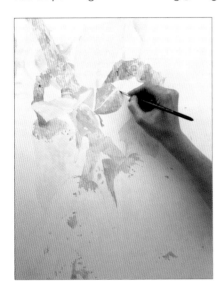

### Stage 1: lightest tones

*For this first step I use pale watery mixes. Each hue area is treated separately so this step also serves to map out what colours should go where. If you do make a mistake at this stage and place paint in the wrong area, you're much more likely to be able to wipe that paint off with some damp kitchen paper because the paint isn't very dark.*

### Visual mixing

*The transparency of watercolours means that as you layer up you need to be sensitive to how your mixes will visually mix on the paper. This is why it's important to map out all major hue areas right from the beginning. At this early stage you can paint, for instance, a pale green into an area that will ultimately be darker green, but you would not paint a pale green into an area that will ultimately be orange or red, because an initial green wash would stop you achieving a bright red, creating, instead, a brown visual mix on the paper.*

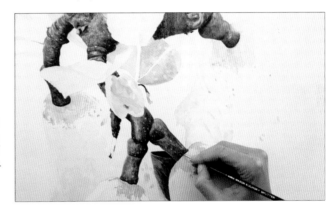

### Stage 2: darkest tones

*Next I paint a few areas of the very darkest tones within the image. This establishes the upper and lower limits of a painting's tonal range.*

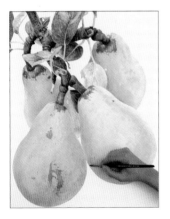
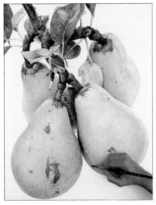
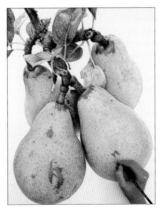

## Let each layer dry!

Crucial to working in layers in this way is that the layer underneath *must* be dry before you apply the next one. This stops the colours from muddying and bleeding into one another on the paper and, crucially, it keeps us completely in control of the marks we're making.

This method places you firmly in control, able to alter and adjust your painting gradually as you work. This in turn allows you to relax into the flow of painting without any stress! For the finished painting, see page 23.

### Stage 3: midtones

*Having the upper and lower ends of the painting's tonal range in place makes it easier to see how dark to take the midtones, which I paint in next, working on the lighter or darker midtones as they meet the lightest and darkest tones already painted, and then meeting in the middle with the mid-midtones. If a painting contains different hue areas to it, each hue area needs to have its midtones painted separately.*

### Stage 4: adjustments

*Once the midtones are darkened it's much easier to perceive that I can go back to the lightest tones and adjust them, then the dark tones again and so on – building up layers of paint until everywhere is as dark as it needs to be. I can also adjust the hue at this stage too by changing the paint mix I'm using to layer up. Again, if a painting had different hue areas within it, this adjustment stage would need to be made for each hue area.*

### Stage 5: details and final adjustments

*Once the painting looks correct tonally, it's time to add the finest level of detail and then take a step back to view the painting as a whole before making any final adjustments to tone or hue.*

# Drawing

For this method, drawing can be seen as the painting's foundation. Getting it really accurate informs your painting and allows you to get into the 'flow' of painting, taking a level of decision-making out of the process. So it's not that our subject won't look right if it's drawn a little differently to the reference photograph, it's that during the painting process you're going to be looking back and forth between your reference photograph and your painting, making comparisons with your eye. If you've made a drawing error, every time you look between painting and photograph, you'll have to think about the differences between them to try to compensate for your error. That kind of thinking will take you out of your right-brain painting flow – and that won't be any fun!

## Style of drawing

We need to make an outline drawing – sometimes known as a 'contour' drawing. What this means is that we're looking to outline with our pencil, every clearly defined transition between shapes of a different colour (see pages 42–43 for an explanation of transitions). The more detail you can add into your drawing, the easier you'll find the painting process, as you will have clear boundaries to work within with your paint. The pencil outlines need to be drawn lightly so that they don't stand out too much and won't end up being too noticeable through your paint. My pencil work does tend to be visible on close inspection of my paintings, but I've never seen that as a problem. The lighter your subject, the lighter your pencil markings will need to be. And conversely, if you are drawing an area that is going to be really dark, you can afford to take your markings much darker (as I've done with the edges to the sunflower centres in this drawing). The final painting of this drawing is on pages 60–61.

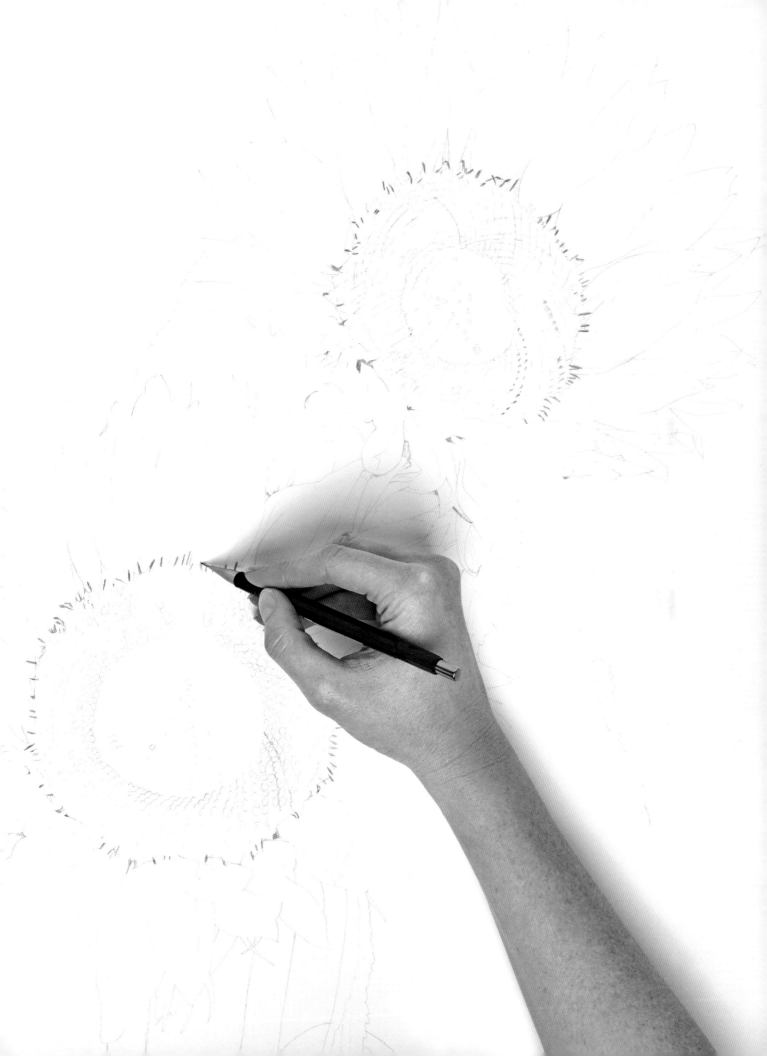

# Drawing process

For the projects in the book, I've supplied you with drawings that you can trace from, so you can guarantee accuracy (see pages 140–143). You won't get quite as crisp a line as if you'd drawn directly onto the paper – so after tracing you'll want to neaten up your line drawing where needed. You can use a polymer eraser for this – the cotton paper we use won't be damaged by it. You can also use tracing paper to create an outline drawing from a photograph that's been printed or that's being viewed on a tablet. If you want to work bigger, you can always make use of high-street printing shops to resize your photograph digitally and then print it off at a larger size for you to then trace in the usual way.

*I use an HB mechanical pencil as it always has a crisp point. I also use a polymer eraser.*

Another option, which I used for years, is to take measurements using a ruler to identify where exactly key parts of the composition should be. Measure along both the horizontal and vertical axes to ensure that the location is exact. With a few key elements measured, you can freehand draw within them, knowing that with the measured elements in the correct places, your drawing can't go too far 'off'. This method also works well when you're wanting to work much bigger than you could print off a photograph. You can measure key areas on your photograph, whether it's printed off or on screen, and then work out how much bigger you want your finished painting to be (for example, twice as big) and then multiply your measurements by that (for example by two). I'm lucky enough to have invested in a digital artists' projector, which was super expensive but really speeds up the process for the majority of drawings. Whichever drawing method you choose, I don't recommend drawing free-hand totally by eye. Even if you're massively experienced you'll struggle to get your drawing as accurate as we want it to be for this method.

## What to draw: hard-line and clearly defined transitions

Even when tracing, you still need to be clear on *what* to trace from within a photograph. The focus needs to be on the hard-line transitions between shapes of colour, wherever the contrast change is reasonably strong, and any other clearly defined transitions that can be reasonably drawn in with a pencil line. As you get practiced at creating drawings for your paintings you'll start to tune in to what this means, but here are a couple of examples:

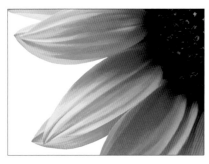

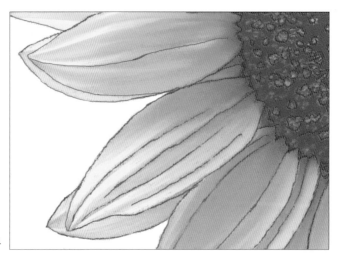

*In this part of a sunflower (from the project on page 92), I've outlined the outside edge of the petals and the most prominent lines of contrast within them, as well as the edge of the flower centre and some shapes within the flower centre.*

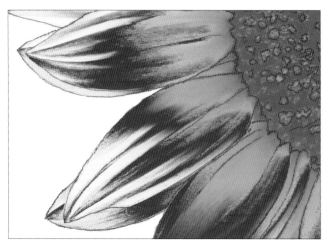

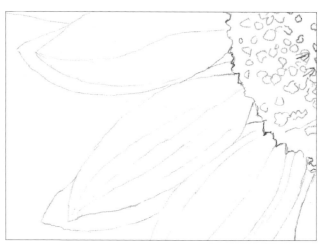

But where there is a large and smooth graduated transition – for example from the darker colours at the base of the petals into the the lighter colour at the tips (shown here in purple), it wouldn't work to try to draw in an outline dividing the two shapes of colour. Essentially they overlap one another so that there is no one pencil line to draw. Instead, larger graduated transitions like this need to be tackled with our paint.

So the pencil drawing shows only the hard-line edge transitions within the flower.

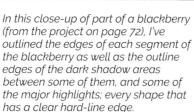

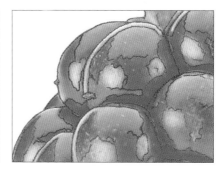

In this close-up of part of a blackberry (from the project on page 72), I've outlined the edges of each segment of the blackberry as well as the outline edges of the dark shadow areas between some of them, and some of the major highlights; every shape that has a clear hard-line edge.

But in this case I've also marked in the textured edges between the highlights and the darker skin around them because their graduated transition is smaller in size. So in this case I've created a textured line, gently with my pencil (shown here in purple), which will show me just where the highlight is but also remind me to make sure the transition is graduated and feathered when I paint.

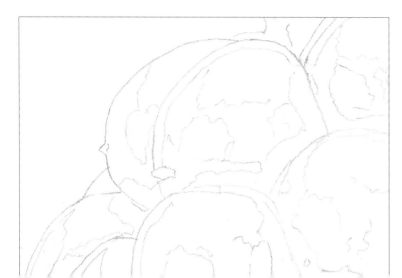

So the pencil drawing here marks in the hard-line edge transitions as well as some of the textured and feathered transitions too.

# Painting

## My paints

### Vibrancy

The subjects I'm drawn to painting are often very bright and vibrant in colour, so it's crucial when getting a realistic result that I can achieve similarly vibrant colours with my paints. This means selecting paints that are really vibrant colours to begin with because it's impossible to mix colours that are more vibrant than the paints you're combining in your mix.

So my palette is full of really vibrant paints, which I can mute down when needed by adding a less vibrant paint. Often this will mean adding one of my neutral paints, as neutral colours contain all the key primaries and are, as a result, more dull in colour.

I have a fairly large number of paints in my palette: 22 at the last count. You can find up-to-date details of my current paints on my website. The reason I have such a large number is because of how hard it is to mix colours and keep them vibrant. For instance, it's impossible to mix a colour as vibrant as the turquoise featured below by combining other colours. So if you find a flower or an insect with this kind of colour, you're going to want this paint in your palette if you're going to achieve realism.

### Transparency

To keep colours clear and vibrant when working in layers we need lots of the white paper to be visible through the layers – so we need to use watercolour paints that are defined as 'transparent' rather than 'opaque'. Manufacturers of watercolour will list the transparency of a paint on their website or on the paint's packaging.

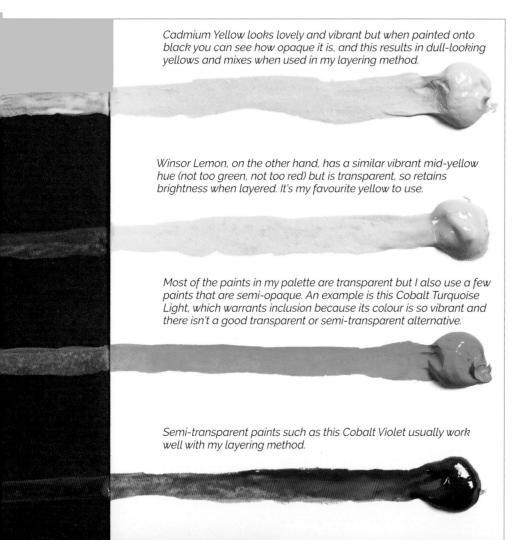

*Cadmium Yellow looks lovely and vibrant but when painted onto black you can see how opaque it is, and this results in dull-looking yellows and mixes when used in my layering method.*

*Opaque and transparent colours can look really similar in the palette and when used in a non-layering way. But when you look at them painted onto black paper their transparency can more clearly be assessed.*

*Winsor Lemon, on the other hand, has a similar vibrant mid-yellow hue (not too green, not too red) but is transparent, so retains brightness when layered. It's my favourite yellow to use.*

*Most of the paints in my palette are transparent but I also use a few paints that are semi-opaque. An example is this Cobalt Turquoise Light, which warrants inclusion because its colour is so vibrant and there isn't a good transparent or semi-transparent alternative.*

*Semi-transparent paints such as this Cobalt Violet usually work well with my layering method.*

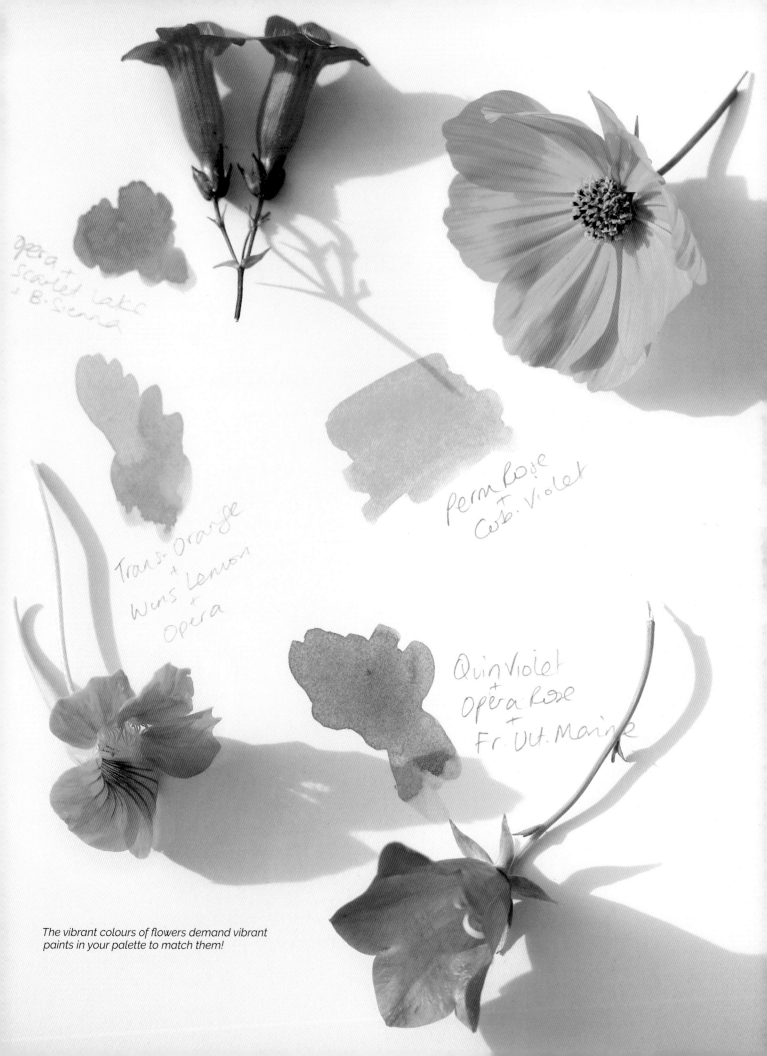

Opera + Scarlet Lake + B. Sienna

Trans. Orange + Wins Lemon + Opera

Perm Rose + Cob. Violet

Quin Violet + Opera Rose + Fr. Ult. Marine

*The vibrant colours of flowers demand vibrant paints in your palette to match them!*

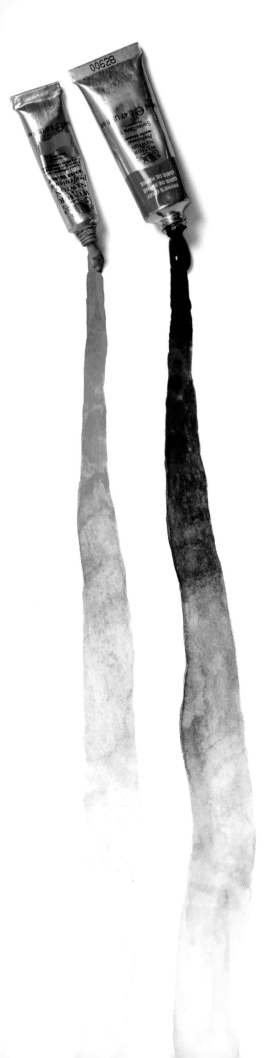

# Consistency

Crucial to achieving realistic effects with my method is the ability to use the watercolour paint at a range of consistencies – from very watery in the early steps, to very thick when working on the darkest of tones. I often use a dairy analogy to describe the consistency of a mix: from watery, to milky, to creamy, through to buttery for the thickest of mixes and you'll see this language used in the projects in this book. Knowing the consistency of a mix isn't necessarily going to let you know how light or dark a mix is though. That's because each paint has a different tonal range to it. The darker the paint when dry, the wider its tonal range because you'll still be able to create a very pale version of it by adding the tiniest amount to a lot of water.

## Pans versus tubes

For years (and in my previous book) I used pans of watercolour, which are where the watercolour is bought dried in a little block that you can fit into a palette. I now use tubes, purely because it's allowed me to use a bigger, flatter palette. I squeeze the paint out of the tubes into a specific part of my palette and I let it dry. Then when I want to use it, I use it in exactly the same way I would a dry pan, adding a touch of water to it with my brush to get it moving. If you are going to use tubes, do make sure you squeeze some paint out somewhere you can keep it and let it totally dry out. That way you'll be able to add just a tiny amount of water to it and be able to achieve a thick, buttery consistency of paint, even thicker than the consistency it is when it comes out of the tube.

# Colour mixing

Although we can adjust hues and tones as we layer up during a painting, we're always trying to get the hue mix looking about right as we go. And that requires accurate colour mixing. I know colour mixing can prove frustrating and I have two recommendations for getting it right:

### 1. Get to know your paints

Each paint has a specific hue, and also a specific tonal range. It's important to play with your paints and familiarise yourself with those to help give you confidence when mixing. I recommend using a sketchbook to test out the tonal range of all of your paints, seeing what range of tones you get when you use the paint at different consistencies.

*Here, Cobalt Turquoise Light (on the left) is a pale paint with a fairly narrow tonal range. It's a fabulous bright colour that is useful for some plants and birds and would be impossible to mix this bright using other colours. I like to have it in my palette but rarely need to use it.*

*Payne's Gray on the other hand (on the right) has a huge tonal range and a dark, muted blue neutral colour that makes its way into almost all my paintings. It's perfect for shadows and for darkening colours, where I'll often mix it with Burnt Sienna to create rich, almost black colours.*

### Palette

So that you can know that the consistency of the paint you're mixing will match what you'll see when you apply it to the paper, you'll want to use a palette that's flat and white (just like the paper). Avoid plastic palettes as they'll stain and the paint will bunch up too much. A ceramic plate works really well.

## 2. Set out your paints in a colour wheel arrangement

This really simplifies the colour mixing process. I like to use the Munsell colour wheel, which has five primaries (red, yellow, green, blue and purple) creating an equal progression around the wheel in consistent steps of colour change, reflecting how we perceive colour changes.

Once you're familiar with your paints you can map them out to fit loosely with the Munsell wheel. Start by mapping the primary colours. Then locate the rest of your colours in the gaps. For instance, if you were looking to place some pinks between red and purple, you would assess each one in terms of whether they were closer to 'red' or 'purple' than each other. It doesn't matter if, like me, you have lots of crimsons and pinks between red and purple, you just need to try and get them in the correct order

in terms of their proximity to red or purple. Your neutral colours such as greys, browns and ochres contain a little of each of the main primaries, so on the official colour wheel they would be located towards the centre of the wheel – though to ensure I have space to mix, I set them out between blue and purple at the bottom of my palette.

With your order decided, squeeze some paint out (if you're using tubes) into place around the edge of your palette, or in a separate palette but where they can stay squeezed out. Remember, it doesn't matter that the paint will dry out – you can always use it by wetting it a little with your brush.

Here we've shown the arrangement I'm using at the time of writing. (All paints are Winsor & Newton unless otherwise stated.) For an up-to-date list of my current paints, plus substitutes from other brands, please visit my website.

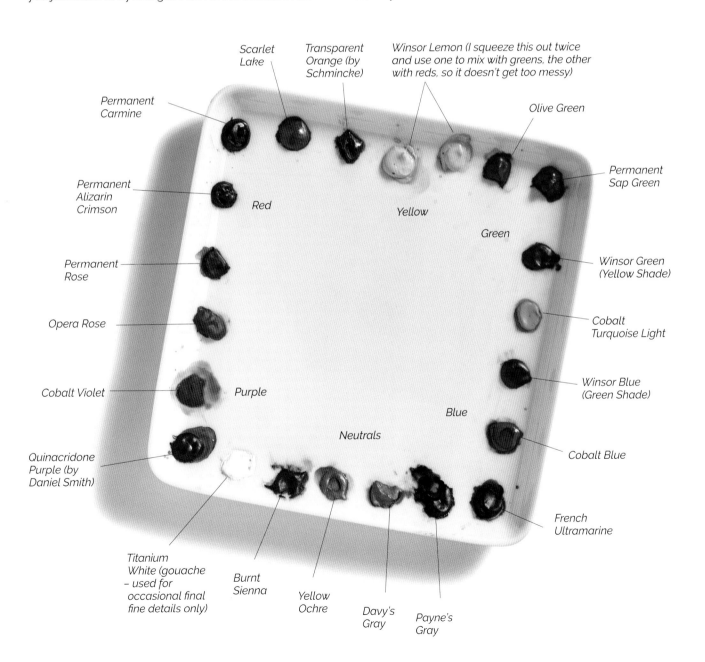

Scarlet Lake

Transparent Orange (by Schmincke)

Winsor Lemon (I squeeze this out twice and use one to mix with greens, the other with reds, so it doesn't get too messy)

Olive Green

Permanent Carmine

Permanent Sap Green

Permanent Alizarin Crimson

Red

Yellow

Green

Winsor Green (Yellow Shade)

Permanent Rose

Cobalt Turquoise Light

Opera Rose

Winsor Blue (Green Shade)

Cobalt Violet

Purple

Blue

Cobalt Blue

Neutrals

Quinacridone Purple (by Daniel Smith)

French Ultramarine

Titanium White (gouache – used for occasional final fine details only)

Burnt Sienna

Yellow Ochre

Davy's Gray

Payne's Gray

# Colour mixing process

With the colours laid out as on page 57, the basic colour mixing process is as follows:

*1* Choose the paint in your palette that's as close to the colour you're matching to as possible. This works when you have a fairly large number of paints in your palette like I do. Most times, when you then look at that one colour in your palette, you'll be aware that it's not a perfect match. It needs another colour mixed with it. And that's where you might struggle to know what to add.

*2* Assess the colour in the palette and decide in which direction on the colour wheel the paint colour needs to be shifted (i.e. if it was an orange, does it need to be closer to yellow or to red?).

*3* Decide if the colour also needs to be muted down and made less vibrant. If so, consider adding the neutral from the relevant part of the colour wheel instead or as well. For instance, if the orange needed to be more red but also duller, try adding some of your red-brown neutral (in my palette I'd use Burnt Sienna for this).

Let's work through a couple of examples.

## Gladiolus

This gladiolus is a very bright purplish-pink. Let's go through the steps to match it:

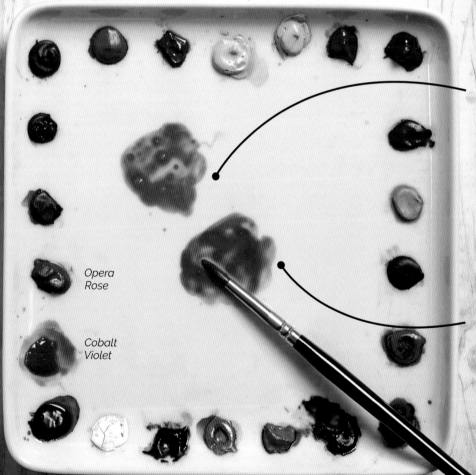

*Opera Rose*

*Cobalt Violet*

*1* The closest match in my palette to this colour is my Cobalt Violet, so I put some of this in the palette and assess it. I keep it fairly thick in consistency as the colour I'm matching to is quite dark. The hue isn't quite right and I can see I need to shift it towards red, rather than purple in the colour wheel.

*2* It doesn't need a massive shift in hue, and it needs to stay really bright, so I opt for the next colour along that's closer to red, and for me that's the bright Opera Rose. I add some of this into the mix and keep the consistency, and therefore tone, quite dark. This is a match!

## Ivy leaf

The dark green within the ivy leaf below is a rich, muted green colour.

*1* I began with some Olive Green, which I felt was the closest match as I looked at it dry at the edge of the palette. But when mixed with some water it appeared far too yellow. So it needed to be shifted towards blue rather than yellow, and it also needed muting down and making less vibrant.

*2* So I added a little of my blue-neutral, the very dark Payne's Gray. This makes a much closer match but to me it now looks a little less bright than it should. It needs brightening and making more 'green'.

Olive Green

Winsor Green (Yellow Shade)

Payne's Gray

*3* I opted to add a tiny touch of my most vibrant green paint, Winsor Green (Yellow Shade) and I feel the mix is a match.

## Tip

*Payne's Gray is so dark it's very potent, so it's a good idea to use your brush to transfer a tiny bit to an area of your palette and then use that paint to add to your mixes so you don't end up getting too much in them at once.*

## Alternative mixes

Colour mixing isn't exact and in these cases it would have been possible to have mixed very similar colours by using different combinations. However, the assessment process is always the same, no matter what your initial paint choice is. Because of the relativity of how we perceive colour, it's hard to get the colour exactly right when mixing. So the layering method is great because you can make subtle adjustments to your mixes as you gradually build up your layers and can see more clearly what needs adjusting to make a match to your subject. This is a reason that mixing in small batches on the small palette as I do (even when working on a large painting) is actually a good thing, as you get to keep re-mixing and reassessing your mixes as you paint.

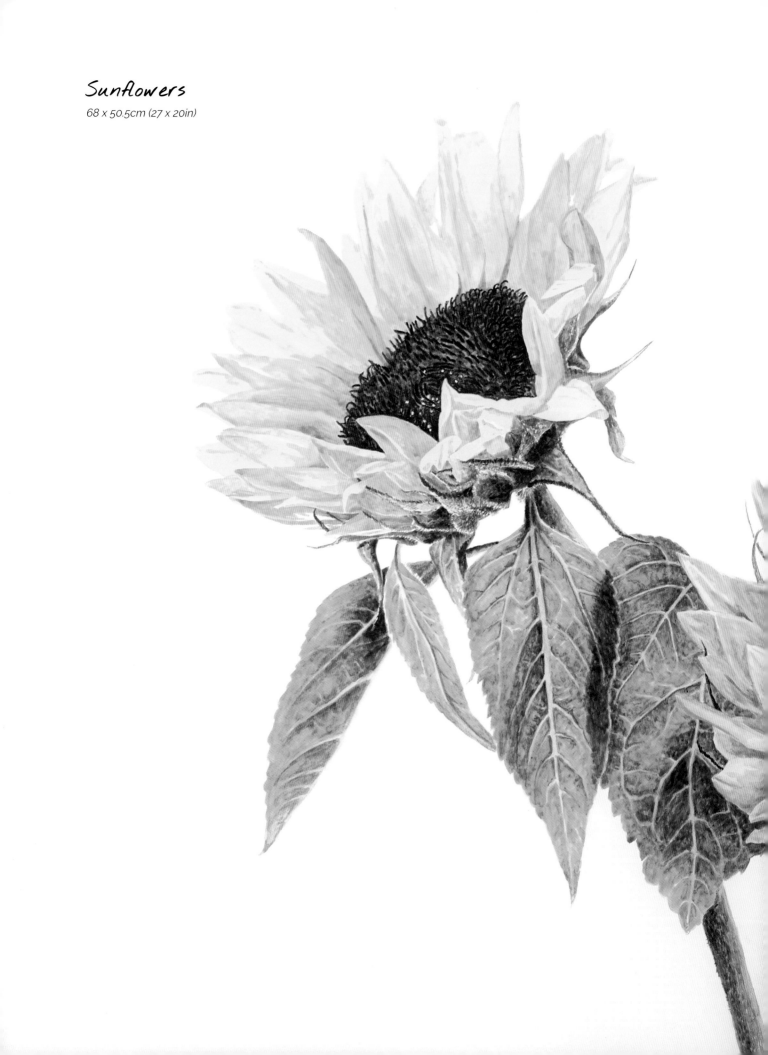

Sunflowers

*68 x 50.5cm (27 x 20in)*

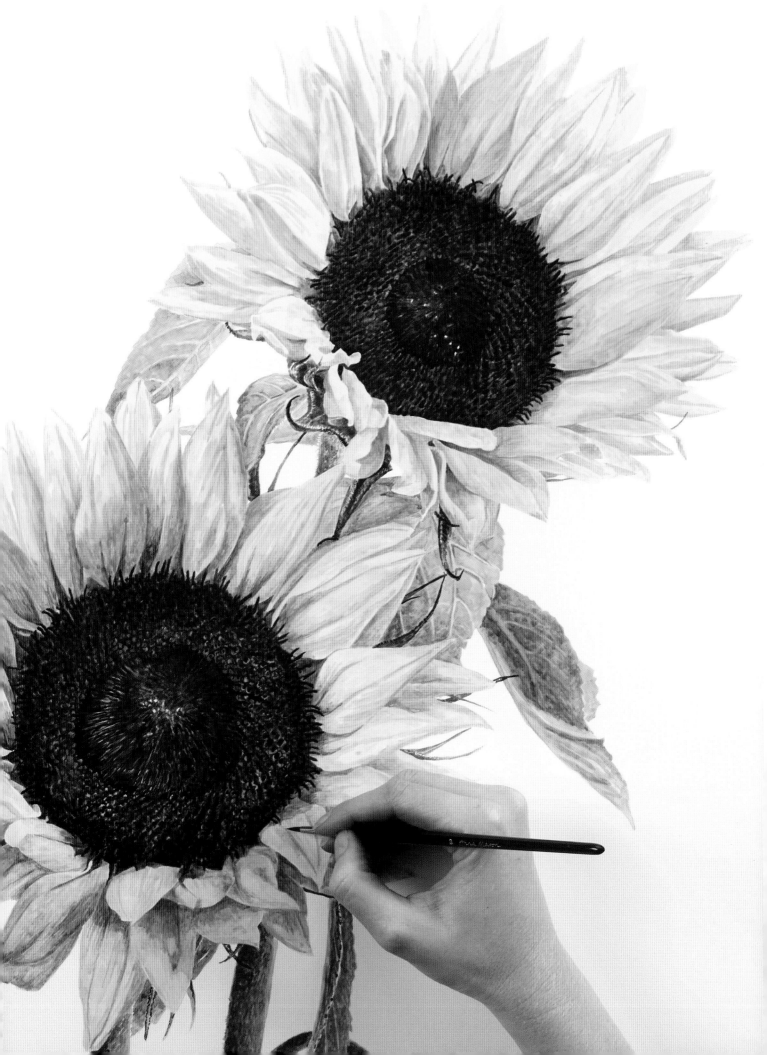

# Brushes

I have a brush set that's made to my specification by Rosemary & Co – a UK manufacturer that sells worldwide – and of course they're ideal. But it is possible to find similar brushes with similar qualities that are well-suited to this style. The two key qualities to look for are:

## 1. Short, teardrop-shaped hairs

The ideal shape for the brush hairs is a teardrop, with a fat base, short length and pointed tip. Often, shorter haired brushes like this are called 'spotter' or 'miniature' brushes. The advantage they give is that they allow more precision in your mark-making. It feels closer to using a felt-tip pen than a brush, and for a lot of my students just getting this type of brush has made all the difference to their painting.

   The hairs can be synthetic or natural. I now use synthetic hair in my set. There have been huge improvements to the manufacture of synthetic hair in recent years so that it's now capable of holding *almost* as much as sable brushes that are made of animal hair, and definitely enough for this technique – plus they're guaranteed cruelty-free.

*I have five brushes in my standard set – from the larger size 5 to a tiny size 000 brush. But if you're looking at other brands don't go by the numbering because that can vary depending on manufacturer and style of brush – go by the actual size as compared to these ones from my set. This photograph is shown at life-size.*

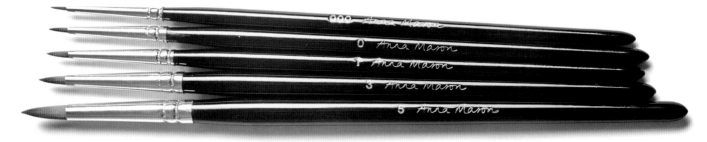

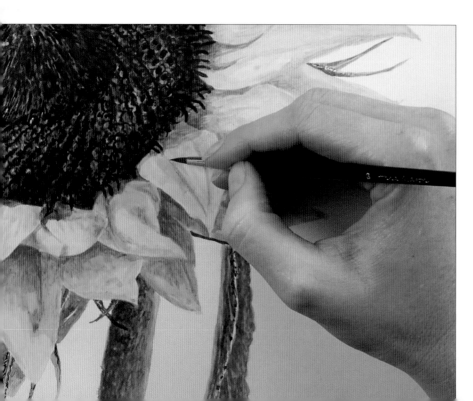

## 2. Small size

I do have a few slightly larger brushes in my kit for when I am wanting to cover a larger area in a wash, but for the most part, even in my larger paintings, I'll use small brushes. The small size allows me great control over where exactly I place the paint and gives the ability to create really fine markings. The other benefit of using these small brushes is that, as they can't physically hold that much paint, they prevent me from depositing too much paint on the paper at once, which would cause the paper to wrinkle. It would also increase drying time, and it's important that the paper dries quickly for this wet-on-dry technique.

# Paper

I use watercolour paper that is bought as several sheets – usually 20 – already glued into what's called a 'watercolour block'. You might have thought that paper needs to be stretched when working with watercolour so that it doesn't wrinkle when wet. However, although wrinkling is really common when using more traditional wet-in-wet methods, my technique only ever deposits small amounts of paint on the paper at a time, so using paper like this in a block means you don't need to worry about stretching. The sheets of paper are glued together, and to a card backing board, on all four edges, which keeps them taut when you paint. Once you finish a painting you simply peel the top sheet of paper off the block.

Paper that comes in blocks like this is usually pretty thick – at 140 pounds or 300 grams per square metre – and it's usually made from 100% cotton, which means it's really absorbent. This is so important for my technique, because I always paint onto dry paper, so a really absorbent paper minimises drying time. It'll also be acid-free, meaning it won't yellow over time. In terms of what brand to go for, I'm a fan of Arches and can also recommend the newer brand Canson. This paper is expensive, so it's a good idea to begin painting on a cheaper pad of paper while you're experimenting.

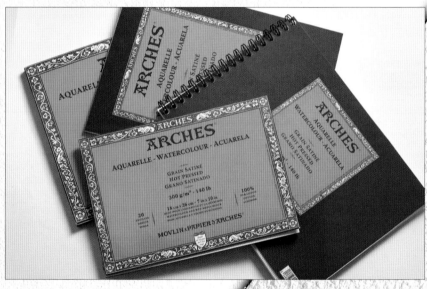

*You might also come across 'pads' of watercolour paper, where the sheets are only glued on one edge or are spiral-bound, but a block is much better for keeping the paper taut.*

Choose a paper that's smooth in texture. Smooth paper goes by the name 'hot-pressed' as opposed to 'cold-pressed' paper, which is rough in texture. The reason I prefer smooth paper is that it allows you to get much smoother lines with your brush and therefore much finer detail. And, when you want to create a really smooth-looking area of texture with your brush, painting onto smooth paper creates the smoothest finish because you can't see the texture of the paper through it. Rough-textured paper is really useful if you're trying to paint a large area in one smooth wash, but with my method that's not something we ever do.

For my largest paintings I often use illustration board, choosing one that's been prepared for wet media, as it totally eliminates any issues with wrinkling when working at a larger scale.

# Brush techniques

The brush technique you need to use will depend on the visual texture of the part of your subject you're attempting to paint (see pages 42–43 to understand visual texture). It's worth noting that although you can try these techniques with longer-haired brushes, they work best when you're able to use spotter or miniature-style brushes (see page 62). Because my method uses multiple layers to build texture and depth of tone, the brush techniques I'm going to show you here are rarely used in isolation. Rather, multiple layers of the same or different techniques are applied so as to best match a given visual texture.

I almost always start with a fairly smooth wash as an initial layer. This serves to map out which hues need to go where within a painting and also establishes the very lightest tones within a given hue area. With that layer applied and dry, the techniques below are usually applied on top to build up the texture.

## Washes for smooth texture

Even when working on enlarged subjects, you'll find you rarely encounter large areas with a truly smooth visual texture. When I am creating a smooth wash over a largish area, it's easier to use the bigger of the brushes in my set: the size 3 or 5. But even when I work on my largest scale paintings, I rarely need a brush bigger than a size 5 because there are very few big smooth areas.

As you apply the paint, keep the angle of your brush low to the paper so that plenty of the brush makes contact with the paper at once and you can cover the maximum area. Move quickly and aim to distribute the paint evenly. As the brush is relatively small, you will need to re-load your brush as you work. After a re-load, you're likely to create patches where you overlap into a section already painted or possibly dried. Don't worry about this! The key to achieving a smooth result with this method is to always work with a mix that is a little lighter in tone to the result you'll ultimately want. This way, once your previous layer has dried, you can apply another layer of the same consistency over the top, which has the effect of smoothing the finish without any effort on your part. Once you're used to it, it's really stress-free!

## Watery layer

*Depending on the combination of paint and paper you're using, your layer when wet may often appear to be far from smooth, with lots of texture to it.*

*However, unless the manufacturer states that the paint is known to 'granulate' (the pigment particles settle in the paper in a way that creates a mottled effect), you'll usually find that this effect reduces greatly when the paint dries, as you can see here.*

*Adding a second layer when the first has dried darkens it a little but also smooths the finish.*

## Thick layer

*You can use this technique with watery paint or thicker, milky to creamy consistency paint, but the paint must be liquid enough that you can spread it on the paper easily and quickly. Again, you can see here that the granulation effects are reduced once the paint dries.*

# Stippling for mottled and flecked texture

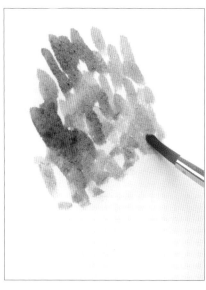

Stippling is a technique in which you apply numerous small dots or dabs of paint to an area. To stipple with your brush: place the tip down first, followed quickly by the belly of brush to make a very short, gently dabbing stroke. The idea is that sometimes your markings will overlap one another, creating darker patches, and other times you will leave little gaps through to the paler layer of paint, or even the unpainted paper underneath, creating lighter patches.

The way I use stippling generally is to achieve a random sort of effect with the markings. If you're new to stippling it can be tempting to apply your markings in a very even and uniform way, but this won't achieve a naturalistic look.

## Loose stippling

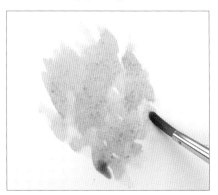 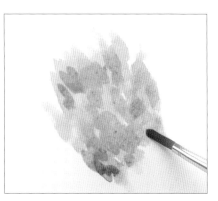

*The larger the brush and the more wet paint you have loaded onto it, the looser the stippling effect will be as you'll end up with more paint on the paper and each mark will tend to spread out and into the ones next to it. This can be helpful when you're looking to create a visual texture that is lightly flecked but overall fairly smooth. If your markings have spread into one another when you didn't mean for them to, you can always let the layer dry and apply another one with a smaller brush or ensure you have less paint on your brush. To stop this extra layer making the area of your painting too dark though, it's important that you always stipple with a mix that's a little paler and more watery in consistency than you ultimately want the area to be. Working in paler layers like this really helps to protect against mistakes as you paint.*

## Full stippling

*To create much more pronounced marks, use a size 1 brush or smaller, or a significantly thicker mix, to create lots of shorter strokes that won't spread into one another.*

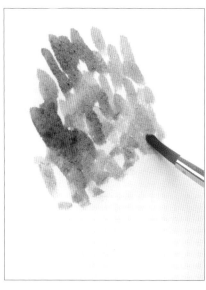

# Dotting for spotty texture

The way you approach painting spotty texture depends on whether the spots you see are darker or lighter than their surroundings.

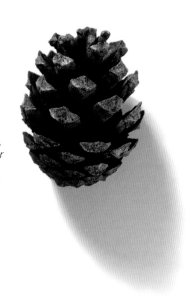

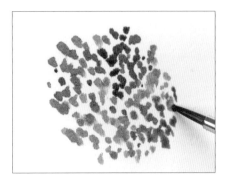

*If they're darker, it's straightforward. Use a brush size to match the size of the dots. Often this will be a size 0 brush or smaller if they're tiny – create dots with the tip of the brush (the angle of your brush will be high off the paper).*

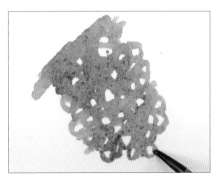

*If the spots are lighter than their surroundings, it's a little trickier. You may be tempted to add some white watercolour or gouache paint to your mix in an attempt to create dots in the same way as you would if they were darker than their surroundings. However, depending on how much lighter than their surroundings you need the spots to be, you'll likely find that the white paints won't allow you to get light enough. The solution is 'negative dotting'. Use the tip of a small brush to create an outline around each spot, thus leaving a gap where the spot is. This is a little fiddly, especially as you may need to do it a couple of times if you are building layers, but it gets great results.*

# Lines for hairy textures, linear textures and outlining

A straightforward technique in which you use the tip of the brush to create either a line or a hard-line edge to a shape. Although all my brushes come to a neat point, you still need to match the size of the brush you use to the width of the line you're looking to create.

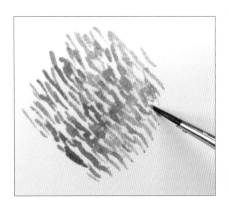

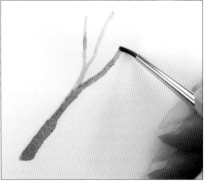

*For hairy textures you'll usually need to create short narrow lines with your brush. The angle of your brush will be fairly high to create these. People often think it's crazy to paint every single hair on a subject, but you can get really quick at painting these markings with practice, and it can be really therapeutic to spend time on them. If you work with a slightly paler mix, you can apply further layers of little lines to build up a very hairy effect.*

*When creating fine lines, such as veins, you'll often want to place them in exactly the right place and keep them neat and often straight. To make sure you can do that, rest your hand on the paper (where it's dry!) to help you keep steady.*

*Where you are creating an outline edge to a shape but also darkening that shape, you can lower the angle of your brush to create a neat line edge using the tip on one side, and a filled-in area on the other using the belly of the brush.*

# Glazes for tonal adjustments

Wherever you're creating rough visual texture, you will be applying paint to create shapes of different colour next to one another. Sometimes as you apply the paint you'll realise that the contrast levels in an area have got too high, and the gap between the lightest tone and darkest tone shapes is too wide. In those cases, you can use a fairly pale mix and a wash technique to gently 'glaze' over the stippling you've done. So long as you make sure that the layer underneath is dry when you do this, and you don't press too hard with your brush, you'll find you won't lose the markings you made before but they now won't stand out as much against the colour around them.

*Harvest Mouse in the Grass*

*23 x 31cm (9 x 12in)*

# Transitions

As we saw on page 43, the key to differentiating between types of visual texture is found in the transitions between the different shapes of colour within a subject. So we need to pay close attention to these transitions when we paint and seek to re-create them with our brush using the right brush technique for the specific sort of transition.

# Hard-line transitions

To create these we use the line brush techniques.

*To create fine lines, keep the angle of the brush high, and steady your hand by resting it on the paper.*

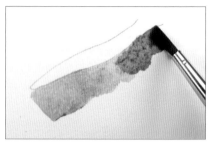

*Lower the angle of the brush to create a neat hard-line edge to a bigger shape with the tip of the brush, while at the same time painting that shape on one side of your line with the belly of the brush.*

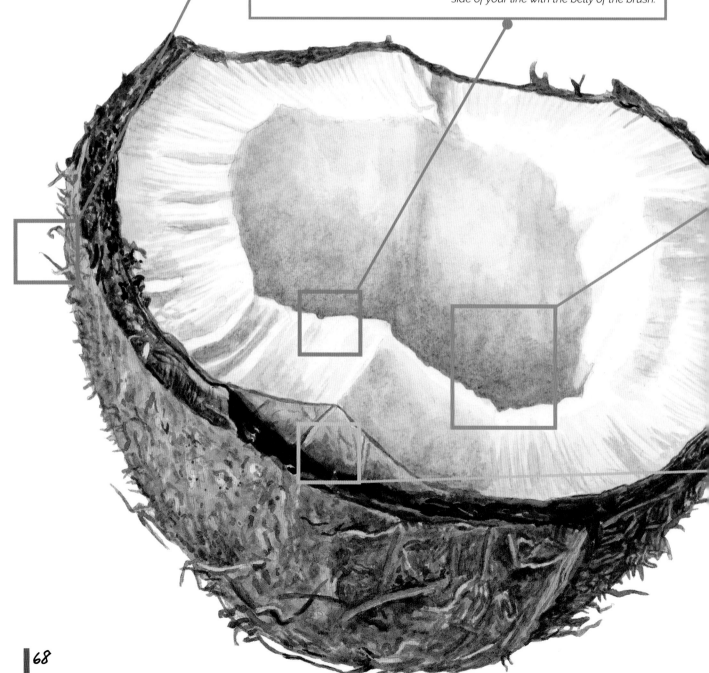

# Graduated transitions

It's more challenging to create graduated transitions, where one shape of colour gradually changes into another.

## Blended transitions

When the transition area is large and smooth we need to blend our paint as we apply it.

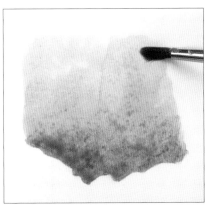 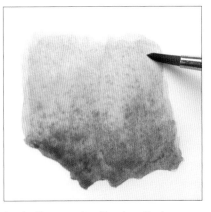

*Use the paint thicker to create a patch at the darker end of the transition and then water the mix down as you apply paint higher up, gently scrubbing at the transition into the darker patch to draw the paint out and blend the colours.*

*Again, if you work with mixes that are a little lighter than the area ultimately needs to be, you can blend away any unwanted overlaps of paint that occur by letting your first layer dry and applying a second.*

## Feathered transitions

Where the transition area is smaller and has more texture to it we need to feather the transition to create the effect.

*Work on the darker of the shapes and as you paint its edge, use the tip of your brush to create short lines perpendicular to the transition line, going just into the lighter area.*

*Make sure the darker mix has dried and then apply the lighter coloured shape, allowing it to overlap onto the feathered edge. You can gently scrub at the transition to blend it if you need a smoother look to the transition.*

# The Projects

These four projects cover a full range of brush techniques. I recommend you attempt them in order as each one is a little more complex than the last. For each one you'll get a pencil drawing to trace (found on pages 140–143) and a colour photograph to refer to at the beginning of the project. I then walk you through each step of the painting. I show you how it fits within the five key stages of the method (see page 49), describe what you need to do in terms of brush technique and show you an example of the mix you'll need to make. Each step includes a picture of my painting at this point so that you know what you're aiming for, and often you'll also be shown a black-and-white version of the photograph (referred to as a 'guide image') with the areas you need to focus on highlighted in pink. Be kind to yourself with these projects. Try not to expect perfection, though I think you may surprise yourself with the results! See my website for video clips relating to these projects.

# BLACKBERRY

Enlarging this simple blackberry reveals a world of detail. There are fairly limited hues, which makes it a great subject to start with if you're new to my method. But in terms of tone, there's plenty of variation, from the lightest highlights through to the super-dark crevices between segments. Getting these highlights looking right, and in the correct places, is what will give the berry its lovely three-dimensional form.

## Paints

- Burnt Sienna
- Payne's Gray
- Permanent Carmine (can use Permanent Alizarin Crimson to substitute)
- Winsor Lemon

(The colours listed are Winsor & Newton; for alternatives, see my website.)

# Pencil drawing

As well as the edges of the segments and the stem, we need to draw in the shapes of darkest colour and also the shapes of highlight. The highlights don't always have neat straight edges to them; instead, the transition from highlight to surrounding darker area is textured, which we need to reflect in our drawing by creating a jagged rather than smooth line (see page 53). You can trace from the drawing provided on page 140.

# Whole painting

## Method stage: 1 Lightest tones

If we look closely for the lightest areas, we can see that right at the edges of the segments there's a very pale reflection. The colour there is a touch darker than our paper colour and is a very pale grey. To match to this, mix Payne's Gray with a touch of Burnt Sienna and masses of water to create the lightest mix you can manage while still seeing a hint of colour. Apply with a wash all over the berry, except for some of the pink and brown coloured tips to the segments. Leave those for now and paint around them. Everywhere else, this pale colour can sit underneath the darker colours that will need to go on top, without creating any visual mixing problems on the paper.

Use a size 5 brush and apply the paint to a segment at a time, using brush strokes that curve with the form of each segment. That way, when you do get unwanted hard-line edges as the paint you're applying overlaps, the lines will be in directions that help to create a sense of the rounded form.

*Payne's Gray with a touch of Burnt Sienna: super-watery consistency*

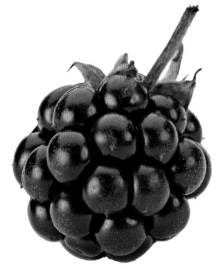

## Method stage: 1
## Lightest tones, pink hues

Before we work on the berry any further, let's paint the lightest tones in the rest of the subject that are different hues, beginning with the pink hues (see guide image, below). Create a super-watery mix of Permanent Carmine with a touch of Burnt Sienna. Make sure the grey paint is dry and use a size 1 brush to apply the watery mix onto those areas where you see it – you can use the tip of the brush to create a few dots and lines where you see this hue within a segment.

*Permanent Carmine with a touch of Burnt Sienna: super-watery consistency*

## Method stage: 1 Lightest tones, green hues

With a size 1 brush, mix some Winsor Lemon, a touch of Burnt Sienna and just a tiny hint of Payne's Gray. As with the other colours, this can be applied into areas that are this hue and tone or darker – so can be applied anywhere you can see this slightly greenish hue.

*Winsor Lemon, a touch of Burnt Sienna and a tiny hint of Payne's Gray: super-watery consistency*

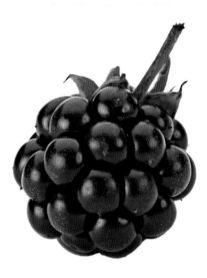

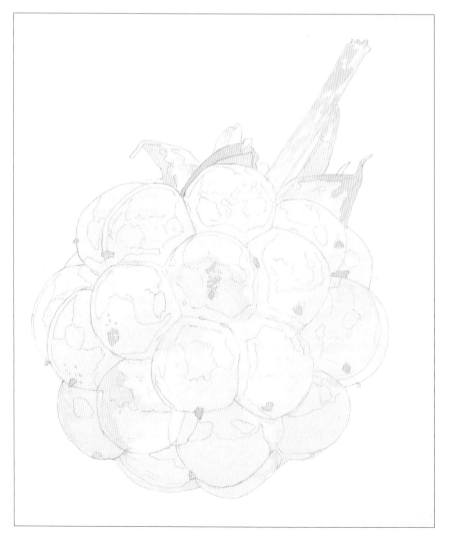

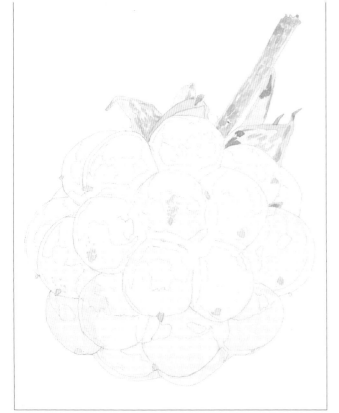

## Method stage: 1
### Lightest tones, brown hues

Many of the browns in the stem and sepals are quite dark, but there are some lighter brown colours there too. So for now, create a mix of about 70% Burnt Sienna to 30% Payne's Gray and take it a little less watery than the grey mix we created before on page 73: making it a watery to milky consistency.

Apply with the size 1 brush in lots of little lines where you see a rougher, more hairy visual texture. Apply wherever you identify a brown hue – even into the areas of brown which will need to be much darker.

By the end of this stage all areas of the painting should have a layer of paint on them, so make sure you fill in any gaps you might have with the correct mix.

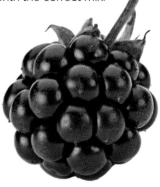

*70% Burnt Sienna and 30% Payne's Gray: watery to milky consistency*

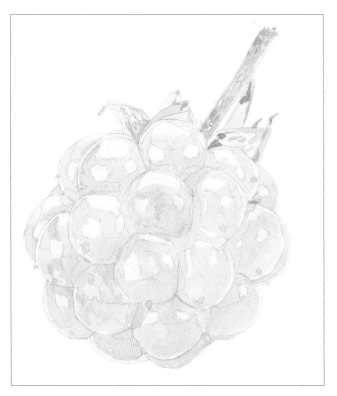

## Method stage: 1 Isolating the highlights

We've now painted the lightest tones, but for a subject like this – where the location of the highlights is so important – it's best to apply another pale layer now to everywhere on the berry except for the main areas of highlights. Make sure that your initial layer is dry and use a size 3 brush to apply a mix that contains a fraction more paint than your initial one everywhere except for the main areas of highlight (your drawing will guide you, but keep looking at the photograph!). Because we're still working with really pale paint, if you accidentally paint into an area of highlight you'll be able to correct your mistake by lifting the colour off using damp kitchen paper. Don't worry about unwanted hard-line edges that appear – we'll be able to smooth those away when we add our next layers.

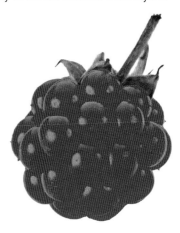

*Payne's Gray with a touch of Burnt Sienna: very watery consistency*

# Berry

Because the berry contains the darkest tones, we'll paint it first, before moving on to the stem.

## Method stage: 2 Darkest tones

Making sure your paper is dry, mix up a really thick and creamy mix of Payne's Gray with a touch of Burnt Sienna, to make the darkest mix you can while still being able to work the paint. Apply using a size 1 brush to the darkest tonal areas. Note how some edges to these shapes are smooth and require a line brush technique, while others are more textured and require using the tip of the brush to feather them a little. Make sure you leave gaps anywhere the tone is lighter.

> Payne's Gray with a touch of Burnt Sienna: thick and creamy consistency

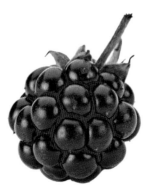

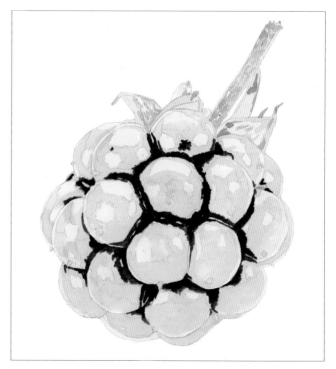

## Method stage: 3 Midtones

Add a little more water to the thick darkest tone mix to create a milky consistency and add a touch of Permanent Carmine. With the size 1 brush, apply this into the areas that are this darker midtone colour, making sure you hold off from applying into any areas that are lighter. Use a wash technique where the texture is smoother and stipple and feather where a rougher texture is required. Along the transitions into the darkest tones, apply the mix over the top of the darker tone, just along the edge, so that you start to smooth the transition (see page 69 for feathered transitions).

> Payne's Gray with a touch of Burnt Sienna and a touch of Permanent Carmine: milky consistency

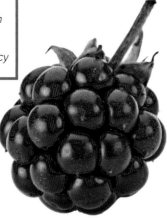

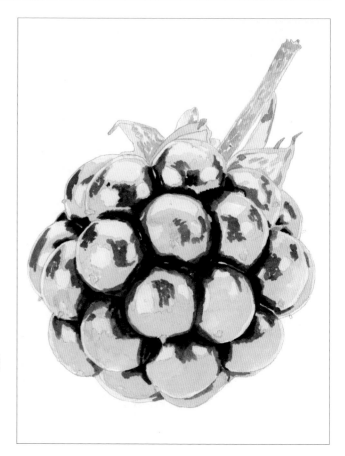

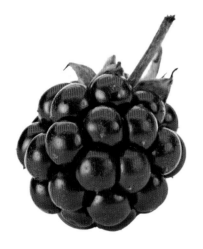

*The lighter midtone areas are around the less bright areas of highlights in particular.*

## Method stage: 3 Lighter midtones

We're going to create a mix that's a match to the lighter midtone areas and then apply it to these areas and anywhere else that's this hue and tone or darker. So this will be into the mid-midtone areas too, but still holding off from any lighter areas, and going around any of the pink marks you've made. We can also apply this mix over the top of the darker midtone areas we just painted as it will help smooth transitions where needed (though don't worry about that too much at this stage). This mix is sufficiently light that it will just subtly darken those areas, which can also be helpful. Create a mix that's a bit darker than the one you used to isolate the highlights on page 75, and with a little more of the Burnt Sienna than before. Apply with a size 1 brush and use the tip to create a feathered and textured edge into the areas of lighter highlight (see guide image, left).

Add a hint of Permanent Carmine to the mix to create a few areas with a more burgundy hue – see guide image below right.

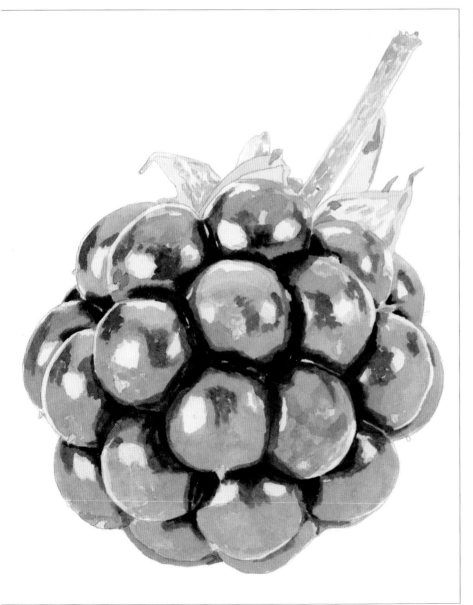

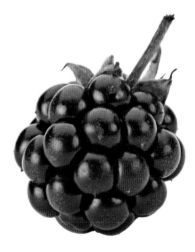

*Payne's Gray with a touch of Burnt Sienna: watery consistency*

*Payne's Gray with Burnt Sienna and a hint of Permanent Carmine: watery consistency*

*There are a couple of areas of a more burgundy hue.*

## Method stage: 3 Mid-midtones

Now we have the full tonal range painted, from light to dark, the blackberry is taking some form. Next we need to develop the mid-midtones within the centre of the berry's tonal range by darkening these areas with another layer of the same consistency paint (always making sure the layer underneath is dry).

Stick to these areas for now, but as you apply using a size 1 brush, don't be afraid to let this layer overlap into areas that are darker and that you can tell will need to be darker still. Most larger areas require a wash brush technique with some light stippling to create a little texture. But you can also use the tip of the brush to outline little spots of the lighter mix underneath where needed (see page 66). Where there are transitions into lighter areas and highlights, use the tip of the brush to create a feathered texture.

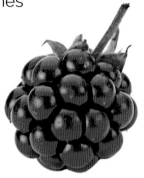

*Payne's Gray with a touch of Burnt Sienna: watery consistency*

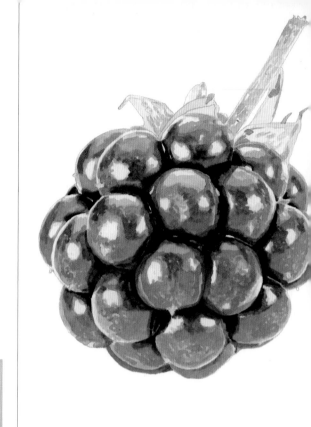

## Method stage: 4 Darker midtones again

Because tone is relative, now that you've worked to darken the midtones, it's likely that you'll notice other parts of your berry that need to be darkened. This will vary a little between your painting and mine, depending on whether your mixes were the same consistency as mine. But in my case, I can see that the darker midtones in the berry need darkening some more. If yours do too, go back to a mix which is the same sort of consistency as the darker midtone one you used before (though you can add a little more water to this if you need to make a more subtle adjustment). Apply it as another layer to those areas that need it. This is a good opportunity to look for any areas you missed the last time, as it can be easy to miss these small shapes. Use a size 1 brush and adjust your technique to match the texture of the section you're working on. This is the time to pay even more attention to texture and aim to match it more closely – you should find yourself stippling and using the tip of the brush to add little lines and dots and detail rather than applying lots of washes.

*Payne's Gray with a touch of Burnt Sienna and a touch of Permanent Carmine: milky consistency*

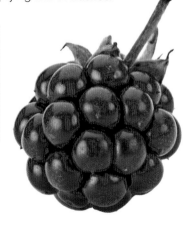

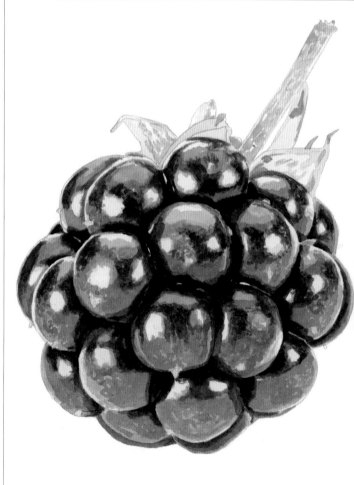

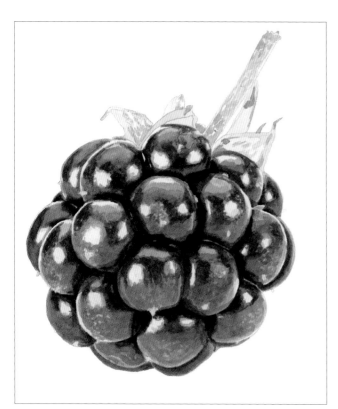

## Method stage: 4 Mid-midtones again

With the darker midtones darkened, I can see that my mid-midtones need darkening some more. If yours do too, use a size 3 brush to cover the bigger areas – and to apply as more of a wash (don't worry, the texture you created in the previous layer will still be visible through). Use the mixes shown and apply them over and into darker midtones, and into some lighter midtone areas, to darken them a fraction more too, if that looks right. Also use this mix and the tip of your brush to work on the transitions between highlights and the dark berry that surrounds them.

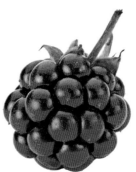

*Payne's Gray with a touch of Burnt Sienna: watery consistency*

*Payne's Gray with Burnt Sienna and a hint of Permanent Carmine: watery consistency*

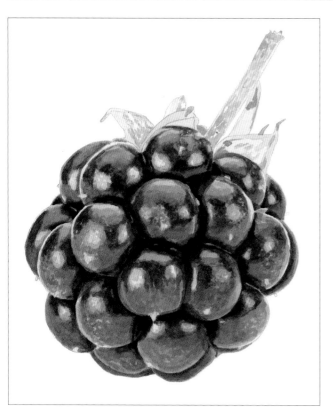

*Payne's Gray with a touch of Burnt Sienna: super-watery consistency*

## Method stage: 4 Lightest tones again

Now we've darkened the midtones some more, the highlights are starting to jump out as looking too light. If that's also the case with yours, use another super-watery mix, as shown (remembering this should be more blue so should include mostly Payne's Gray). To apply another layer to the highlights you need to darken (for me this is most of them except for a few of the very lightest ones around edges of segments), use a size 1 brush and apply as a wash over whole highlights that need darkening – or use the tip to stipple and leave gaps on highlights where there are lighter areas. Work gently around the transitions into darker colours so you don't cause the darker colours to bleed into the lighter ones.

Once this is done I can straight away spot that my darkest tones and midtones need further darkening in many areas. But this will be easier to judge once we've darkened the pink/brown areas we see on many of the segment tips – and also the stem.

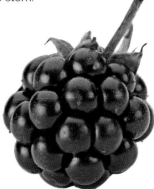

# Stem and sepals

## Method stage: 2
### Darkest tones

Use the tip of a size 1 brush and a milky pink mix (Permanent Carmine, a touch of Burnt Sienna and a hint of Payne's Gray) to work on the darkest tonal areas that are this hue – including in the tiny styles and in the sepals.

Once dry, use a thick, milky Burnt Sienna and Payne's Gray mix to work into the darkest brown areas within the styles, stem and sepals, layering the paint on top of the pink colour where you need to.

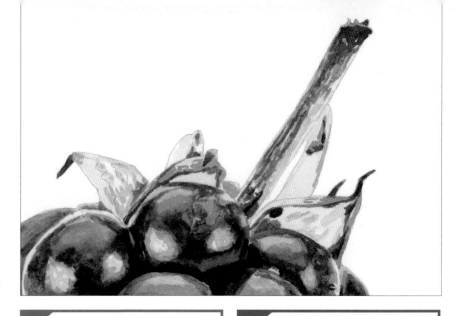

*Permanent Carmine, a touch of Burnt Sienna and a hint of Payne's Gray: milky consistency*

*Burnt Sienna and Payne's Gray: thick, milky consistency*

## Method stage: 3 Midtones

Still with a size 1 brush, use a thicker, milkier version of the green mix from page 74 and apply as a second layer to the green areas, watering down where a lighter shade is needed. These areas are mainly fairly smooth textures so a wash technique can be used.

Then add more Burnt Sienna and Payne's Gray to the mix to create a pale brown mix and apply in a stipply way to areas on the sepals and main stem.

Create a mix with Permanent Carmine, Burnt Sienna and Payne's Gray that's a little more watery than that used for the darkest tones, but thicker than the pink mix on page 74. Apply to the midtone areas of this hue on the stem and some sepals – again this will be as a second layer to some of the paler parts, but make sure you leave gaps through to the initial layer in any areas that should be lighter.

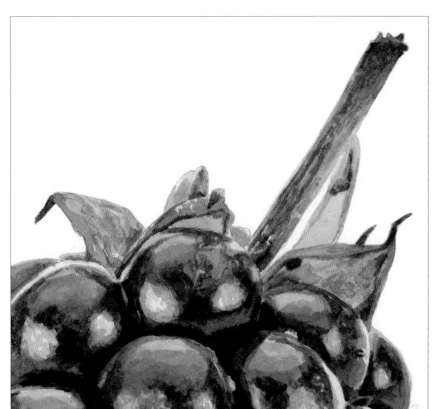

*Winsor Lemon, a touch of Burnt Sienna and a tiny hint of Payne's Gray: milky consistency*

*The above mix plus more Burnt Sienna and Payne's Gray: milky consistency*

*Permanent Carmine, Burnt Sienna and Payne's Gray: watery consistency*

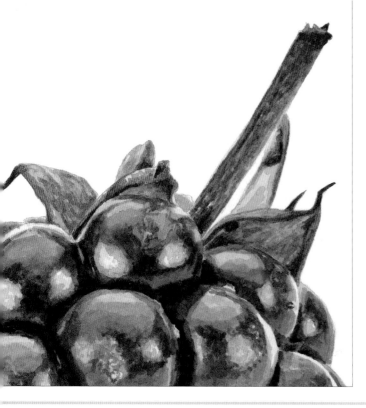

### Method stage: 4 Adjustments

Now the midtones are darker, check your darkest tones again and apply another layer to any areas within them that need darkening (making sure the paper underneath is dry). The consistency of your mix will depend on how much darker you feel an area needs to be. A more watery mix will achieve a more subtle darkening. This is also the stage for adding an extra level of detail as you focus on painting the smaller shapes you can see. You may want to go down to a size 0 brush to make some of these smaller marks.

> Permanent Carmine, a touch of Burnt Sienna and a hint of Payne's Gray: milky consistency

> Burnt Sienna and Payne's Gray: thick, milky consistency

# Whole painting

> Payne's Gray with a touch of Burnt Sienna: thick and creamy consistency

### Method stage: 5
## Final adjustments and details, darkest tones again

With the stem and sepals darkened – as well as the tiny styles within the berry – we now need to step back and assess the painting as a whole. It's a good idea to check your darkest tones within the berry. Unless you took yours much darker than I have on page 76, you'll probably find they need darkening. If so, go ahead and add another layer to them using a thick mix of your darkest tone. When darkening your darkest tones again, use a size 0 brush as it will give you more control to neaten edges of the segments as you work. Also use the tip of the brush to create additional texture to the transition around the highlights where you see it.

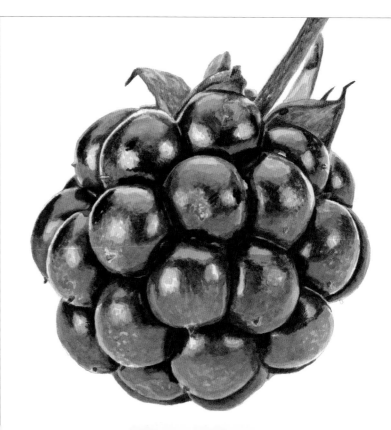

## Method stage: 5 Midtones again

You'll find as you darken one area, it will reveal to you that another needs darkening to bring the painting back into tonal balance. In my painting I need to darken my midtones again, using a size 1 brush. Mostly I'm focusing on the berry, but do assess the stem and sepals too, to see if they need darkening again once you've darkened the berry.

I'm mostly using the more watery lighter midtone mixes for fairly subtle darkening effects. Match the consistency of your mix to how much darker you need to take an area, but remember that you don't want to risk taking areas too dark at this stage, so it's safer to work with more watery mixes, even if this means you need to apply two layers to get an area as dark as you want it.

You can keep applying layers like this until you're satisfied that the tonal range looks right – just make sure you're letting each layer dry before you apply another! And don't forget to take regular breaks during this stage so that you can return to your painting and the photograph with 'fresh eyes', able to see more clearly what darkening your painting requires and where.

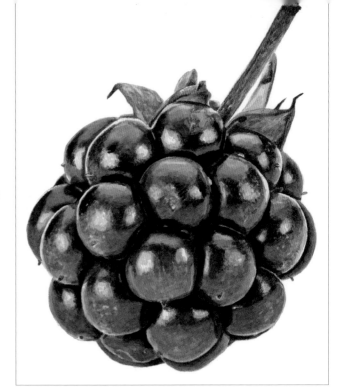

*Payne's Gray with a touch of Burnt Sienna: watery consistency*

*Payne's Gray with Burnt Sienna and a hint of Permanent Carmine: watery consistency*

## Method stage: 5 Details

In these final stages, check over your painting for any details you need to add. Use the smallest brush (size 000) and focus on neatening edges by making sure they are smooth where they should be, using fairly watery to milky mixes so that you only darken very subtly. Also look at the little styles within the berry segments and darken those, as well any other areas with the pink hue within them.

Finally, use the tip of the size 000 brush with the lightest tone mix (see below), and add more texture into those areas of highlight you feel need it. This adds extra realism but will slightly darken the highlights, so don't do this if you already feel your highlights have become too dark.

*Payne's Gray with a touch of Burnt Sienna: super-watery consistency*

With these extra details added the
blackberry is complete!

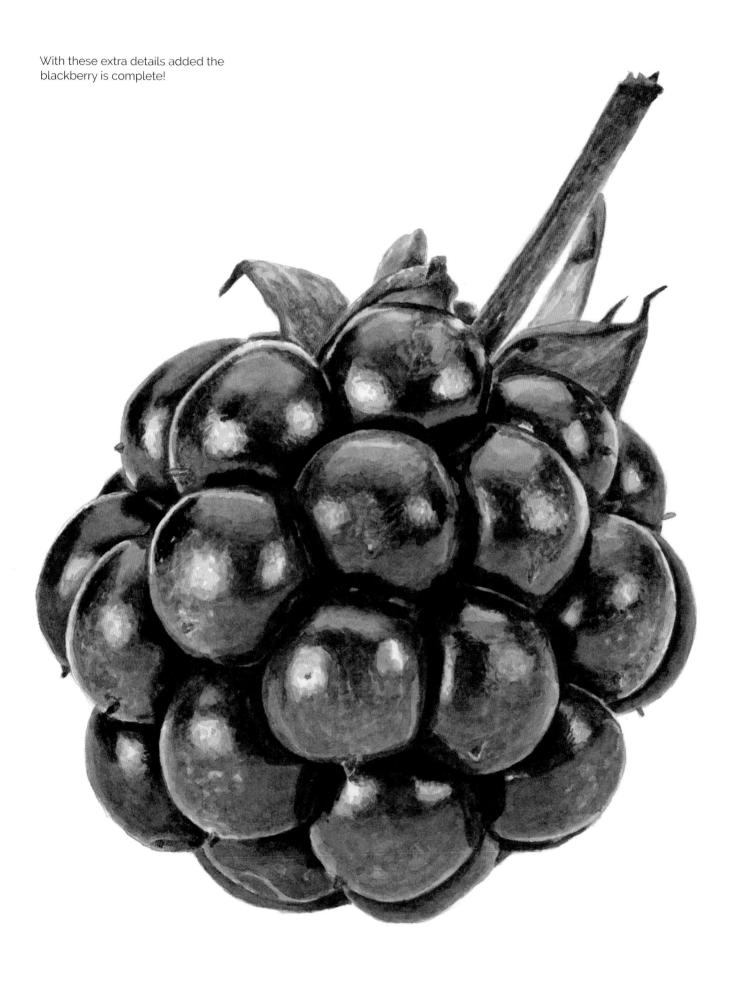

# AUTUMN LEAF

With its gorgeous golden yellows and rich reds, this autumn leaf shows plenty of contrast in its hues. But when we look at it tonally (look at the black and white versions on the following pages) we can see that it has a smaller tonal range than we might expect. So our challenge is to get the leaf looking tonally unified and solid while painting the contrasting hues within it so that they remain distinct.

## Paints

- Transparent Orange (by Schmincke, previously called Translucent Orange)
- Scarlet Lake
- Winsor Lemon
- Burnt Sienna
- Payne's Gray
- Permanent Carmine

(The colours listed are Winsor & Newton and Schmincke; for alternatives, see my website.)

## Pencil drawing

The drawing consists of the outline edge of the leaf and also contains an outline to the major veins down the centre of each of the leaf's lobes. As the major veins are paler than the surrounding leaf, I've created a line either side of them so we'll be able to paint the veins themselves and then paint around them using the pencil marks as a guide. The narrower veins coming off the main ones are so small that I've just marked them in with a single line. When we paint them we'll leave a small gap on one side of the pencil mark. Getting the angles of the veins right is important for giving the leaf a realistic shape and structure. You can trace from the drawing provided on page 141.

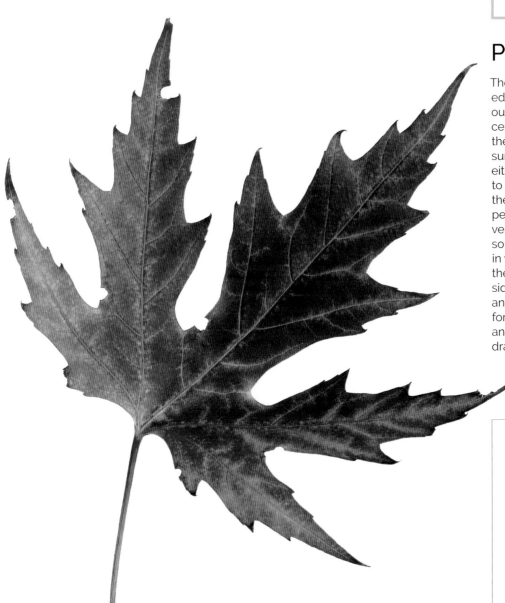

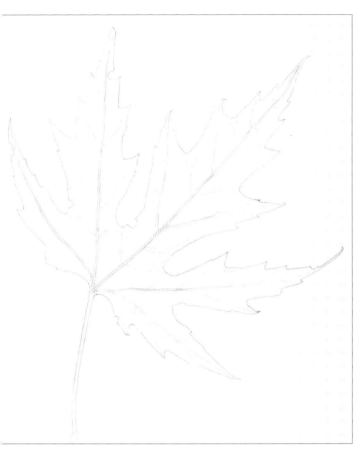

# Whole painting

## Method stage: 1
### Lightest tones, leaf veins

The lightest tones in the whole leaf can be found within the main veins. To match to this pale peachy colour, mix equal (tiny) parts of Scarlet Lake with Winsor Lemon and massively dilute until it's really watery. Apply with a size 1 brush to the veins. You can be generous with this mix and not worry about sticking within your pencil outline in the veins because only the brightest of yellows in the leaf would be affected by having this mix sit underneath them. When painting onto a vein where you only have a single pencil line to define it, choose to paint on one side or the other of your pencil line.

*Equal parts Scarlet Lake and Winsor Lemon: super-watery consistency*

## Method stage: 1 Lightest tones, yellow areas

The next lightest tones are found within the yellow areas of the leaf. The hue is an orangey-yellow, so to create it mix around 70% Winsor Lemon with 30% Transparent Orange. The lightest tones within the yellow area are not as light as the veins we just applied, so this mix can be a little thicker, at a milky consistency. With the veins now dry, apply this mix to the yellow areas with a size 1 brush. We can be generous with where we apply this mix, as in most places we will be able to work with the darker browns and reds over the top of this mix, so make sure you apply it wherever you see a hint of yellow. Stipple with your brush to leave gaps to the paper where there is definitely no yellow and use the tip of the brush to create neat edges up to the veins in the many places where the yellow is found up against a vein. Also use the tip of the brush to paint the yellow over veins, or parts of veins that have a yellow colour but, again, you don't have to be precise about this and can paint lines much wider than the actual vein.

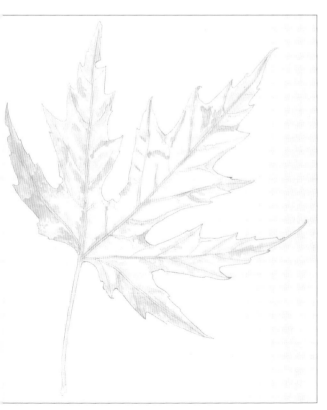

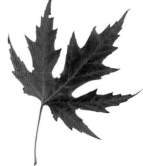

*70% Winsor Lemon with 30% Transparent Orange: milky consistency*

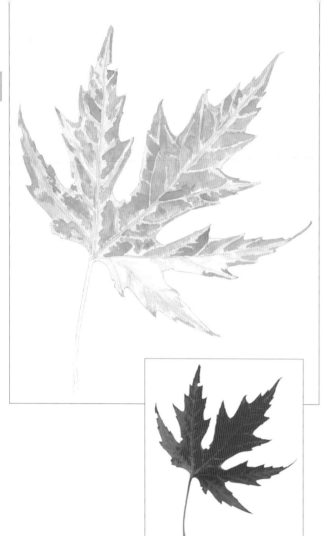

## Method stage: 1
### Lightest tones, red-brown areas

The red-brown areas contain some of the darkest tones within the whole leaf. But within them there are also lighter tones, and it's those we want to match to with this first wash. In fact, we want to keep this mix a little brighter in hue than we see in the overall area and match it to the slightly brighter hues we see in the transitions into the yellow areas. It's easier to darken and mute colour down but it's not as easy to brighten it later, so for this layer, mix equal parts Scarlet Lake with Transparent Orange at a milky consistency similar to the one used for the yellow mix.

Apply with a size 0 brush into the areas of this colour. In the right-hand lobe you will be applying on top of the yellow paint (which must be dry). Elsewhere you'll be working up to the areas of yellow and you can allow this mix to overlap it in places, stippling with your brush to achieve the mottled visual texture to these transitions. Again, use the tip of the brush to go around veins that we have already painted, though you'll also find you can apply this mix into some smaller veins that are this hue and tone or darker. As you apply, it's possible you'll discover areas that you missed that should have been yellow. If so, leave them, then once this layer has dried, go back with the yellow mix to fill those gaps. Hold off applying to the bottom right lobe, as that has a hue that's a little different.

*Equal parts Scarlet Lake and Transparent Orange: milky consistency*

## Method stage: 1
### Lightest tones, brighter red areas

Use a milky mix of neat Transparent Orange and apply it to the brighter red areas within the bottom-right lobe and on the stem. Note how this ends up looking similar to the far-left lobe, where we applied a red-brown layer over the top of yellow. This goes to show how we can colour mix by layering on the paper, or by mixing paints together in the palette.

Use the size 0 brush again and apply as in the step above, but hold off from applying the details around the veins at this stage; we'll add those later on with a darker version of this hue. Before you move on, check over the leaf to see if there are any areas where the paper is visible and, if so, apply a layer to match the colour it's closest to, choosing rom one of the mixes we've used so far.

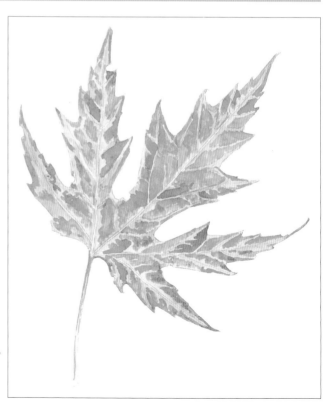

*Transparent Orange: milky consistency*

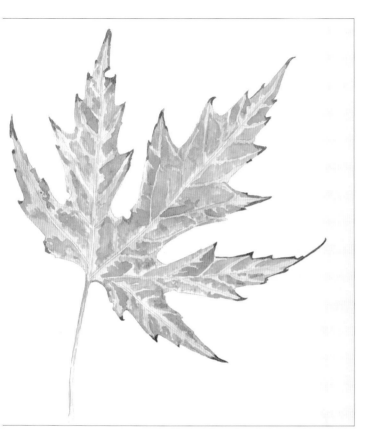

## Method stage: 2 Darkest tones

Next we'll paint the very darkest tones: the dark brown tips on some of the leaf's lobes. The aim here is to get this mix looking as dark as we think it needs to be, though judging this can be tricky at this early stage in the painting. With the darkest tones painted it will then be easier to see how dark to take the darker midtones. Mix about 70% Burnt Sienna with 30% Payne's Gray at a thick milky consistency. Use a size 0 brush and apply to the lower two lobes first, where the colour is darkest. Use the tip to work within your pencil outline at the edges and try to re-create the shapes of these areas of brown, most of which have a fairly hard-line transition into the colour around them. Water the mix down a little to work on the other lobes, and remember to leave gaps where there is a lighter vein within a brown area.

*70% Burnt Sienna and 30% Payne's Gray: thick milky consistency (darker swatch)*
*Same mix with added water: watery to milky consistency (lighter swatch)*

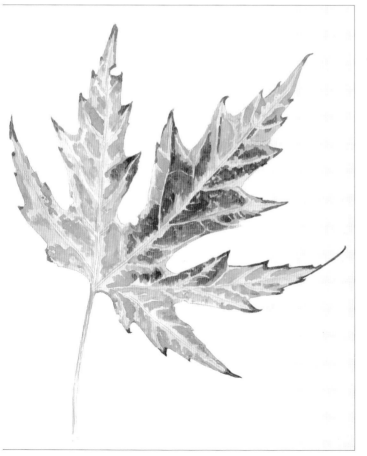

## Method stage: 3 Darker midtones

Next we'll work on the darker midtones, which in a few places connect up with the brown tips we just painted. The darker midtones are concentrated mostly on the main central lobe and have a rich red-brown colour to them. For this, use Permanent Carmine as a base then add to it around 50% as much of Scarlet Lake and an equal amount of Burnt Sienna. Then add a touch of Payne's Gray. Take this to a thick milky consistency and, if you're concerned in any way that your mix may be too dark, water it down some more. You can always apply another layer to it to darken it up. Apply your mix with a size 1 brush into the darker midtone areas, paying close attention to the visual texture, often stippling with your brush where there are lighter patches within shapes of this colour. Use the tip of the brush again to outline veins where you need to. There are some fine lines of this colour under some veins, but we can apply that level of detail later once we're happy the leaf is correct tonally overall.

*Permanent Carmine, Scarlet Lake, Burnt Sienna and a touch of Payne's Gray: thick milky consistency*

### Method stage: 3
### Mid-midtones, red-brown

Water your last mix down a touch and add in a little Winsor Lemon: both actions will lighten the mix and the yellow paint will make it a little more orange. Now, with the previous layer dry, use the size 0 brush to apply this mix into all areas this hue and tone or darker. This will involve painting with a glaze over and into the darker midtone areas to fill in gaps you've left in the stippling there. It will also involve stippling into lighter areas to leave gaps to the yellow washes applied on page 85. As you work into some of the yellow areas, use the tip to work closer to the veins to define them a little more.

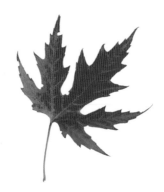

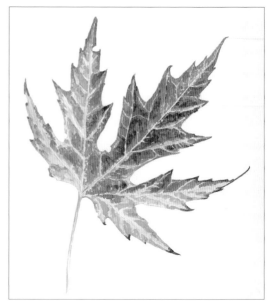

*Permanent Carmine, Scarlet Lake, Burnt Sienna, a touch of Payne's Gray and Winsor Lemon: milky consistency*

### Method stage: 3 Mid-midtones, brighter reds

Ensuring the previous layer is dry, create a thick milky mix of Transparent Orange with equal Scarlet Lake and a touch of Permanent Carmine. Use a size 0 brush and apply into areas where you see the brighter colour. You can apply on top of some areas of the red-brown you just applied, as well as stippling into the brighter red areas you mapped out on page 86. Stipple along some of the veins but, again, hold off from creating fine-line detail around the veins as we will come to that later once we have darkened the veins themselves.

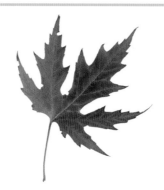

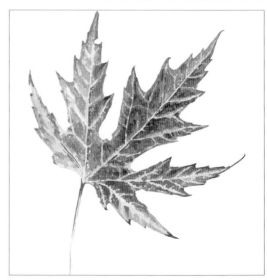

*Transparent Orange, Scarlet Lake and a touch of Permanent Carmine: thick milky consistency*

### Method stage: 3 Lighter midtones, yellows

We now need to darken the yellow hue areas. This will start to make the leaf feel more solid. Create the Winsor Lemon and Transparent Orange mix from page 85 at a slightly thicker milky consistency so it's a little darker. Make sure the previous layer is totally dry and use a size 3 brush to apply the mix generously as a glaze over all yellow areas that need darkening, avoiding lighter veins. Work gently with your brush so as not to disturb the paint underneath too much. Also add a touch to the yellow parts of the stem, including the very bottom.

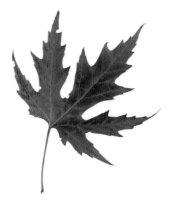

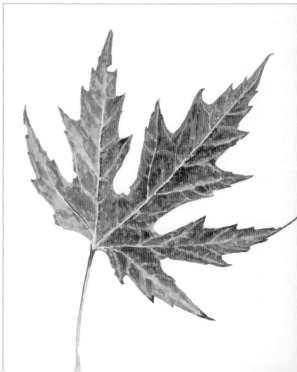

*Winsor Lemon and Transparent Orange: thick milky consistency*

## Method stage: 4 Adjustments

Each of our paintings will need handling slightly differently at this stage, depending on how dark your initial mixes were and where exactly you applied them. So you'll need to assess yours for yourself. If you're unsure how much darker to take an area, water your mix down to a watery to milky consistency. That way you will only make a subtle adjustment and can add a further layer to darken more if required. Just make sure you let each layer dry first!

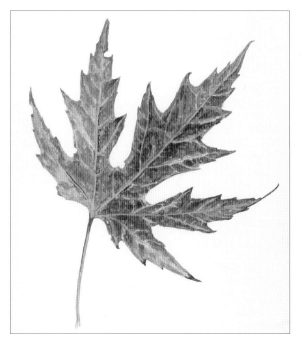

## Method stage: 4 Adjustments, lightest tones

With the midtones worked on, the lightest tones in my painting – the veins – are now jumping out as too light in comparison. To darken them, use some milky, neat Scarlet Lake, which creates a pink colour. Apply with a size 0 or 000 brush over the veins: don't worry if this mix also sits on top of the areas immediately to the side of the veins – it won't matter so long as your previous layer is dry. Once this has dried, apply a second layer to any veins that still need to be darker. Also apply to the stem in a few places that have this hue to them.

> *Scarlet Lake: milky consistency*

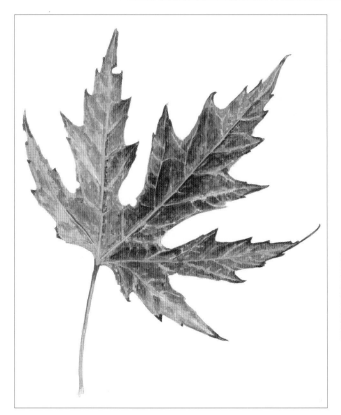

## Method stage: 4 Adjustments, darkest tones and darker midtones

With the lightest tones darkened, reassess your darkest and darker midtones (the areas painted in both steps on page 87). Use the same mixes you used during those stages at about the same consistency (water them down a touch if you don't think you need to darken these areas very much). Begin with the darkest tones and use a size 000 brush to darken them. Then use the size 0 brush and the darker midtone mix to darken larger areas, stippling to create texture. Then use the size 000 brush with this mix to work on the undersides of the veins on the top lobes and cutting into the yellow areas more to add a further level of detail where required.

> *70% Burnt Sienna and 30% Payne's Gray: thick milky consistency (darker swatch)*
> *Same mix with added water: watery to milky consistency (lighter swatch)*

> *Permanent Carmine, Scarlet Lake, Burnt Sienna and a touch of Payne's Gray: thick milky consistency*

## Method stage: 4 Adjustments, mid-midtones

With the previous layer dry, use the red-brown midtone mix from page 88 to work with a size 0 and 000 brush into the areas of that hue that need darkening – changing your brush technique to match the visual texture and using the mix to define veins further where required. Water the mix down to a watery consistency and stipple into the left two lobes; also use the tip of your brush to darken a couple of areas within the stem.

When dry, do the same thing with the brighter red mid-midtone mix from page 88 in the red hue areas, including using a size 000 brush around many of the veins that seem to have a red outline to them.

*Permanent Carmine, Scarlet Lake, Burnt Sienna, a touch of Payne's Gray and Winsor Lemon: milky consistency*

*Transparent Orange, Scarlet Lake and a touch of Permanent Carmine: thick milky consistency*

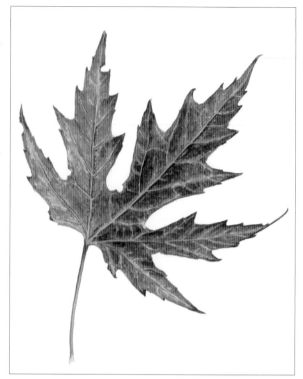

## Method stage: 5 Final adjustments and details, stepping back

Take a break at this point to refresh your eyes. When you are ready, step back from your painting and compare it with the reference photograph. Look for any large areas that need to be darker – use a size 1 brush and the two midtone mixes to darken with another layer where needed. Check the hues, too – if you need more red, use neat Scarlet Lake or even a touch of Permanent Carmine.

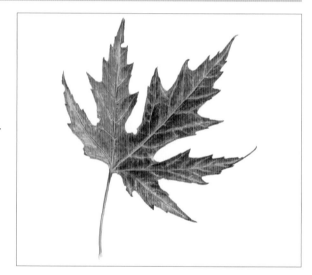

## Method stage: 5
### Final adjustments and details, veins

Now's the time to make sure your veins aren't too prominent or standing out too much in comparison to the now darker leaf colours around them. In all likelihood you will now need to go back to the yellow mix on page 88 and possibly the pink vein mix on page 89 and apply another layer of these mixes to them. You can also use the yellow mix to darken bigger patches of the leaf that are yellow and may be too pale now.

In relation to the veins, do check to see if it is just this treatment that's needed or if, in fact, the veins actually need to be narrowed, which will also have the effect of darkening them when viewed from a further distance. If this is the case, use a darker colour to paint into them and narrow them. Getting the tonal balance right with the veins and the surrounding leaf will make the leaf feel more solid.

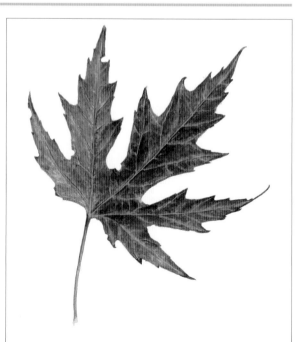

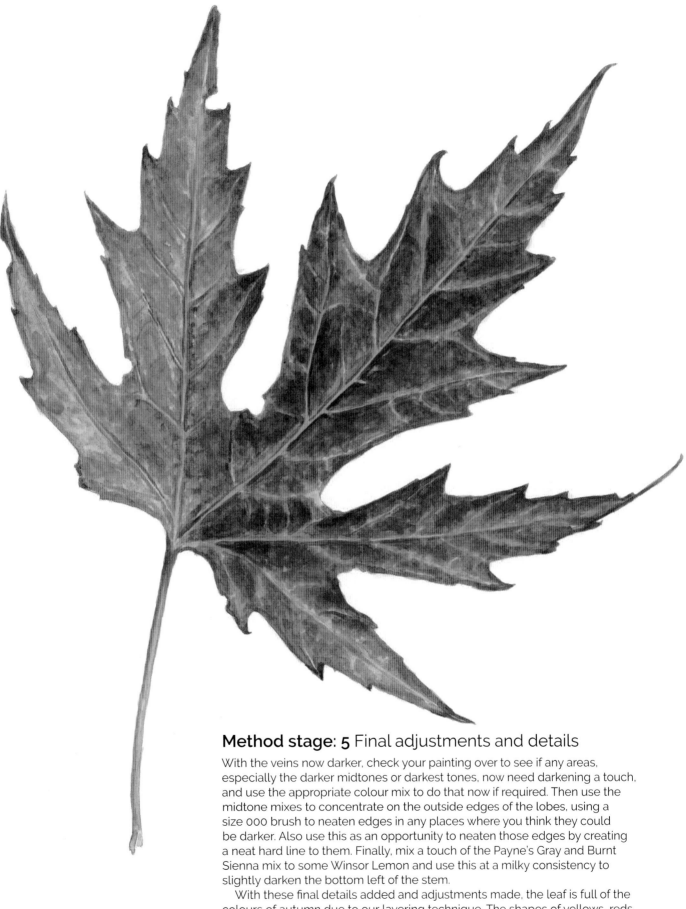

## Method stage: 5 Final adjustments and details

With the veins now darker, check your painting over to see if any areas, especially the darker midtones or darkest tones, now need darkening a touch, and use the appropriate colour mix to do that now if required. Then use the midtone mixes to concentrate on the outside edges of the lobes, using a size 000 brush to neaten edges in any places where you think they could be darker. Also use this as an opportunity to neaten those edges by creating a neat hard line to them. Finally, mix a touch of the Payne's Gray and Burnt Sienna mix to some Winsor Lemon and use this at a milky consistency to slightly darken the bottom left of the stem.

With these final details added and adjustments made, the leaf is full of the colours of autumn due to our layering technique. The shapes of yellows, reds and browns have stayed distinct while coming together at the level of the whole to create a solid-looking leaf.

# SUNFLOWER

I've painted this sunflower a little smaller than life-size, but you might like to enlarge it a little, which will make painting the details easier. In this painting we need to achieve the strong contrast between light petals and dark centre, while also getting the colour right on the darker parts of the petals. The tonal range within the petals mustn't be made too wide as, when you look at the black-and-white version of the photograph, you can see that there isn't actually very much contrast there at all.

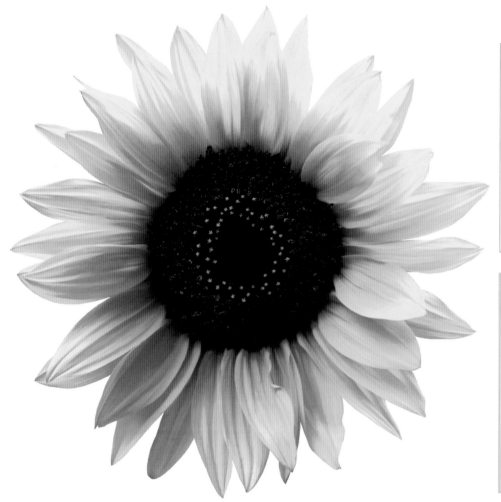

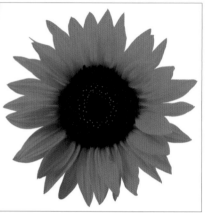

## Paints

- Winsor Lemon
- Transparent Orange (by Schmincke, previously called Translucent Orange)
- Burnt Sienna
- Payne's Gray

(The colours listed are Winsor & Newton and Schmincke; for alternatives, see my website.)

## Pencil drawing

The drawing outlines the edges of the petals lightly so that the pencil won't be too noticeable through the pale yellow paint. Around the centre of the flower I've been much more bold with the pencil as we'll be painting thick dark paint over this part of the drawing. I've also marked in a lot of the detail in the centre of the flower, which will make it easier to paint the lighter colours in the right places and not miss any of this detail when painting. You can trace from the drawing provided on page 142.

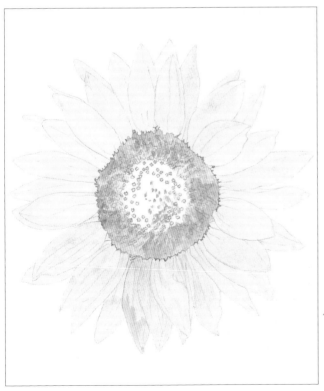

# Whole painting

## Method stage: **1** Lightest tones

Use a size 3 brush and create a mix of mainly Winsor Lemon with the slightest touch of Transparent Orange at a milky consistency. Aim for a mix that's not too pale but is a match to the lightest parts of the petals (see guide image, below). As the yellow is such a light-coloured paint, we'll need less water with it to achieve the tone we're after. Apply all over the petals, even into areas that will need to be darker. Apply in strokes up and down the lengths of the petals. This way if you get overlaps with your paint they will form lines in the same direction as the darker creases we can see on the petals. Use the tip of the brush to also apply to the lightest patches of pollen in the flower centre.

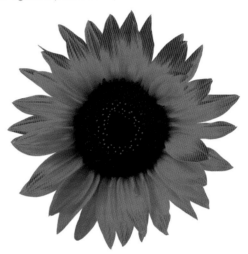

*Winsor Lemon with a touch of Transparent Orange: milky consistency*

## Method stage: **1**
## Lightest tones, flower centre

Use the size 3 brush to create a mix of Winsor Lemon with a touch of Burnt Sienna and a tiny hint of Payne's Gray at a milky consistency. Apply this as a ring to the edge of the flower centre – you don't need to apply the paint in a smooth way, as there is so much texture in this centre. We can apply this across the whole area, even though much of this mix will end up sitting underneath darker colours we'll apply on top. Also apply this mix as a few dots within the very centre.

Add more Winsor Lemon to the mix to work on a smaller ring inside the darker one you just applied, where you can see the long, paler anthers. The transition between the two mixes can be rough and textured.

*Winsor Lemon with a touch of Burnt Sienna and a tiny hint of Payne's Gray: milky consistency (darker swatch)*

*Same mix plus additional Winsor Lemon: milky consistency (lighter swatch)*

# Flower centre

The centre contains the darkest tones of the whole painting.
Painting them next puts us in a stronger position to be able
to judge how dark to take the darkest tones within the much
lighter petals.

## Method stage: 2 Darkest tones

Now we'll create a mix that's a lighter version of the very darkest tones
we can see in the flower centre. Using this we can position our darkest
tones and if we place this colour into the wrong areas, we are able to
lift it off a little to correct the mistake. Importantly, it allows us to have
this layer underneath the thicker mixes we'll be applying on top, so
that we can leave gaps through to this mix wherever the tone needs
to be slightly lighter.

   Create a watery to milky mix of 50% Burnt Sienna and 50% Payne's
Gray. Making sure the layer underneath is dry, apply with a size 1 brush
to all the darkest areas of the flower centre, paying attention to the
curved sorts of lines that fan out from the centre. Be careful to use
the tip of your brush to outline the yellow
pollen in the very centre and avoid
placing the paint in areas that are
lighter in tone than this mix.

50% Burnt Sienna and 50% Payne's
Gray: watery to milky consistency

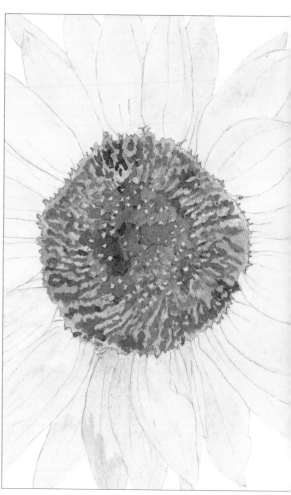

## Method stage: 2 Darkest tones again

Once the paper has dried, create a much thicker, creamy
mix of 50% Burnt Sienna and 50% Payne's Gray. Use
a size 000 brush and begin by outlining the yellow
pollen in the centre, using the tip of the brush to try to
create star shapes around the pollen. Then use a size 1
brush and apply the mix to the rest of the darkest areas,
concentrating on the very centre as well as the bigger
patches within the brown outer edge. Don't work right
up to the petals at this stage though – this is better done
later once we've darkened the petals (see page 100), in
case painting the petals causes this dark colour to bleed
into them. Use a stippling technique
to try to create lots of texture.

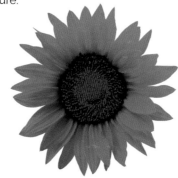

50% Burnt Sienna and
50% Payne's Gray: thick,
creamy consistency

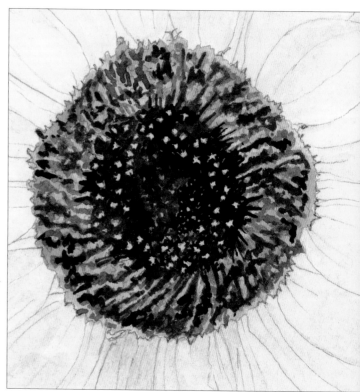

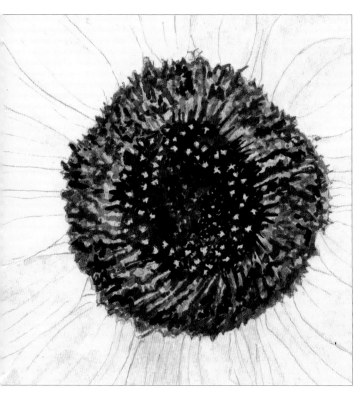

## Method stage: 3 Darker midtones

Create a mix of Burnt Sienna with a touch of Payne's Gray at a thick, milky consistency. With the paper dry, apply with a size 0 brush and focus on the edges, leaving plenty of gaps in your application so you can see the lighter colours coming through. Then apply in bigger patches towards the bottom where the flower centre is overall a little darker.

*Burnt Sienna with a touch of Payne's Gray: thick, milky consistency*

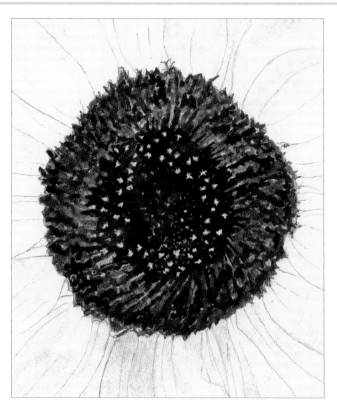

## Method stage: 3 Mid-midtones

With the darkest tones painted, the lighter areas of the flower centre, painted on page 93, are really standing out as too pale. Within them there are a couple of shades, some a mid-brown and some a slightly lighter, more golden hue. Let's paint the brown areas now. Create a thick, milky mix of Burnt Sienna with a hint of Payne's Gray and some Winsor Lemon. Use a size 0 brush and apply to an area you know needs to be much darker. Then from there, apply this mix out into all areas that are this dark, leaving a few gaps to the lighter colour underneath. Where the mix sits next to the darker mixes you don't need to be precise and can apply it on top of those darker colours – just do so gently so that the darker colours underneath don't bleed into your mix.

Add a touch more Winsor Lemon to the mix as you apply to the anthers on the inside of the brown outer ring.

*Burnt Sienna with a hint of Payne's Gray and some Winsor lemon: thick, milky consistency (darker swatch)*

*Same mix plus additional Winsor Lemon: thick, milky consistency (lighter swatch)*

## Method stage: 3
### Lighter midtones

With the midtones a little darker now, it makes it clearer that the lighter areas within the centre need to be made a little darker, and given a more golden glow. Create a mix of Winsor Lemon with a touch of Burnt Sienna at a thick, milky consistency and apply it with a size 1 brush to all the lighter areas within the centre, focusing on the inner ring where the anthers are. Leave the little dots of yellow pollen in the centre as they are lighter than this mix. Again, you can apply over and on top of the darker colours next to these lighter areas.

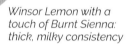

*Winsor Lemon with a touch of Burnt Sienna: thick, milky consistency*

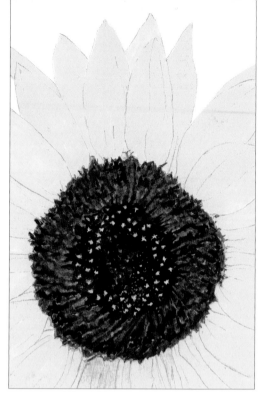

## Method stage: 4
### Adjustments, darkest tones again

Now that we've darkened the midtones, it's time to reassess the darkest tones again to check they look as dark as they should. Mine need to be a bit darker. Do check whether yours do, as they may not. If they do, mix up the dark, thick, creamy mix of Burnt Sienna and Payne's Gray and apply with a size 0 brush, focusing on the very centre of the flower. We will come back and darken the edges more when we've painted the petals.

Darkening the darkest tones may cause the little lighter grey spots in the centre to seem too pale in comparison. So water down your mix to a watery/milky consistency and apply another layer over those lighter spots.

*50% Burnt Sienna and 50% Payne's Gray: thick, creamy consistency (darker swatch)*

*Same mix: watery to milky consistency (lighter swatch)*

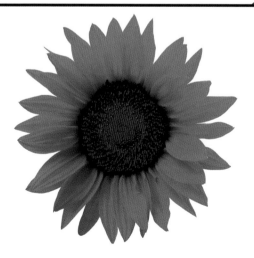

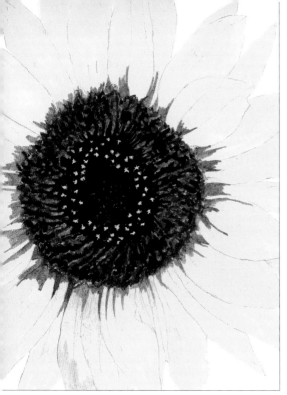

# Petals

## Method stage: 2 Darkest tones

The darkest tones within the petals can be seen at the base, against the flower centre. It's challenging to judge how dark to take these darkest tones without the petal midtones being painted, but it is worth trying to place a few now as it will actually help us paint the midtones.

Create a milky mix of Burnt Sienna with a touch of Payne's Gray and a touch of Winsor Lemon. Use a size 0 brush to apply around the centre, paying close attention to the reference photograph. Don't apply it too far up the petals. Instead, feather the edge of the paint you're applying where it will need to transition into a lighter shade on the petal.

Create a mix with less Payne's Gray in it and use that where the hue needs to be less grey.

*Burnt Sienna with a touch of Payne's Gray and Winsor Lemon: milky consistency (darker swatch)*

*Same mix but with less Payne's Gray (lighter swatch)*

## Method stage: 3 Mid-midtones

We're going to paint the mid-midtones now, and also apply the mid-midtone mix into the darker midtone areas that connect up with the darkest tones we just painted. Create a milky mix of Winsor Lemon with a touch of Transparent Orange and a tiny hint of Payne's Gray. Use a size 1 brush and begin by applying it onto the transitions into the darkest tones we just painted to create a graduated transition. Then apply your mix on any areas of the petals that are this hue and tone or darker, holding off from anywhere that seems lighter in tone. Use the tip of your brush to create the lines within the petals and also to create further feathered transitions into areas of the petals that are lighter. You don't want to overdo things at this stage, so if you're in any doubt about your mix, water it down and keep it lighter. You can always apply another layer to darken it later.

You can also add more Winsor Lemon to the mix for those areas that need a slightly more yellow hue.

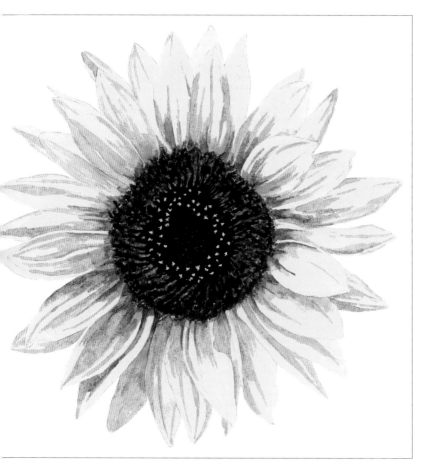

*Winsor Lemon with a touch of Transparent Orange and a tiny hint of Payne's Gray: milky consistency (darker swatch)*

*Same mix with more Winsor Lemon (lighter swatch)*

97

## Method stage: 3
## Lighter midtones

Now the mid-midtones have been painted, it shows us that there are areas of lighter midtone that need to be darkened. These lighter midtones are the areas of the petals that are lighter than the mid-midtones but not as light as the lightest tones painted on page 93. So we need to paint the rest of the petals except the lightest tones, which are shown in the guide image below, and are mostly in the top half of the flower.

Create two fairly thick mixes of neat Winsor Lemon and add to one a touch of Transparent Orange, and to the other a little less Transparent Orange. Apply along the lengths of the petals with a size 3 brush to bigger areas, and a size 1 brush where you need more control. This mix can be applied on top of the midtones you applied before, providing, of course, that they are dry.

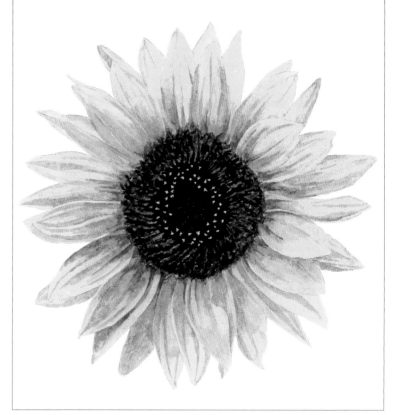

*Winsor Lemon with a touch of Transparent Orange: fairly thick consistency (darker swatch)*

*Same mix with slightly less Transparent Orange (lighter swatch)*

## Method stage: 3
## Darker midtones (more orange)

With the lighter and mid-midtones painted it's easier to tackle the darker midtones, which connect up with the darkest tones in the petals. These darker midtones need to have quite a bit of orange to them to get the hue looking correct. Create a couple of mixes of thick milky Winsor Lemon and add around 50% Transparent Orange to one, and just a touch of it to the other. With the layer underneath dry, apply with a size 1 brush to all the darker midtone areas (see guide image, below).

*Winsor Lemon plus around 50% Transparent Orange: thick, milky consistency (darker swatch)*

*Winsor Lemon with just a touch of Transparent Orange (lighter swatch)*

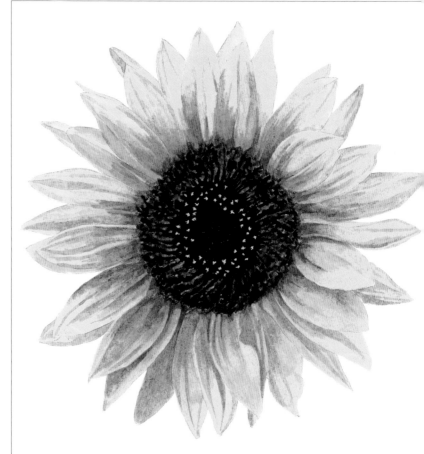

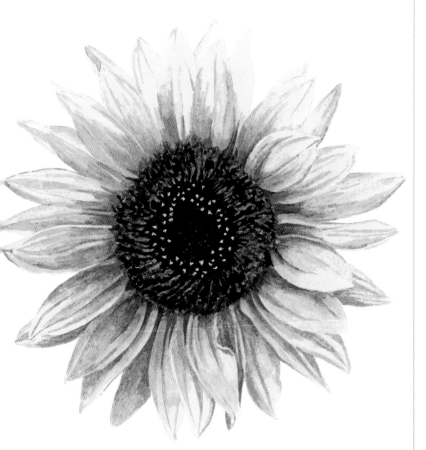

## Method stage: 4 Adjustments, darkest tones again

Now that the darker midtones have been darkened, it may show you that you can afford to darken your petals' darkest tones some more. That's the case with my painting. What seemed really dark against the pale petals when I first applied it, now needs darkening in many areas, and also needs to be more orange in hue. If your darkest tones need this treatment too, create some mixes of Transparent Orange with differing amounts of Payne's Gray – change the consistency to achieve the amount of darkening you're looking for in an area. Then apply with a size 000 brush to all parts of the darkest tones that need it, using the smallest brush to neaten the shapes you apply.

*Transparent Orange with differing amounts of Payne's Gray: different consistencies*

## Method stage: 4 Adjustments, darker and mid-midtones again

Having adjusted the darkest tones, we now need to assess the petal midtones again and darken in a few places if needed. Create a milky to watery mix of Winsor Lemon with a touch of Transparent Orange and a tiny hint of Payne's Gray. Apply with a size 000 brush to those areas that need darkening, and use this stage also to add extra line details to the petals where needed.

*Winsor Lemon with a touch of Transparent Orange and a hint of Payne's Gray: milky to watery consistency*

# Whole painting

### Method stage: 5 Final adjustments and details, flower centre

With the petals so much darker, it's time to reassess the darkest tones in the flower centre, and at this stage we can also work on the outside edge of the flower centre, where it meets the petals, and add the extra detail there. Use a thick, creamy Payne's Gray and Burnt Sienna mix and a size 000 brush to create the little 'v' shapes around the edge and also to add little lines to the centres of some of the anthers, as well as to darken the larger areas within the flower centre where needed. Also use a mix of Transparent Orange with a touch of Payne's Gray to work into areas with more of a brown hue to them, allowing this colour to overlap into the darker areas.

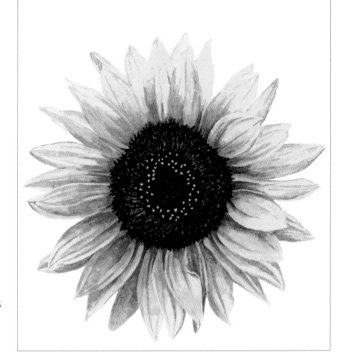

Burnt Sienna and Payne's Gray: thick, creamy consistency

Transparent Orange and a touch of Payne's Gray: thick consistency

### Method stage: 5 Final adjustments and details, darker tones in petals

With the flower centre so much darker, again assess the darkest parts of the petals and their midtones. You may only need to make some subtle adjustments here, so use a watery to milky mix of Winsor Lemon with a hint of Payne's Gray and differing amounts of Transparent Orange to work into areas of the petals that need darkening – all the while using the size 000 brush and adding extra detail to the petals where you see it.

Winsor Lemon with a hint of Payne's Gray and Transparent Orange: watery to milky consistency (darker swatch)

Same mix with less Transparent Orange (lighter swatch)

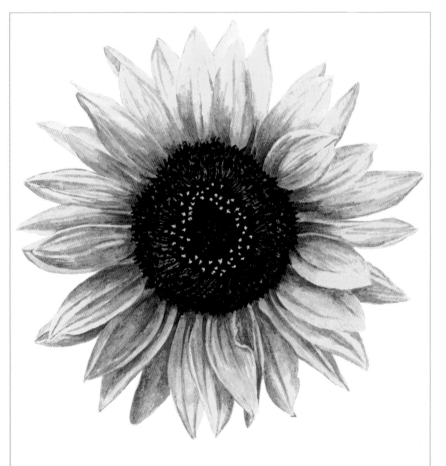

## Method stage: 5 Final adjustments and details, lighter midtones in petals

And finally, once you've darkened the darker tones and midtones within the petals, check the lighter tones within the petals and see if they need darkening to be brought into balance. Create a mix of thick, milky Winsor Lemon with a tiny hint of Transparent Orange. Apply with a size 1 brush over those petals that need darkening – always holding off from areas that don't. You can also apply this mix as a layer over any mid- and dark-tone areas where you feel the hue needs brightening and making more yellow. Add a touch more Transparent Orange to the mix where a more orange hue is required – especially towards the flower centre. Also use this stage to smooth away gently any unwanted hard-line edges that may have appeared.

   With these final adjustments made, the golden sunflower is both glowing and bright but also has a three-dimensional quality to the petals.

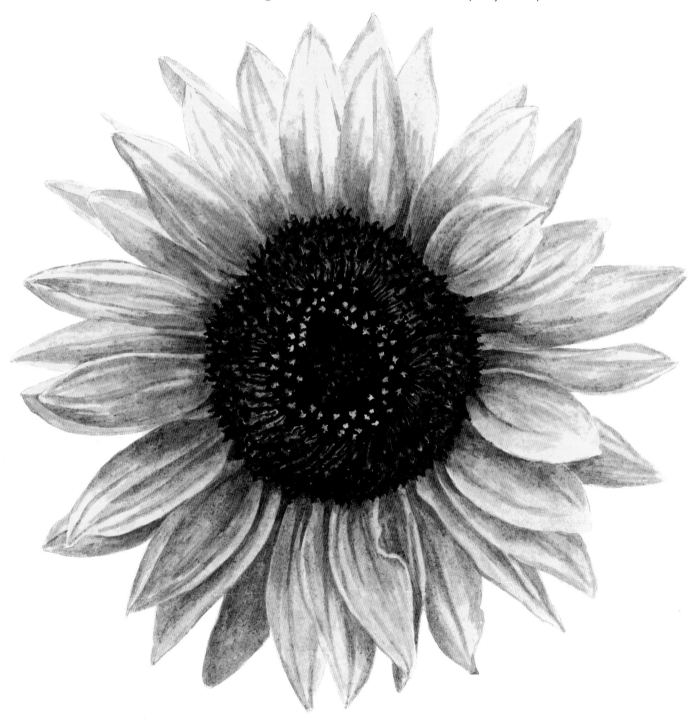

# GARDEN BIRD

This inquisitive little blue tit is all the more beguiling when painted larger than life, where its beautiful feathery detail can be captured in paint with more ease. You may wish to enlarge it even more, and if you do, you'll probably want to use a brush size bigger than I refer to here. Because it contains so many hues, this painting requires a more extensive Stage 1, where we paint in a light version of each different hue. Not only does this begin the layering process but it also helps map out exactly where each hue needs to go so that we can make sense of the drawing. Once this stage is complete, I think you'll find that the rest of the painting is relatively straightforward.

## Paints

- Payne's Gray
- Burnt Sienna
- Winsor Lemon
- French Ultramarine
- Winsor Blue (Green Shade)
- Permanent Carmine

(The colours listed are Winsor & Newton; for alternatives, see my website.)

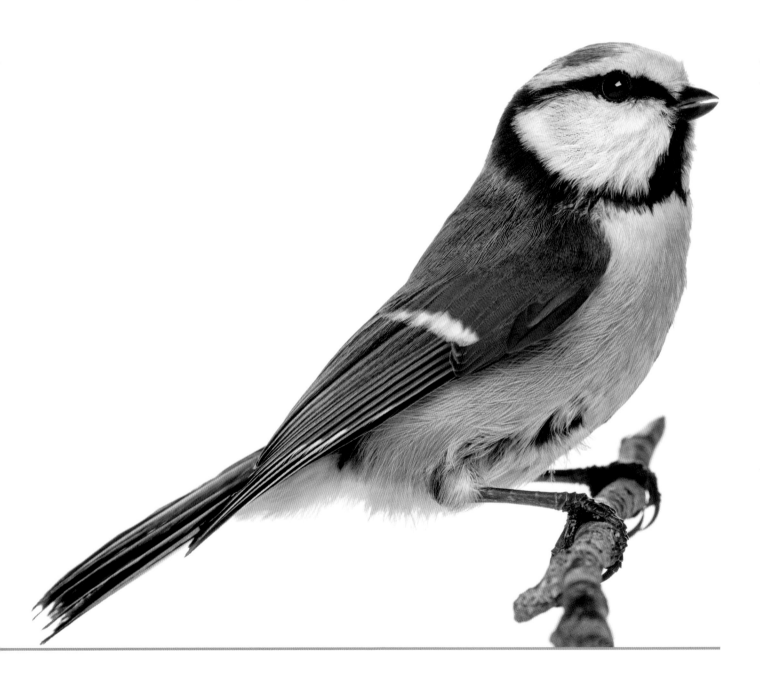

# Pencil drawing

I've marked out the boundaries to each of the main blocks of hue, wherever there is a fairly hard-line edge transition between them. I've also been quite heavy with the pencil in any areas that will be really dark, like the pupil in the eye and black areas on the wing. You can trace from the drawing provided on page 143.

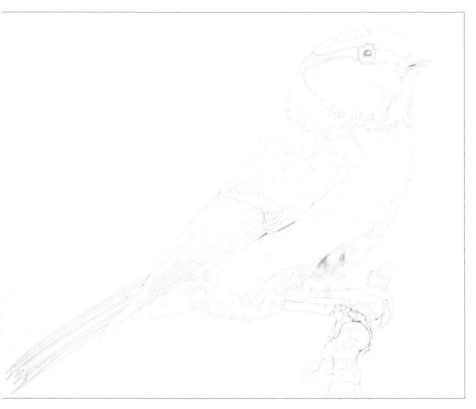

*Off-whites.*

*Pale greys.*

# Whole painting
## Method stage: 1
### Lightest tones, off-whites

The lightest tones in the whole painting are found in the reflection in the bird's eye. It's so light we need to leave it with no paint on at all and look to paint the next lightest tones instead, which are found in the off-white areas within the feathers. Use a size 3 brush and apply a super-watery mix of Payne's Gray with a touch of Burnt Sienna into the off-white areas – to make them just a shade darker than your paper.

You can extend this out into all of the pale grey areas, too, and be generous with this mix, applying it wherever you see the off-white or grey colours – including into the wing, tail and branch in a few places. If you go into areas you shouldn't it won't matter as you'll be able to paint other colours on top of this pale mix. Try to apply it in the direction of form – in this case, in the direction of the feathers within each area of the bird. You can begin to stipple a little and apply in little line strokes even at this early stage to start to create the feathery visual texture.

*Payne's Gray with a touch of Burnt Sienna: super-watery mix*

## Method stage: 1
### Lightest tones, grey hues

Once the paint has dried, use the same mix with a size 1 brush to apply as a second layer into the grey areas of the bird, making sure you hold off from applying into the lightest off-white parts. Use plenty of little lines with your brush, in the direction of form, and leave plenty of gaps through to the layer underneath to start to create the visual texture.

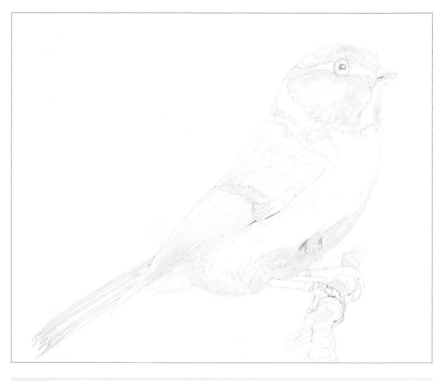

*Payne's Gray with a touch of Burnt Sienna: super-watery mix*

## Method stage: 1 Lightest tones, yellow hues

Next we'll paint the lightest tones within the yellow area. Create a very watery mix of Winsor Lemon and apply it with a size 3 brush into all the yellow areas, including where the yellow will need to be much darker. Also paint a couple of patches on the branch. You can allow this to overlap into the grey area of the body under the tail (having ensured the paper is dry), leaving a few gaps through to the grey where you can see it. Use short line brush strokes to begin to achieve the texture.

*Winsor Lemon: very watery consistency*

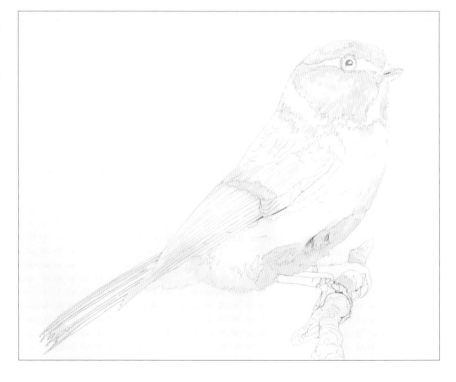

## Method stage: 1
## Lightest tones, blue hues

Now let's paint the lightest blues. Create a very watery mix of 50% French Ultramarine and 50% Winsor Blue (Green Shade) and apply using a size 1 or size 0 brush (whichever feels easier) into all the blue areas, including where the blues will need to be darker in tone than this mix. You can be quite liberal and apply this a little into the areas that will be darker grey and black too, to help to create the transitions there.

*50% French Ultramarine and 50% Winsor Blue (Green Shade): very watery consistency*

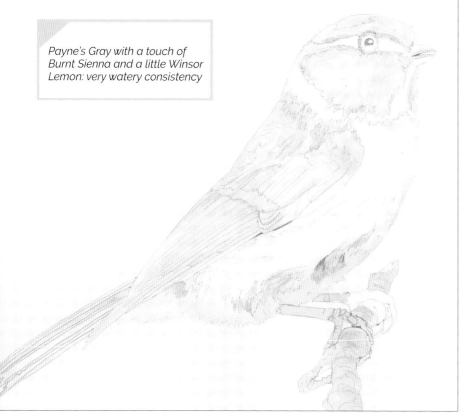

## Method stage: 1 Lightest tones, grey-green hues

Next let's paint the greys that have a more green tinge to them. Again you can be generous with this and apply along the transitions into areas that will be a darker grey or black. Create a very watery mix of Payne's Gray with a touch of Burnt Sienna and a little Winsor Lemon. Take a size 1 or size 0 brush and use the same brush techniques to apply into all the areas of this hue, including around the eye and into the front foot and also the branch.

*Payne's Gray with a touch of Burnt Sienna and a little Winsor Lemon: very watery consistency*

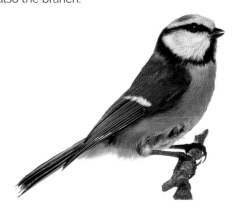

### Method stage: 1 Lightest tones, dark greys and blacks

Now let's paint in a light version of the black areas within the bird. Although most of these areas will end up being much darker, within them there are flecks of a lighter colour, which are what create the feathery texture, so we want to paint that now. Also, by applying the black areas in this lighter colour first we can guard against mistakes, as it won't matter so much if you apply the lighter colour into the wrong area – this really helps us with the process of mapping out what colours should go where. Create a milky consistency mix of about 60% Payne's Gray and 30% Burnt Sienna and a touch of Permanent Carmine.

Use a size 0 brush so you can create very fine lines and apply to the eye to begin with – all over it except for the highlight. Work around the eye too, taking care to leave a paler ring around the eye. Apply in short strokes at the correct angles in the black stripe on the bird's head, making sure to create a feathered transition of little line strokes into the paler areas of feather either side. Apply in bigger, smoother patches to the wing and tail, and into the feet and branch, being sure to hold off from applying into any areas that might be lighter in tone than this mix. Water the mix down a touch when working into the grey areas within the upper wing and into the legs. This stage will take a little while, but once it is done we can start to see our bird's potential!

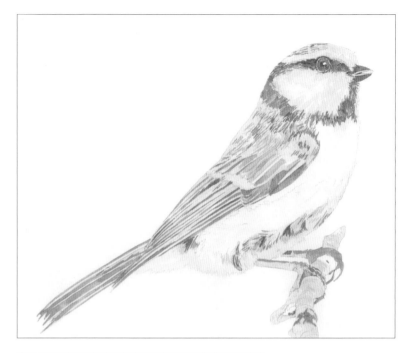

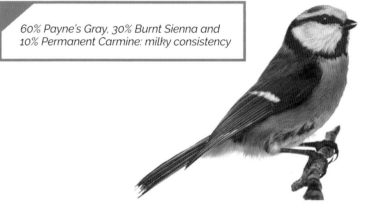

*60% Payne's Gray, 30% Burnt Sienna and 10% Permanent Carmine: milky consistency*

# Eye

Birds and animals immediately take on some character when we paint their eyes, which is why we'll now work through the darkest tones and midtones on the eye, to bring it to a complete stage, before coming back to work on the darkest tones in the rest of the painting.

### Method stage: 2 Darkest tones, blacks

Create a very thick, creamy mix of about 60% Payne's Gray, 30% Burnt Sienna and a touch of Permanent Carmine to achieve a rich, dark black. Use the tip of the size 000 brush to apply to darkest shapes in the eye, leaving a very narrow gap, if you can, around the pupil, creating an outline to the eye and creating the curved shape to the top of the reflection.

*60% Payne's Gray, 30% Burnt Sienna and 10% Permanent Carmine: very thick, creamy consistency*

## Method stage: 2
### Darkest tones, browns

*Thick Burnt Sienna plus the dark mix made in the previous step: very thick consistency*

Use some thick Burnt Sienna and add in a touch of the black mix you just made to make a very dark brown to fill in the iris and complete the top of the curved area of reflection, again with the size 000 brush.

## Method stage: 3 Midtones

*60% Payne's Gray, 30% Burnt Sienna and 10% Permanent Carmine: watery to milky consistency*

Water down the black mix to a watery to milky consistency a fraction lighter than the mix used when working on the first layer in the eye. With the thick black and brown paint now dry, apply this mix with the size 000 brush to the area of reflection, the fine line around the pupil and some of the lighter area around the edge of the eye, to darken those areas a little.

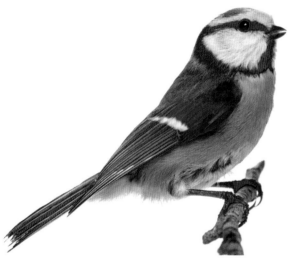

# Whole painting

## Method stage: 2 Darkest tones

Create a mix just a little less thick than the one used for the blacks of the eye and use a size 0 or size 000 brush to apply this into all the black areas that are this dark, holding off from any areas that are lighter. Apply in lots of short line strokes and pay attention to their direction to match the directions of the feathers as you observe them in the reference photograph.

*60% Payne's Gray, 30% Burnt Sienna and 10% Permanent Carmine: very thick, creamy consistency*

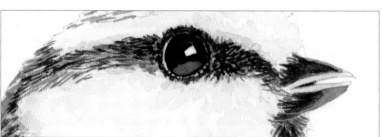

*Begin with the area around the eye to create the little lines and shapes you can see there. Apply in a bigger, smoother patch to the beak, leaving gaps for the tiny paler feather lines to be visible around the edge, and being careful not to go right to the edges of the beak where the tone is paler.*

*Apply in bigger patches to the darkest parts of the feet.*

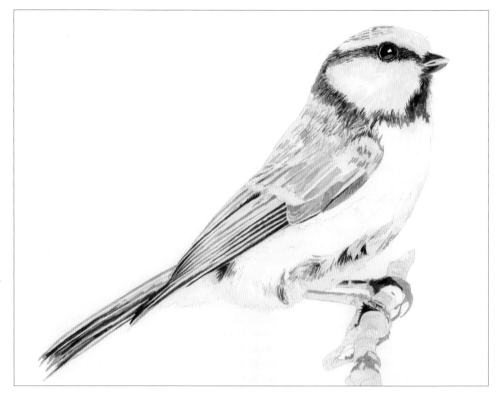

*Hold off applying fine lines into areas of the bird that will need to be made much darker and are a very different hue – the blue and yellow areas. The issue is that it'll be hard to darken up around these dark markings without risk of it bleeding into the surrounding colour, so we'll add this level of detail with this darker mix at a later stage (see page 112).*

# Hue area by area

We'll now work on each hue area at a time, applying the darkest tones and midtones within each one. Collectively these areas are the midtones within the painting if we consider it as a whole.

## Method stage: 2 Darkest tones, blues

Create a thick, milky mix of French Ultramarine and Payne's Gray. On the wing, use the size 000 brush to apply in little lines as before. Around the darker patch on the neck, apply in a wash technique, going over the now dry brush marks underneath to darken the gaps between them.

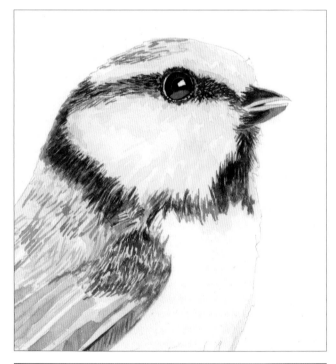

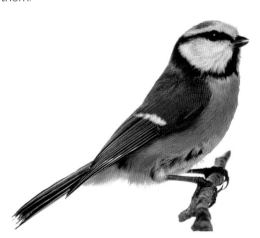

*French Ultramarine and Payne's Gray: thick, milky consistency*

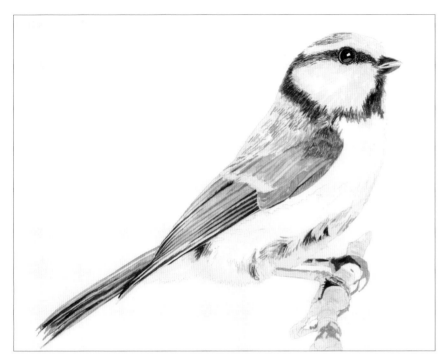

## Method stage: 3
### Midtones, blues

With the darker blues now painted it's easier to judge how dark to take the blue midtones. Create a mix of 50% French Ultramarine and 50% Winsor Blue (Green Shade) at a milky consistency this time. Making sure the paper is dry, apply as a glaze with the size 1 brush over the darker blue areas. Be gentle with your brush so as not to lift off or cause bleeding from the darker colours you're painting on top of.

Water the mix down some more when working on the lighter blues in the wing and tail, again being gentle with the brush so as not to disturb the darker colours next to, or underneath, this colour.

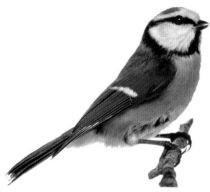

*50% French Ultramarine and 50% Winsor Blue (Green Shade): milky consistency (darker swatch)*

*Same mix with more water (lighter swatch)*

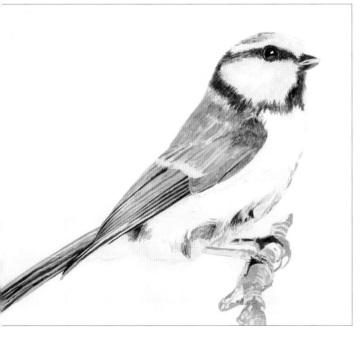

## Method stages: 2 and 3 Darkest tones and midtones, grey-greens

Next we'll darken the grey-greens within the bird and branch. Create a thicker, milky mix of Payne's Gray with a touch of Burnt Sienna and a little Winsor Lemon. Use a size 1 brush and apply in a stippled way into the neck area, leaving a few little line gaps through to the lighter colour underneath where you see a lighter area. Apply in short lines in the transition into the black areas on the bird and on the tummy where you see this colour. Apply in bigger patches to the branch, trying to create the curved shapes we see there, which will help give the branch form.

*Payne's Gray with a touch of Burnt Sienna and a little Winsor Lemon: thick, milky consistency*

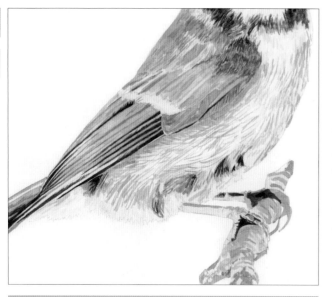

## Method stages: 2 and 3
### Darkest tones and midtones, yellows

We'll begin here with the darkest tones within the yellow area, which have a more grey hue to them. Create a watery to milky mix of Winsor Lemon with a touch of Burnt Sienna and Payne's Gray. Use a size 0 brush to apply lots of lines, paying attention to their direction and creating bigger patches under the wing.

Once that's dry, create a slightly thicker, milky mix of Winsor Lemon with a touch of Burnt Sienna. Apply this with a size 0 brush into all areas within the yellow part that need darkening. You can overlap the darkest tones you just applied and make sure you apply in little line strokes, leaving plenty of gaps through to the lighter yellow mix underneath wherever you see lighter feathers.

*Winsor Lemon with a touch of Burnt Sienna and Payne's Gray: watery to milky consistency*

*Winsor Lemon with a touch of Burnt Sienna: thick, milky consistency*

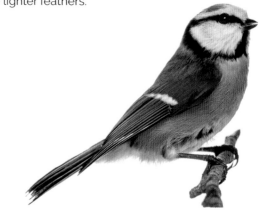

## Method stage: 3 Midtones, darker greys

Now we've effectively worked on the mid-midtones of the whole painting, it's easier to see how much darker to take the darker midtones: the dark greys. For these, create a mix the same as you used to paint the lightest tones in these areas – a milky mix of about 60% Payne's Gray and 30% Burnt Sienna with a touch of Permanent Carmine. Use the size 000 brush to apply to all dark grey areas that need darkening. Apply as a glaze over the black areas of the feathers to darken the lightest tones there where needed. The dark grey is also present throughout many parts of the blue, grey-green and the edges of the white areas of the bird as feathery lines, including as diagonal narrow lines on the feathers in the wing, so use the tip of the brush to create those markings (ensuring that the paint underneath is dry first). Apply in larger patches in the legs, feet and branch, leaving gaps where there are lighter tones, such as where there's a little white feather in front of the back leg.

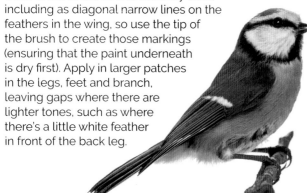

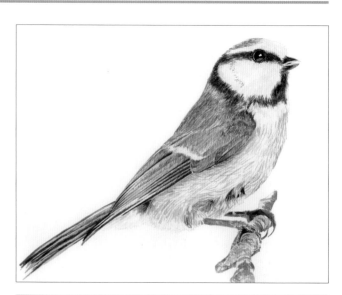

*60% Payne's Gray, 30% Burnt Sienna and 10% Permanent Carmine: milky consistency*

# Whole painting

At this stage, although our focus is on adjusting the tone, we still apply the paint in little lines, now with the size 000 brush so that we're creating the finest lines we can. In so doing we layer up the markings and create richer, more detailed visual texture. Create the same mixes again for each hue area and work into those parts that need darkening when you compare your painting to the reference photograph (you can also refer to the guide images where these areas are defined if you find it helpful), allowing plenty of gaps through to the lighter colours underneath where needed. Apply as a light glaze where bigger areas need darkening, including in the wing, where the glaze can sit on top of the detailed grey markings you've just added.

## Method stage: 4
### Adjustments, blues

French Ultramarine and Payne's Gray: thick, milky consistency

French Ultramarine and Winsor Blue (Green Shade): milky consistency

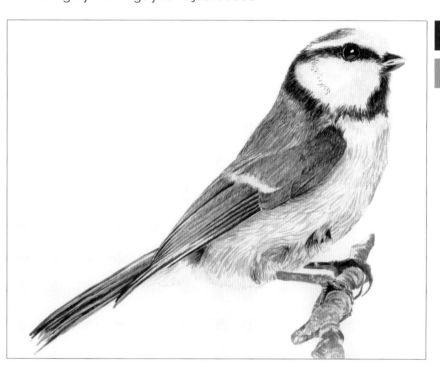

## Method stage: 4
### Adjustments, grey-green and yellows

Payne's Gray with a touch of Burnt Sienna and a little Winsor Lemon: thick, milky consistency

Winsor Lemon with a touch of Burnt Sienna and Payne's Gray: watery to milky consistency

Winsor Lemon with a touch of Burnt Sienna: thick, milky consistency

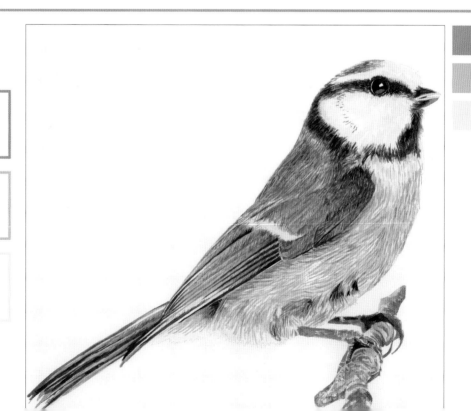

## Method stage: 4 Adjustments, light greys

When working into these light grey areas again, use the size 000 brush to add line details in places like the face. Then also take an overview of the whole bird, looking for bigger patches that could be darker – apply with a size 3 brush gently as a glaze onto the edge of the yellow breast and into the white area on the tummy to darken.

*Payne's Gray with a touch of Burnt Sienna: super-watery mix*

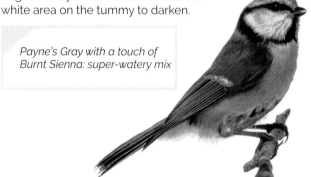

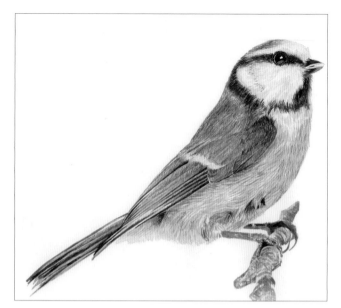

## Method stage: 4 Adjustments, darkest tones, blacks and greys

Now that we've darkened the lightest tones quite a bit, it's easier to see that the very darkest tones – the blacks and the dark greys – need to be darkened some more. Use the thick black mix of Payne's Gray, Burnt Sienna and Carmine from page 106 to apply another layer to the black areas, and then water this down to a milky consistency to work into the grey areas. Use the size 0 and size 000 brushes and the same techniques as before to build up the feathery texture where required, and working in bigger patches into the wing, tail, feet and branch.

Now we've darkened the other hues, it's time to add more of the darker feathery detail into those now dry areas too, adding detail as well as darkening in the process.

*60% Payne's Gray, 30% Burnt Sienna and 10% Permanent Carmine: very thick, creamy consistency*

*60% Payne's Gray, 30% Burnt Sienna and 10% Permanent Carmine: milky consistency*

*Darken in the yellow area with grey, adding more feathery line details, especially under the wing (above).*

*Darken and add detail to the feet, making sure to leave plenty of gaps to the lighter colours underneath and to add fine line detail so that the segments in the feet stand out (left).*

## Method stage: 5
## Final adjustments, darker midtones again

At this final stage, your painting may not need the same treatment as mine. If you painted your darker midtones darker before, you may not need to darken them again now. But in mine, having darkened the darkest tones again, I can see I need to darken the blues, grey-greens and yellows in many places in order to bring them back into tonal balance. If you need to do this too, use the same paint mixes as before, mainly at a milky consistency so that you're only making a subtle shift in tone. Use a size 1 brush and apply to any areas that you can see should be darker. You should be comparing to the reference photograph to look for areas of your painting that should be darker. Work very gently with your brush so as not to lift the dark lines you've just been applying. Also, use the grey-green mix to darken parts of the branch as well, if you need to.

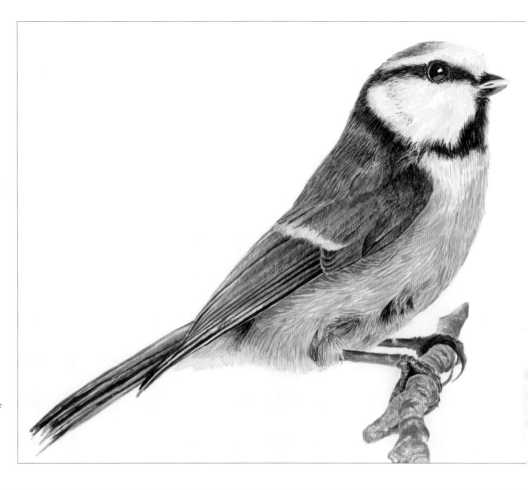

## Method stage: 5 Details

We're now making the finishing touches; all of these small markings can be made with the size 000 brush.

*Use Burnt Sienna and some Winsor Lemon with a touch of Payne's Gray at a watery consistency to apply to the edge of the beak. Add some of the light grey mix of Payne's Gray, Burnt Sienna and a touch of Permanent Carmine to the tip and underside, wherever needs darkening.*

*Burnt Sienna and some Winsor Lemon with a touch of Payne's Gray: watery consistency*

*60% Payne's Gray, 30% Burnt Sienna and 10% Permanent Carmine: watery to milky consistency*

*Use the same mix to add more fine-line detail to the face, matching the direction of the lines you see in the reference photograph.*

# Method stage: 5 Details continued

*Water down the light grey mix some more and apply as a glaze again to the edge of the breast and tummy to darken subtly there. This really helps give a curved form to the body.*

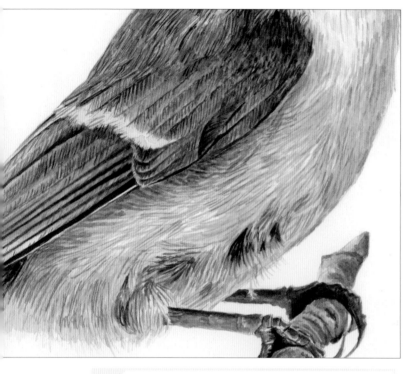

*Work with the same light grey mix to apply bigger patches under the white stripe on the wing to create shadow, throwing the white part of the wing forward. Let this dry and use a thicker mix to darken the lines on the edges of the white area, going into it to create more texture.*

*Add more fine lines to the wing with the light grey mix.*

*Payne's Gray with a touch of Burnt Sienna: super-watery consistency*

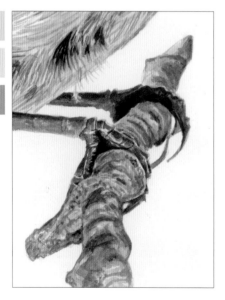

*Use some watery Burnt Sienna and Winsor Lemon to pick out a few more orange areas within the branch.*

*Then use some watery Payne's Gray and Winsor Lemon to add a few more green coloured areas.*

*Let that dry and then use the dark grey mix of Payne's Gray, Burnt Sienna and a touch of Permanent Carmine to add extra darker details to the branch where needed.*

*Winsor Lemon with a touch of Burnt Sienna: milky consistency*

*Burnt Sienna and Winsor Lemon: watery consistency*

*Winsor Lemon and Payne's Gray: watery consistency*

*Payne's Gray, Burnt Sienna and a touch of Permanent Carmine: milky consistency*

*Use a milky mix of Winsor Lemon and Burnt Sienna to darken the yellow area under the wing a little. Apply as a glaze, which is easiest to do with a size 1 or a size 3 brush.*

## Stepping back

Finally it's time to take a step back and assess your painting as a whole. Take a break to get a fresh perspective and then compare your painting to the reference photograph, looking for anywhere in your painting that needs to be darker. In my painting I could see that, after all the darkening that had happened by adding the extra details, the yellow area of my bird needed to be darkened a little to be brought back into tonal balance. The hue needed correcting a touch too to make the yellow a bit more green. So I applied a glaze of milky Winsor Lemon with a hint of Winsor Blue (Green Shade), very gently with a size 3 brush.

And with the final adjustments made, the bird looks like it's about to launch into flight, or a song!

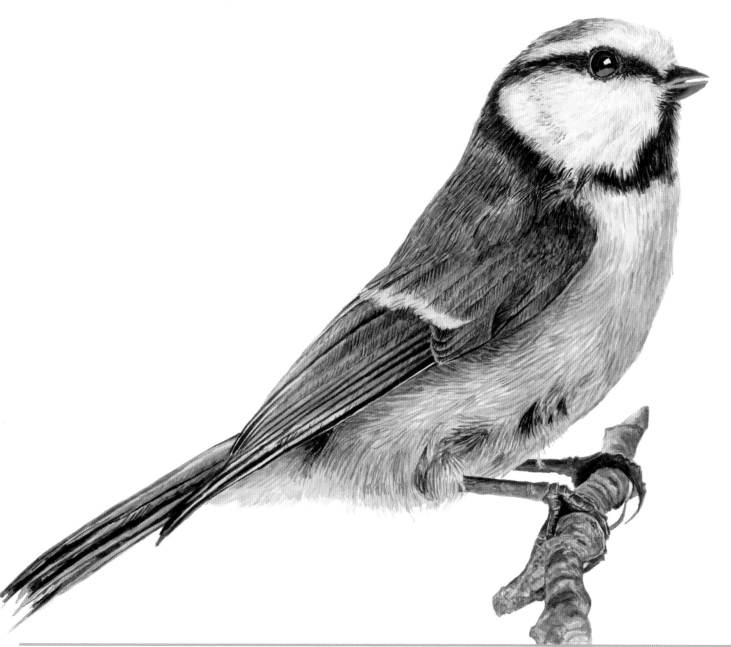

Keys to
Improving

# Practice right

Learning a new skill like painting, especially as an adult, can be a real challenge. As young children we all have a total belief in our ability to learn new skills. We'll readily try things out and we won't beat ourselves up if we don't immediately succeed. Most of the time we're not even aware we're learning, rather we're playing. That's certainly how I learned to paint as a child. But fast forward into adulthood and we often find ourselves failing to start things we say we want to, or giving up before we've got as good as we'd like. This is usually due to our attitude; either our fear of failure or a frustration with our progress.

This is especially true of painting. Often the ability to paint is put down to a thing we call 'talent'. And 'talent' (or the lack of it) is a really defeatist concept because it's assumed you either have it or you don't. However, recent research into brain development is showing that the brain is capable of changing and developing, throughout life, much more so than previously thought. Learning new skills is always possible, and I know from my experience of teaching thousands of adults that this goes for painting too. In her book *Mindset* (Ballantine Books, Penguin Random House 2017), Stanford University psychologist Carol Dweck writes about how this new knowledge of the brain can help people develop what she terms a 'growth mindset', which is the belief that the ability to learn is not fixed, but rather it can change with practice. But how much practice? Have you ever heard that it takes 10,000 hours to get good at something? That's guaranteed to make you feel like you don't have the time to get good at anything! But as Josh Kaufman explains in his book *The First 20 Hours: How to Learn Anything… Fast* (Portfolio, Penguin Random House 2013), the '10,000 hours' thing, which first came from research done by Anders Ericsson, was actually the amount of time it seemed to take to get to the absolute *top* of an ultra-competitive field. It's since been used out of context so that it's often now used to describe how long it takes to simply learn something. A very different proposition. But Kaufman goes so far as to propose that with just 20 hours of practice, you can become *good* at a new skill.

His research is hugely inspiring because scheduling in 20 hours of structured practice time is something totally achievable, taking at worst only a few months if the practice is regular. Although, there are a couple of caveats to the shape this painting practice needs to take:

1 You need to be able to deconstruct the skill, so you can practice the most important parts of the skill first.

2 You need the right tools.

3 You need to be in a position to self-correct as you practice, which usually comes from some kind of instruction, at least initially.

The practice has to be structured so you don't keep repeating the same mistakes. To get through the frustrating and uncomfortable early hours, you need to see the mistakes you do make as a *totally* normal part of learning and improving. And with that attitude, as your hours build, you will get through that early stage and start to get good!

It's because making mistakes is a necessary part of the process that I strongly recommend you keep a sketchbook when you're learning to paint. Painting in a sketchbook takes away a level of pressure to be creating a painting worthy of being shown to people. It allows you to complete quick exercises and it can become a space where you can experiment and play.

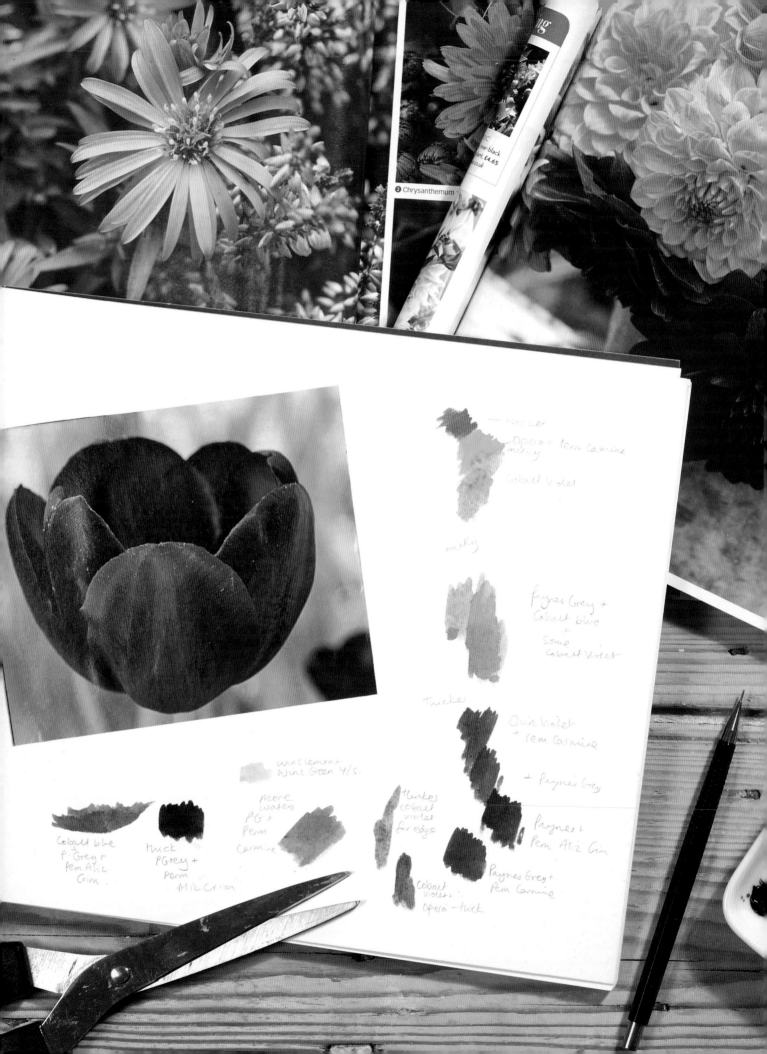

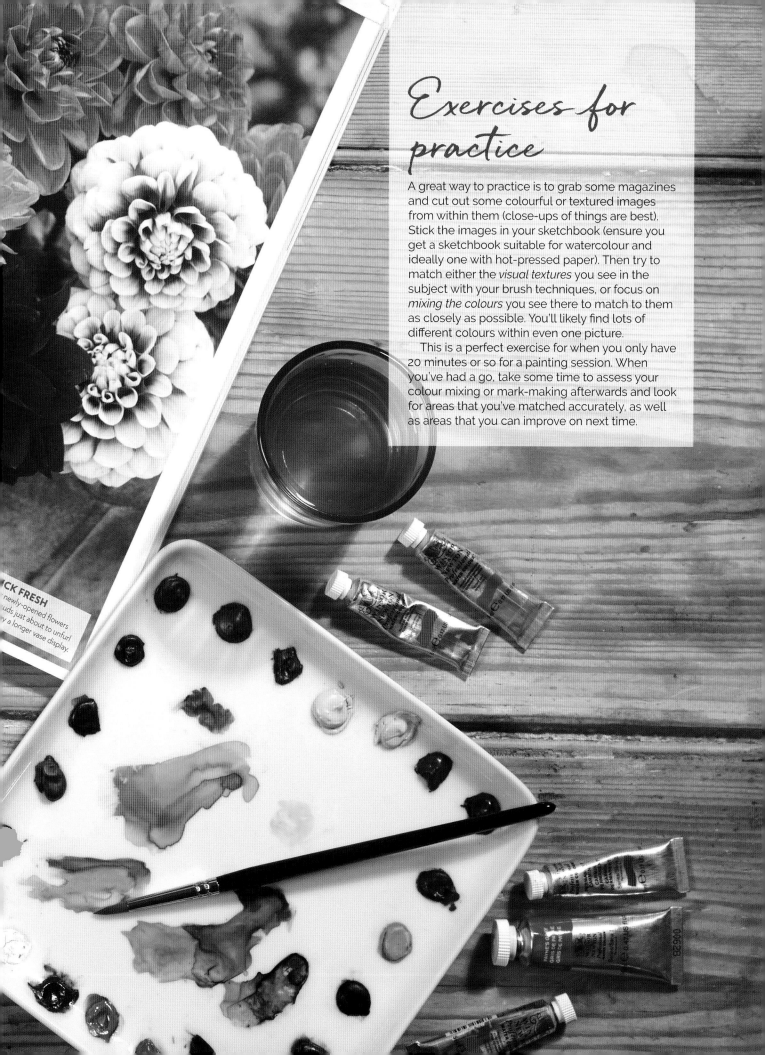

# Exercises for practice

A great way to practice is to grab some magazines and cut out some colourful or textured images from within them (close-ups of things are best). Stick the images in your sketchbook (ensure you get a sketchbook suitable for watercolour and ideally one with hot-pressed paper). Then try to match either the *visual textures* you see in the subject with your brush techniques, or focus on *mixing the colours* you see there to match to them as closely as possible. You'll likely find lots of different colours within even one picture.

 This is a perfect exercise for when you only have 20 minutes or so for a painting session. When you've had a go, take some time to assess your colour mixing or mark-making afterwards and look for areas that you've matched accurately, as well as areas that you can improve on next time.

CK FRESH
newly-opened flowers
uds just about to unfurl
y a longer vase display.

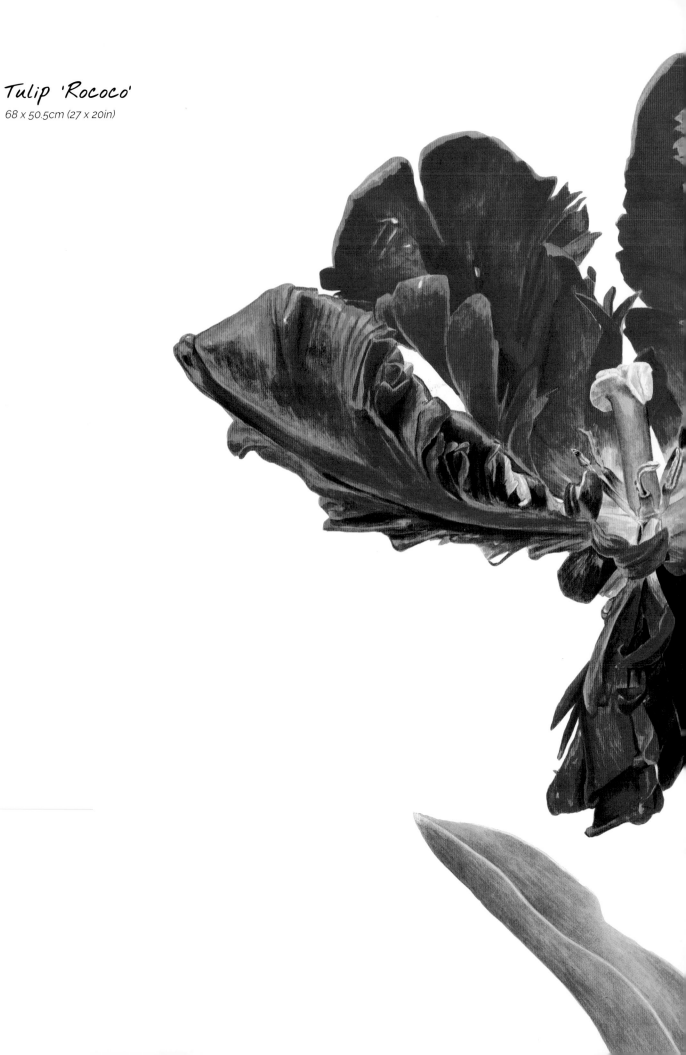

Tulip 'Rococo'
68 x 50.5cm (27 x 20in)

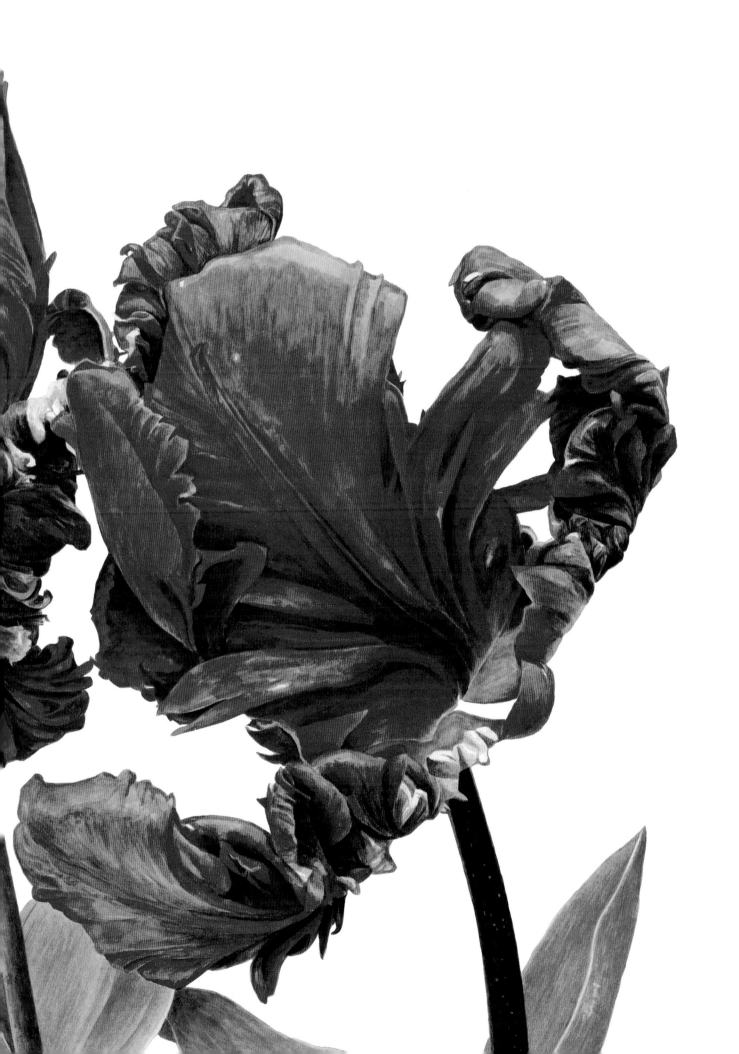

# Making practice happen

Even with the best of intentions it can be hard to make regular practice happen. Here are some ways to give yourself the best chance of making good progress:

## Keep it convenient

Though learning as an adult can be tricky, the good news is that choosing this style of watercolours over and above other paint media allows you to overcome one of the major barriers to learning: inconvenience. Your paints are going to take up minimal space, don't smell, and, working with the small quantities I use, are mess-free too. Cleaning up after a session is as easy as rinsing a brush under the tap or wiping the palette with a kitchen towel.

This was a really important factor in my painting success. When it comes to tidying up, I can be super lazy and get swamped in mess before I know it, which saps my creativity. So I would never have stuck with a messier medium. Also, because you'll only take up one desk's worth of space – or one place at the kitchen table – it makes it more likely you'll be able to find a room or a 'nook' where you can leave your paints out. This is a really helpful thing to do if you can, because it removes another barrier to painting – having to set up each time.

If you can leave your space set up, the other benefit of watercolours is that you can let them dry out. All you need to do is add some more water to them in order to use them again. So this means you can afford to paint in really short sessions, then just walk away, without feeling like you might end up wasting paint. When I was getting started I used to fit in 20-minute painting sessions before work in the mornings. It's amazing how much progress you can make when you do this really regularly.

## Schedule your sessions

This is probably the number one rule for improving. Get your painting sessions in your schedule or diary in the same way you would book in an appointment with a friend, hairdresser or a medical professional! What you're actually doing is prioritising yourself here. Having painting sessions is the only way you're actually going to improve in the way you want to, so scheduling them in tells yourself that this is actually a priority. Schedule shorter 20-minute painting exercise sessions, as well as longer 'project' sessions.

## Don't wait for inspiration to show up!

You'll want to have a plan for what to do in your painting sessions. Crucially, you do not want to wait to be inspired. That's a sure-fire way of scuppering your sessions. Instead, start to take photographs of subjects that inspire you when you see them. That way you'll build up a library of images that you can use to paint from. And if taking your own photographs is too challenging, create your library of inspiring photographs by making use of photo-sharing websites online (be careful about copyright, but there are several websites where people share their photographs freely online specifically for you to paint).

Don't spend ages agonising over your choice of subject. By getting on and painting anything, you open yourself up to be inspired and the ideas begin to flow. As one of my online school members, Wendy King, put it, painting like this 'teaches you to see, and when you see, you start to find things you want to paint wherever you look!'

*You only need one desk's worth of space to paint in this style, and if you get yourself a good-quality lamp with a daylight colour bulb, you can paint well into the evenings and whenever the light outside is poor.*

# Trust the method

Starting a new painting can be really daunting. I've got lots of experience painting in this way, but with a complex painting like this iris I'll still find myself experiencing thoughts like: 'How am I going to do this?' And, 'What if this one's too hard?' But my experience has taught me to 'trust the method'. Instead of thinking of the end result – the finished painting – and getting overwhelmed at everything there is still to do, it's best to break it down to focus only on the next step you need to take. That's why using a structured approach, like the one I detail in this book, can be a key to improving.

I now never get unnerved when I see my painting at its messy halfway stage, where the contrast levels are all out. This is often called the 'ugly duckling' stage of a painting (before it turns into a beautiful swan). I'm unphased by this because I've painted so many times that I know the messy look is just a natural part of the process. I trust the method. But I know this stage of a painting can pose real problems for those learning – it's where their inner critic really gets vocal and tells them their painting is looking bad and even that they should abandon it!

Practice is, again, key to moving past this. Each time you use the method and it works, with your painting 'coming together', your trust in it builds a little more and you'll be able to keep that inner critic at bay!

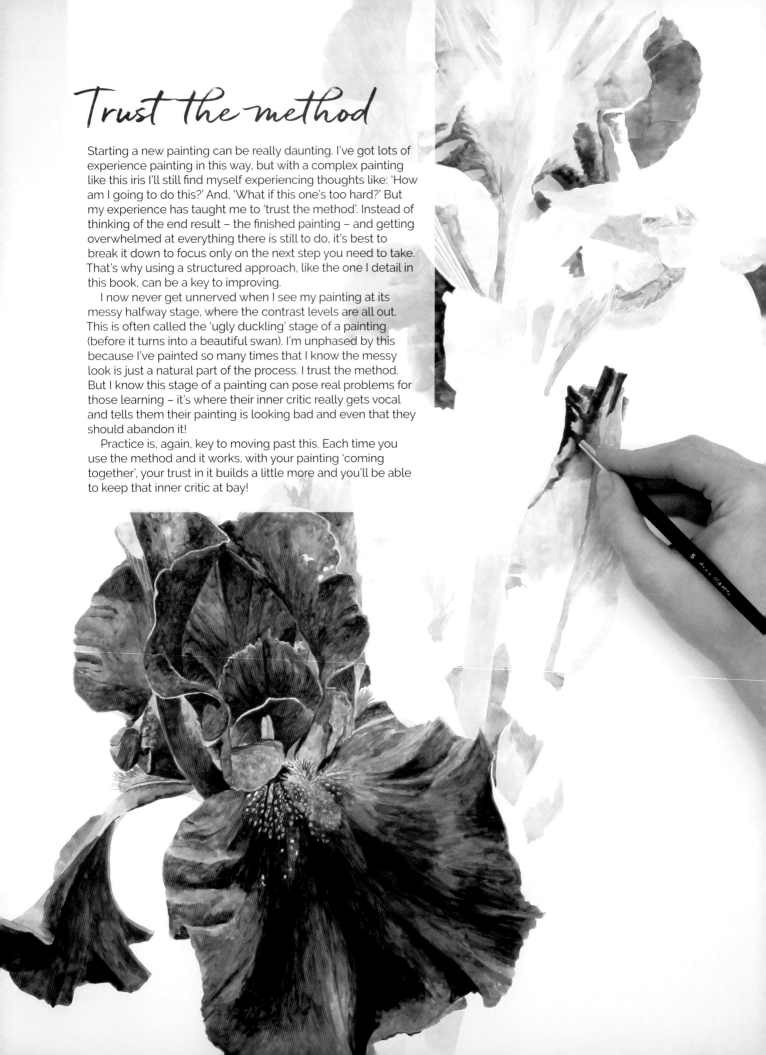

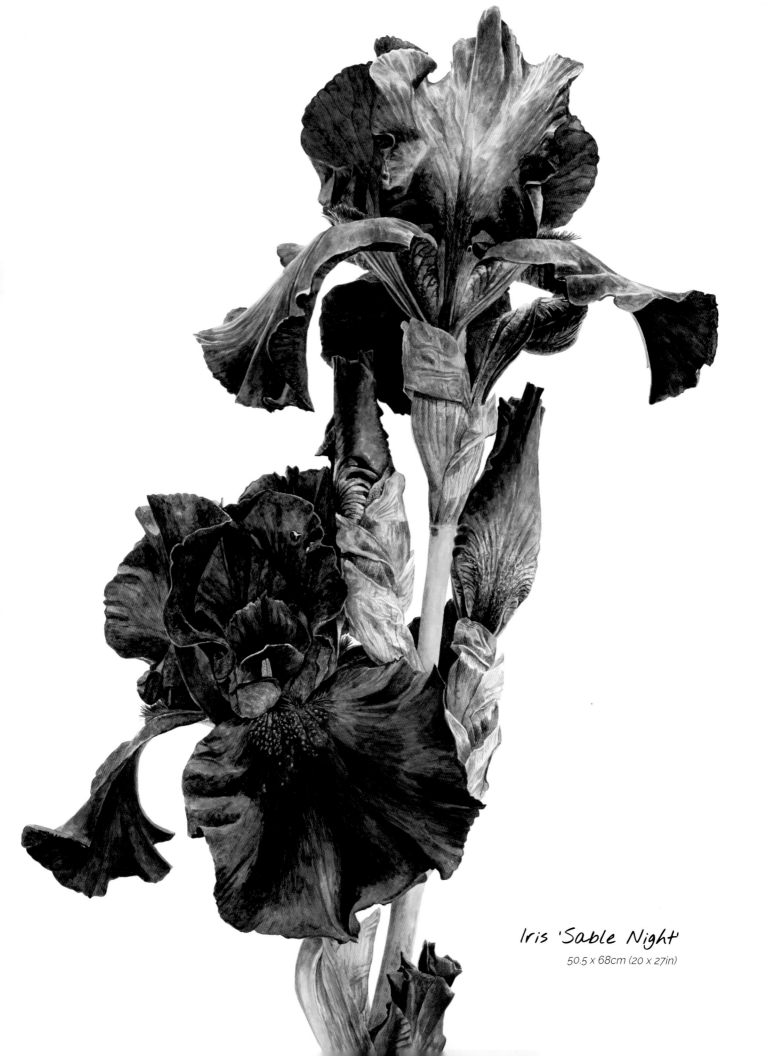

Iris 'Sable Night'
*50.5 x 68cm (20 x 27in)*

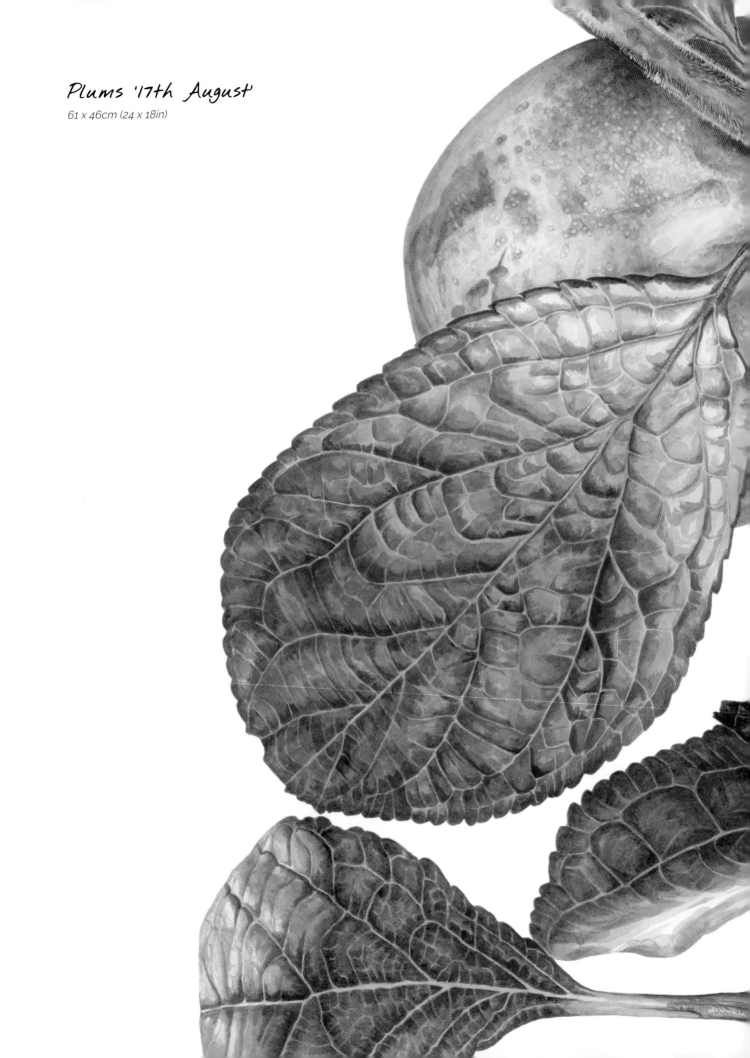

Plums '17th August'
61 x 46cm (24 x 18in)

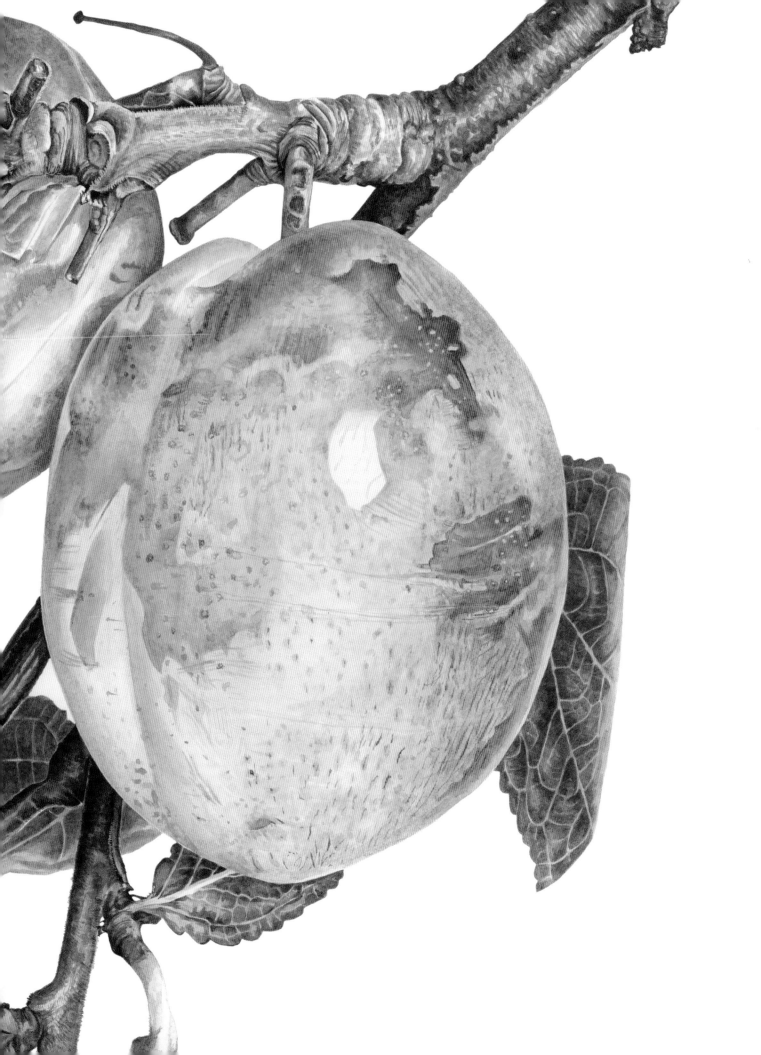

# Taking a strategic break

Taking a strategic break from your painting can be *the* thing to allow you to identify what it is you need to do to improve it. This is especially true towards the middle and later stages of a painting. Only by seeing the painting as a whole, can we work out what areas we need to work on to improve the overall piece. As we saw on page 41, seeing the painting as a whole is especially important for painting form correctly.

I've found the need for a break to be especially important when I've been helping students in workshops. For many students, fixating on detail after working without a break for too long isn't a happy experience. It's often accompanied by their inner critic being in full flow – telling them that the particular detail they're working on isn't quite right somehow.

## Time for a tea break

Obviously, as a Brit, 'tea' is the main thing that springs to mind when I think 'break' (or in numerous other situations actually!). But going and making a cup of tea and then drinking it, away from the painting, takes around fifteen minutes and allows your mind, eyes and body to refresh while you're taking some time out to recharge and reflect.

## It works

When students return after their break, they are almost always a lot more impressed with the painting they return to and view from a few paces away. All of a sudden they can see it as a whole and can see what they've actually achieved in the last few hours. It feels as if they have a new pair of eyes ('fresh eyes' as I often put it) and they can see clearly what *is* working with their painting, which gives them a confidence boost. They're also able to compare their painting to their reference photograph and see immediately what areas they need to work on further.

So, when you find yourself under the influence of the inner critic and obsessing about a part of your painting, make sure you take a strategic break.

*Make a cup of tea, get fresh eyes, and come back to finish your painting off with pleasure!*

130

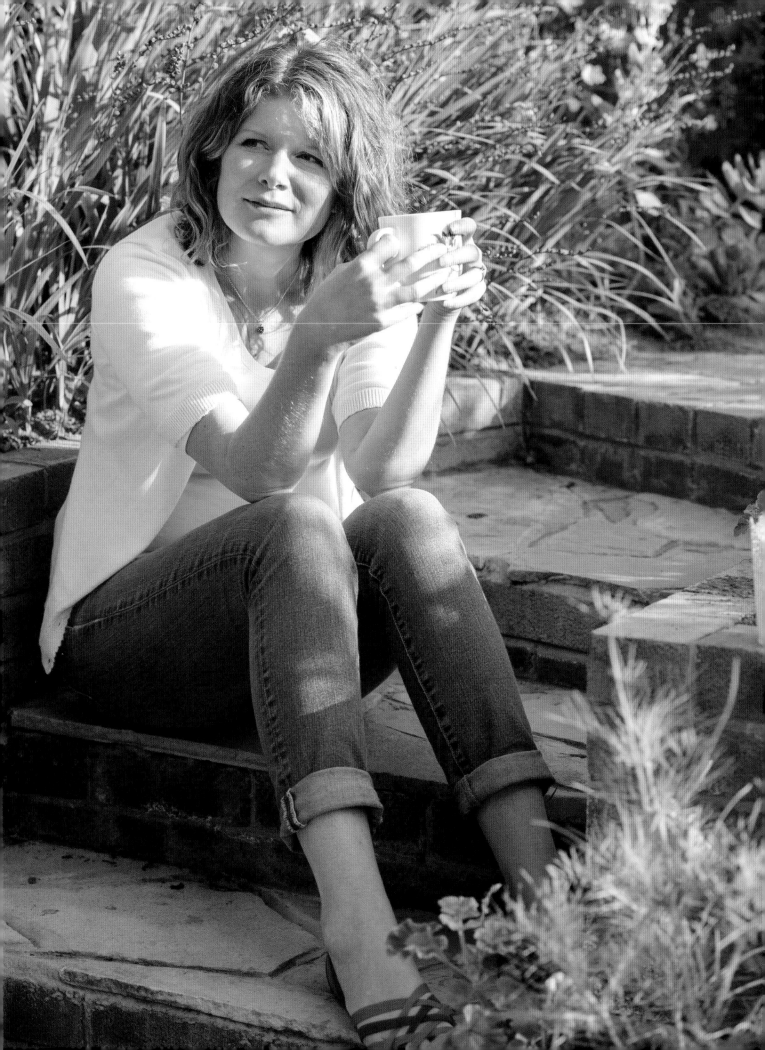

Quince
*61 x 46cm (24 x 18in)*

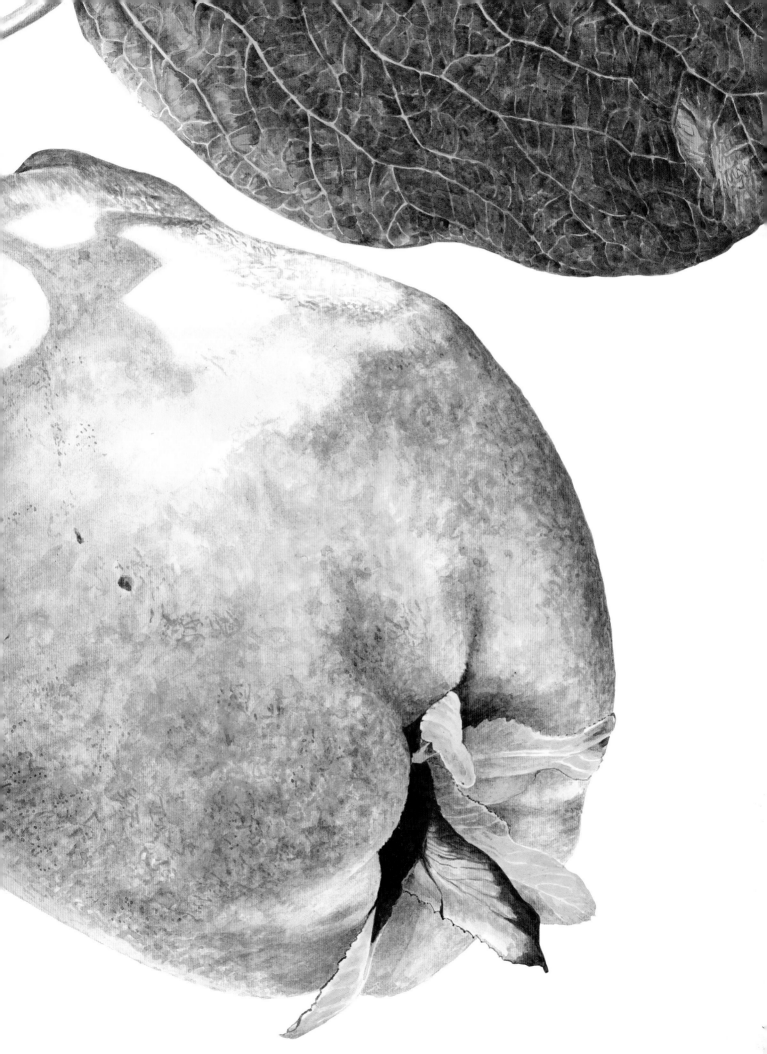

# Sharing

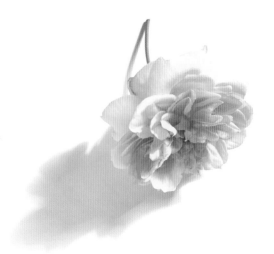

Once you're actually producing work, whatever you think of the quality, sharing it with others (the right people anyway) can be another key to improving quickly. This is for a couple of reasons:

## Encouragement

Painting can be a solitary pursuit, and that's one of the lovely things about it, but there's nothing so encouraging as receiving a positive comment or response from someone about a painting you've done or are working on. It can be the thing to boost your confidence, to spur you on to your next painting, or the thing to give you the strength to pull a painting out of the rubbish bin and finish it off! Having a supportive friend or partner will make a world of a difference to your efforts to improve your skills. And it can be even more rewarding to receive feedback from someone else who is also learning – I would recommend seeking out fellow learners in your local area or online.

## My first exhibition

*It was a humble beginning but I'm really glad I got past my own nerves and decided to share my first few paintings back in 2007. The encouragement I received at my first few exhibitions really gave me a boost to continue on to pursue painting as a career!*

## Corrective feedback

If you choose the right people to share your work with, you can also benefit from receiving some 'corrective feedback' in the form of supportive tips and pointers for where to improve your current and future paintings. This can then inform your practice sessions and really bring your work on in leaps and bounds. Where do you find people who can help you? Check out your area for informal art clubs where people get together without an instructor just to paint, draw and share artwork together. Online there are websites that are 'safe', troll-free spaces for sharing your work and receiving encouragement – my online school is one of them.

So with the benefits so clear, why is sharing your work *so* scary? It's a sign that painting is really important to you, which is actually a good thing. And the fear you feel is also a sign that you're making yourself vulnerable to criticism, which is also actually a good thing!

To help get the courage to share your paintings, try stepping outside of yourself for a minute and think of what sharing your work can mean to others. Your painting won't be perfect, but by sharing its imperfection you help others who see it to realise that it's fine for their paintings to be imperfect too. You'll encourage them and spur them on to paint more and share more too. So I hope you'll be courageous and share the paintings you do from the projects in this book. Share them with your friends, family and in 'safe' spaces online. You can even use #AnnaMasonArt to tag them in social media and get inspiration from others who've used the tag.

Your paintings *are* good enough to share, and I'd love to see them!

*"Vulnerability is the birthplace of love, belonging, joy, courage, empathy, and creativity. It is the source of hope, empathy, accountability, and authenticity."*

Brené Brown
*Daring Greatly: How the Courage to Be Vulnerable Transforms the Way We Live, Love, Parent, and Lead*
(Avery Publishing, Penguin Random House, 2015)

## Barbara's Hummingbird

"I always think my paintings are not good enough. I didn't realise that sharing them and gaining feedback would give me the confidence and motivation to keep painting. Had I not shared my paintings I might have given up."

**Barbara Kulas, Georgia, USA**

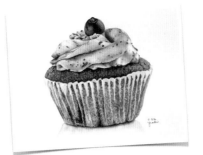

## Jean's Cupcake

"Since I was a beginner, I was afraid that my work would be embarrassing to share with anyone! But you won't believe the amount of support you'll receive. The community within Anna's School was in the same boat as I was, they were MY people. It made me braver. Braver to post more, paint more, try harder subjects... until I realised one day that I was at a level even I couldn't believe I was at! It was exhilarating! It still is!"

**Jean Martin, New York, USA**

## Patricia's Peapod

"Although I found sharing my work intimidating at first, I received wonderful uplifting feedback that encouraged me to continue to push my work to the next level. I've also learned that the great thing about sharing is that you can inspire others in turn. The experience is amazing!"

**Patricia Roncone, Ontario, Canada**

## Lorraine's Plums

"Self doubt is a big hurdle to get over for someone new to painting, or even ones not so new! By offering paintings up for critique to fellow School members and friends you receive recognition for your efforts and encouragement – these are great confidence boosters. Self doubt starts to recede... Happy painting!"

**Lorraine Damm, Mannum, Australia**

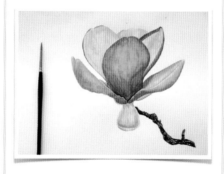

## Cynthia's Magnolia

"Sharing my paintings is a very real source of encouragement for me. It's easy to get hung up on a detail in your painting and it's hard to 'step back' and look at the whole painting. The process of snapping a picture really helps me with stepping back towards the end of Anna's tutorials, which stops my brain and eyes from focusing on what I think is terrible. I am my worst critic, so sharing what I think is not good provides me so much positive reinforcement and encouragement to keep painting."

**Cynthia Lane, Arizona, USA**

## Margaret's Bee

"I am a firm believer in the saying 'we learn from our mistakes'. If no one tells you that you are making a mistake you will continue to make the same mistake over and over again. Receiving feedback from other students has helped enormously to boost my confidence when it has been slipping and introduced me to friends all over the world. Creativity is contagious in a good way. It heals the soul, calms the mind and brings joy to those around you."

**Margaret Orchard, Norfolk, UK**

*All paintings on this page were completed using video tutorials available in Anna's online school.*

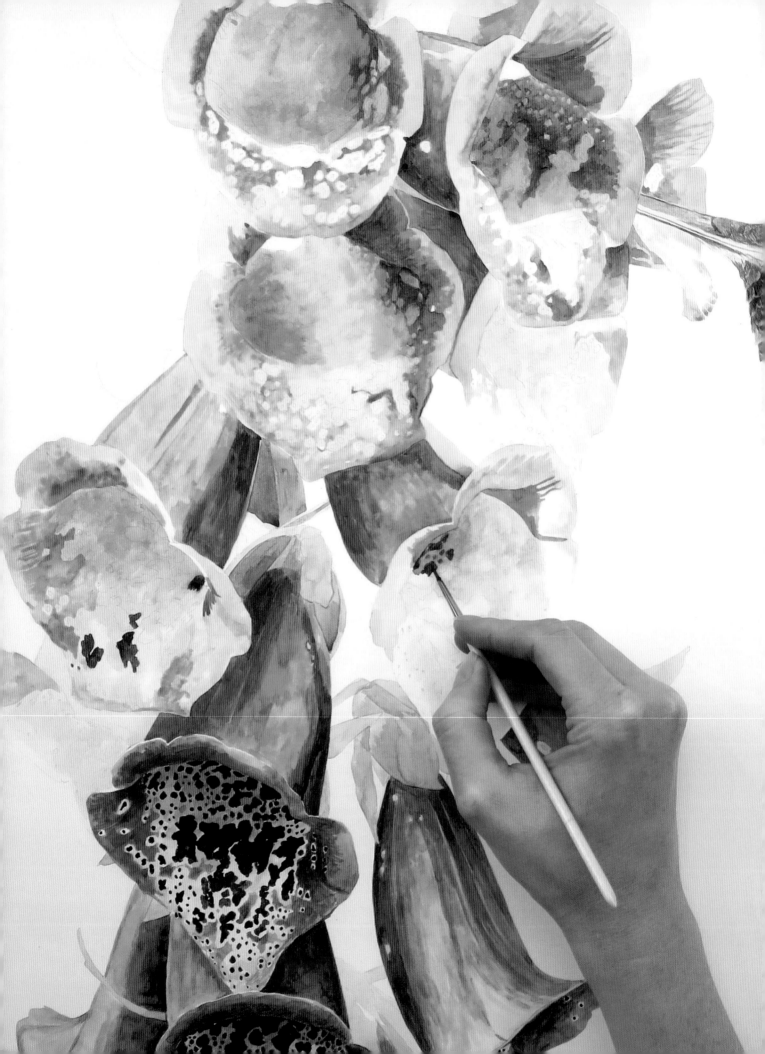

# Where you're heading: flow

With your practice then, you're aiming to repeat the method enough that it begins to embed in your muscle memory or mental circuitry – becoming in the process an automated activity. In this state your inner critic can be quietened and you can experience 'flow'. Flow was popularised by psychologist Mihaly Csikszentmihalyi in his book *Flow: The Psychology of Happiness* (HarperPerennial, HarperCollins, 2002) as:

*"a state of joy, creativity and total involvement, in which problems seem to disappear and there is an exhilarating feeling of transcendence."*

When you're in flow with your painting, you can think of yourself as operating out of the 'right' rather than 'left' part of your brain. While in reality we use both halves of our brain all the time, the right brain is what we associate with creativity and visual perception, whereas the left brain tends to be the area that deals with language and is certainly where our inner critic resides, which is why it's not where we want to be operating from when painting. I often find it helps to get into right-brain flow to have music or an audio book playing while I paint to help 'distract' the left part of my brain.

When you're able to get into flow when you paint, you really get to experience its magic. It can relax you, distract you, and rejuvenate you and can be like a trusted friend during life's hard times as well as the good.

Know that with the right practice, this flow state will be available to you too.

*Enjoy! xox*

*The enjoyment of being in flow and taking the time to create a painting you can be proud of is something I hope you come to experience and love!*

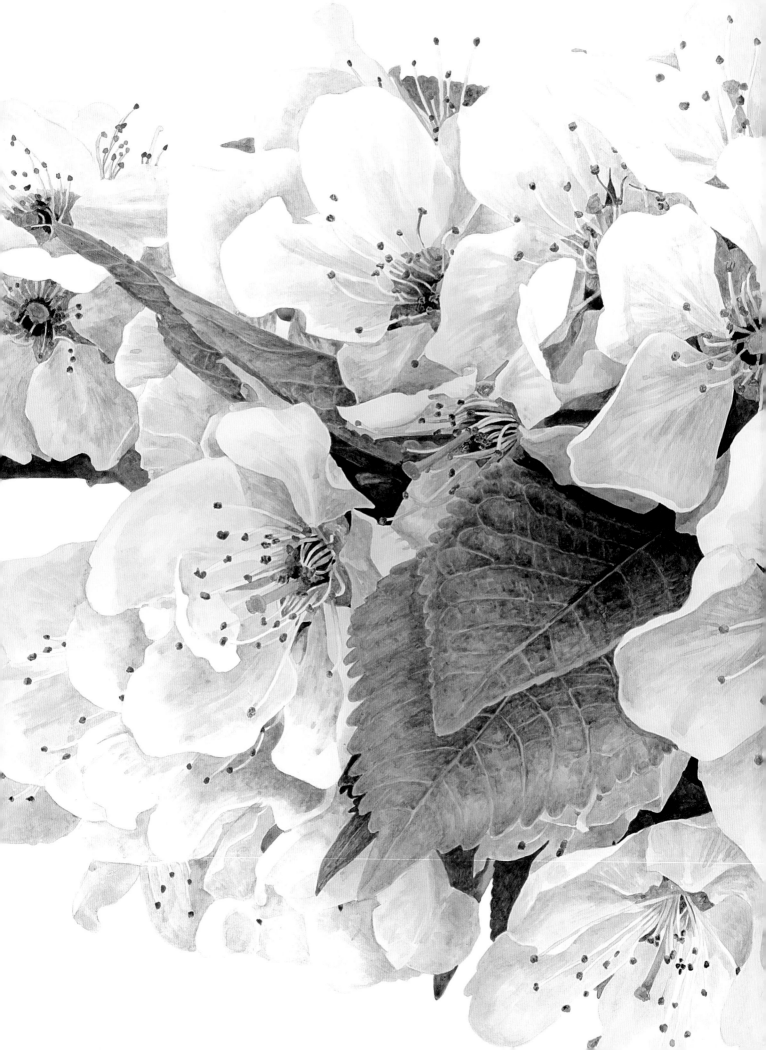

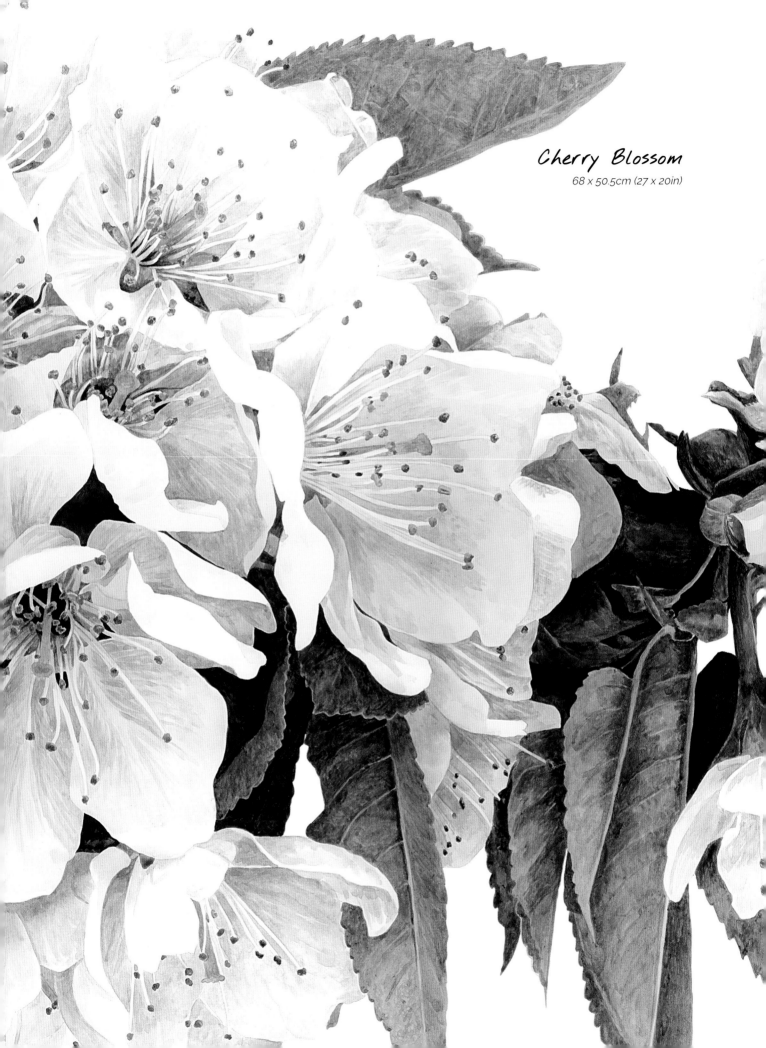

Cherry Blossom
68 x 50.5cm (27 x 20in)

# Outline drawings

The outline drawings on the following pages are provided for you to transfer onto your paper. If you enjoy working at a larger size, why not scale them up?

## Blackberry
*see pages 72–83*

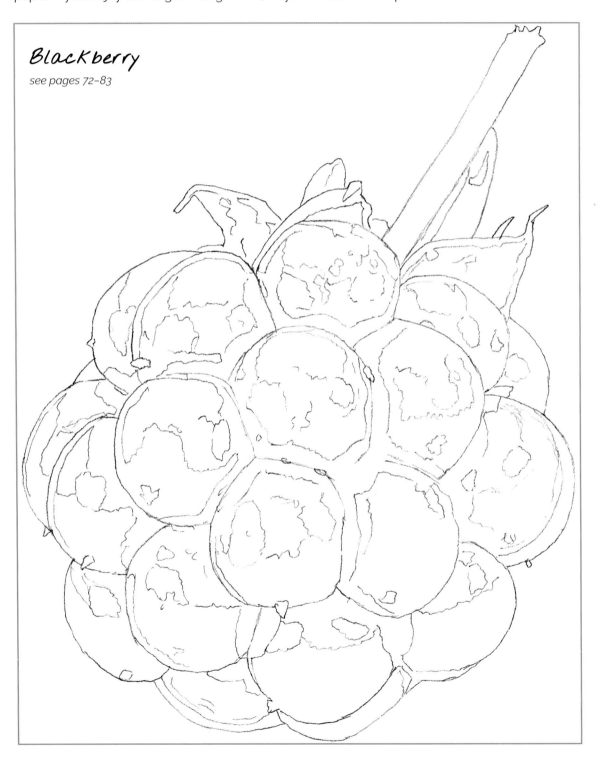

# Autumn leaf

*see pages 84–91*

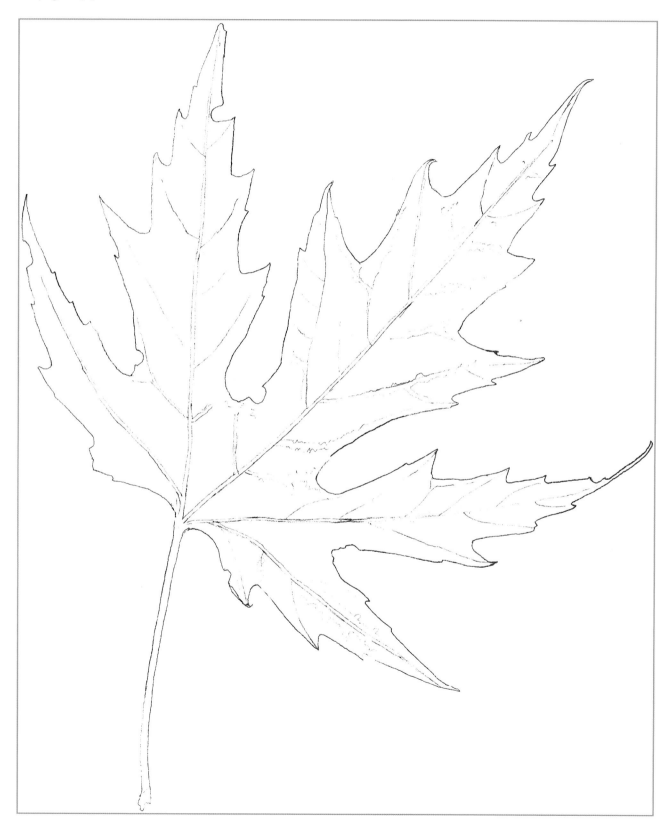

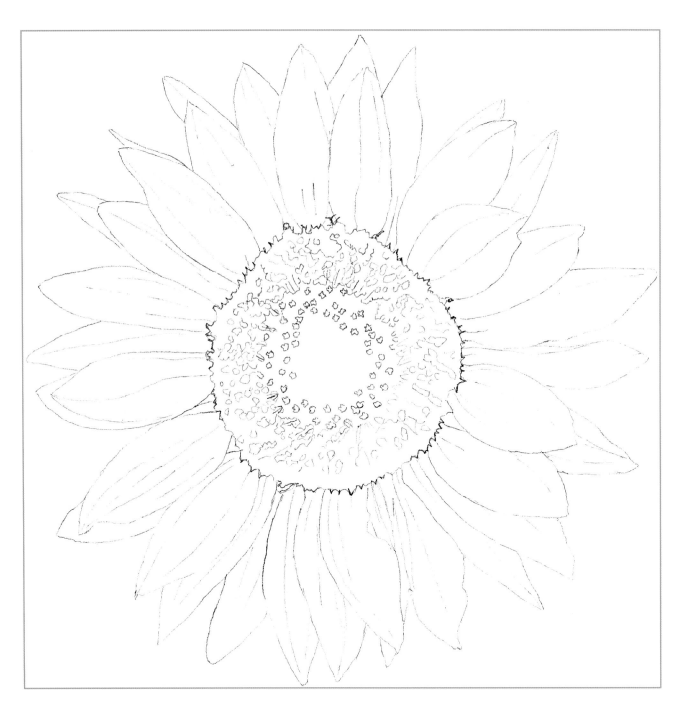

## Sunflower

*see pages 92–101*

# Garden bird

*see pages 102–115*

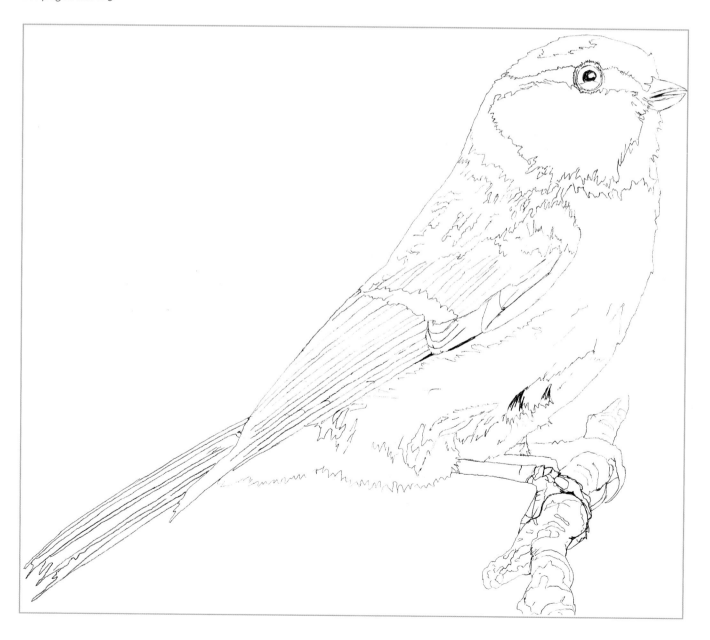

# Index

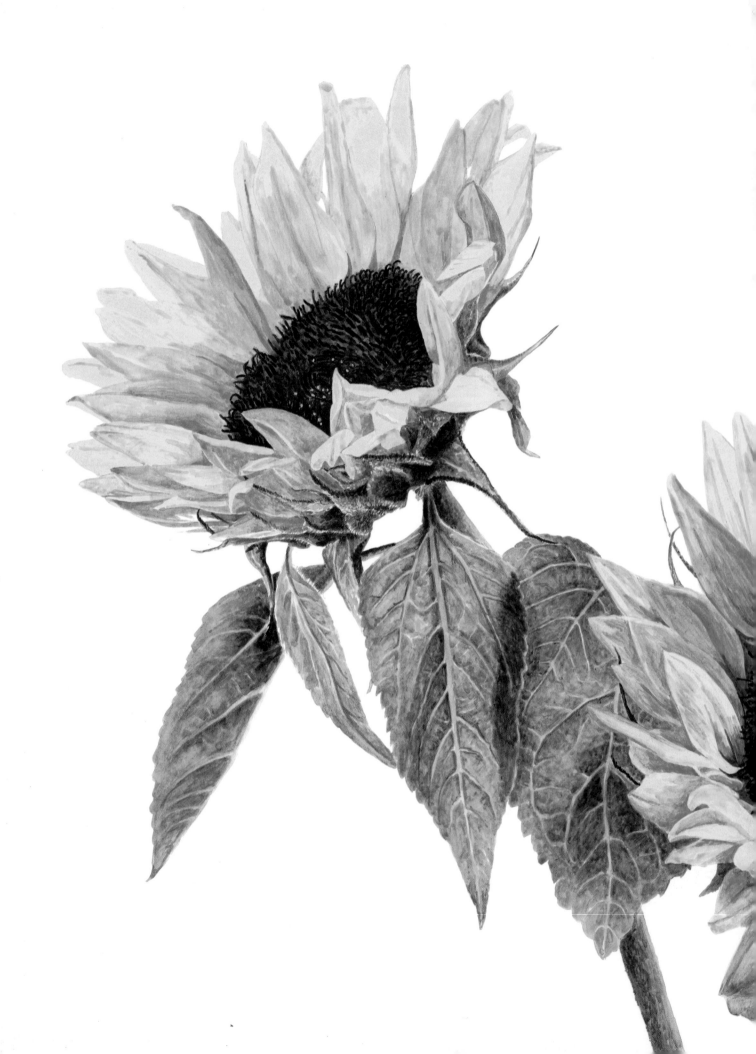